PATTI HANSEN

A Portrait

PRODUCED BY IVAN SHAW

CONDÉ NAST ARCHIVE

EDITED BY LAIRD BORRELLI-PERSSON

ABRAMS

New York

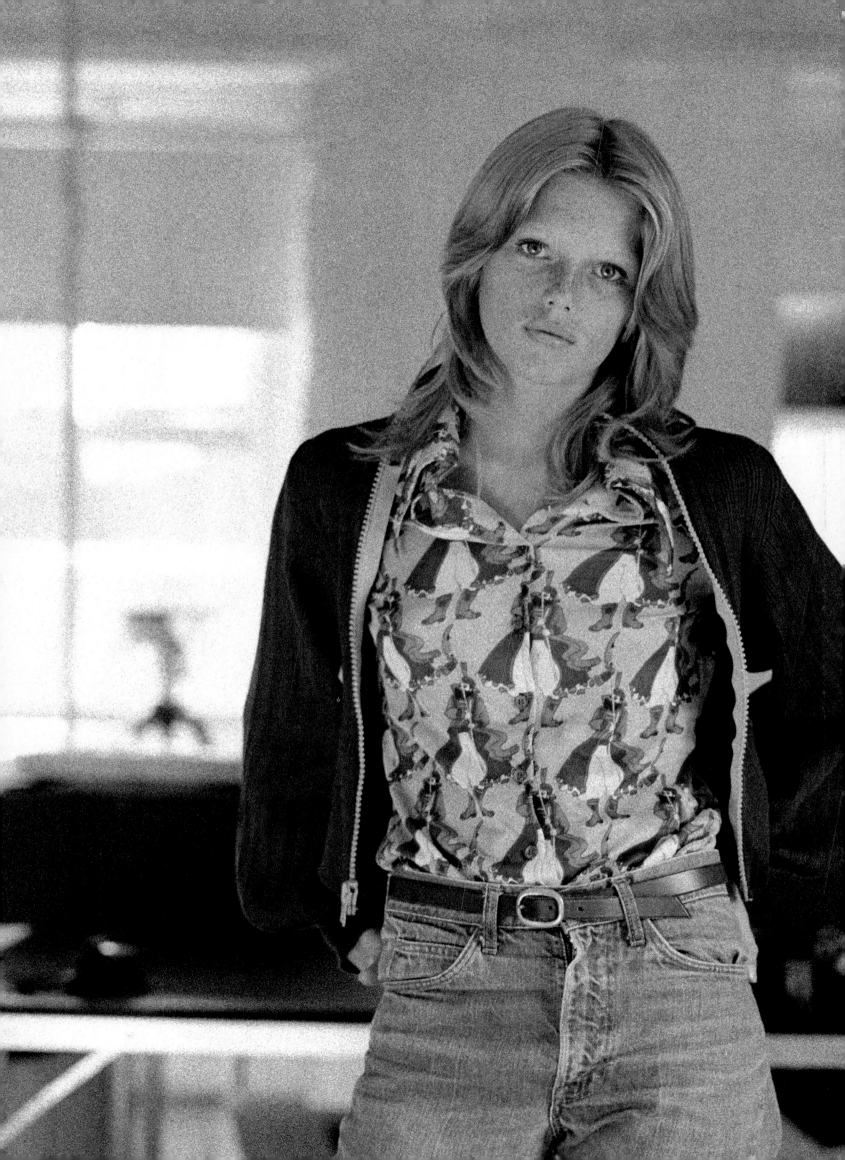

OPPOSITE
Arthur Elgort documented Hansen's
first go-see with him in 1972.

FOLLOWING PAGES
Mike Reinhardt, *Glamour,* April 1974.

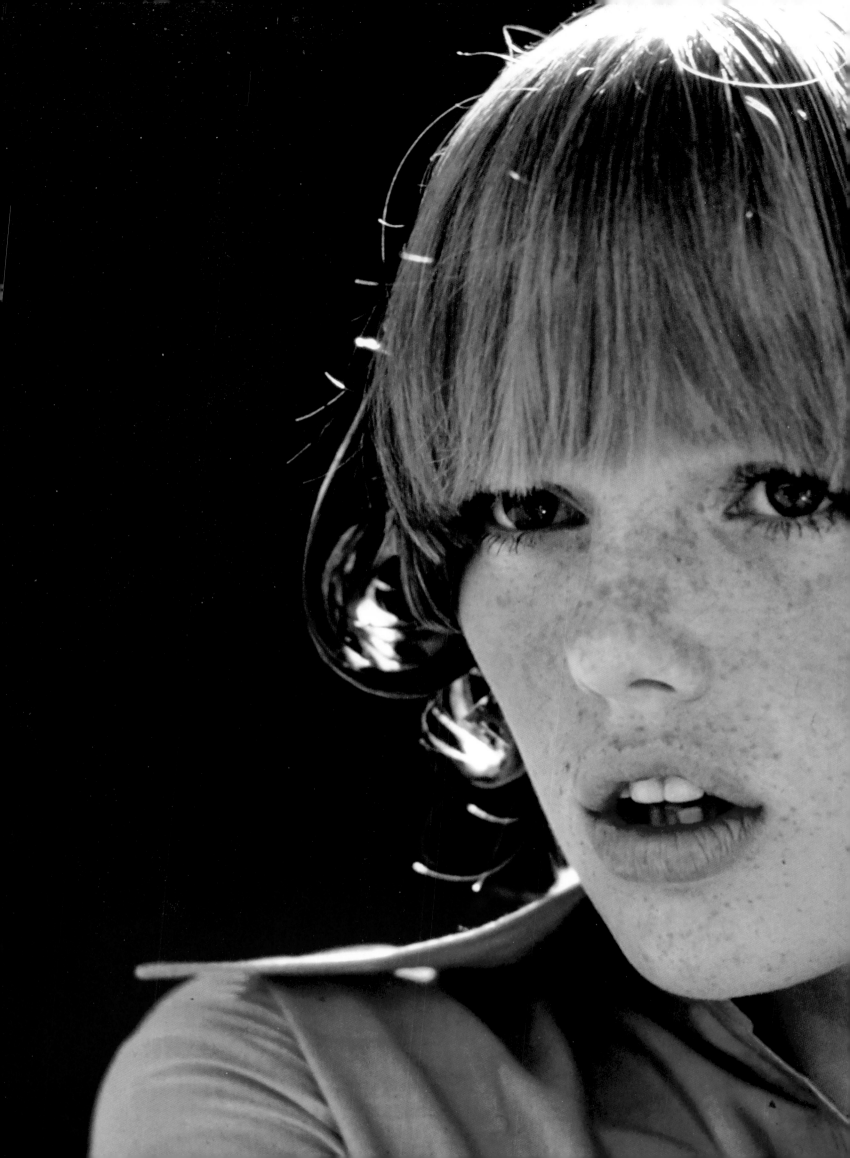

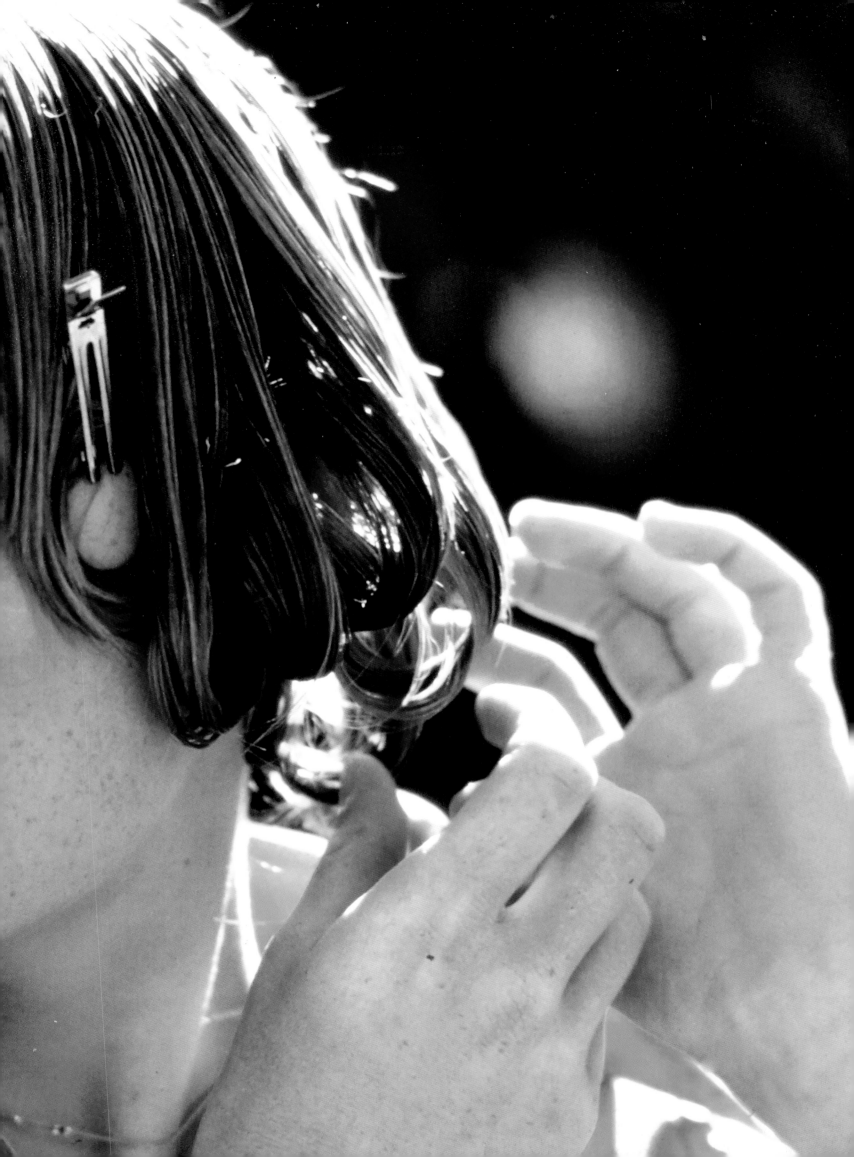

FOREWORD

EARLY IN MY MODELING CAREER, I spent hours in *Vogue*'s glossy lobby waiting for the booking editors to call my name. While praying for the chance to work with the legendary magazine, I gazed at a stunning photograph of Patti Hansen that hung on the wall. Although I didn't know Patti or her story at the time, I found myself absolutely lost in the photo's overwhelming beauty.

Originally shot by Arthur Elgort, the image is iconic: Patti wears a one-piece swimsuit by Calvin Klein and stares intensely away from the camera. Her undeniable edge, athleticism, and all-American persona radiate through. For an anxious aspiring model, Patti's image in that lobby was an aspirational yet reassuring beacon.

Over the years, Patti became a role model for me. I am lucky to be among generations of models inspired by her and all she has accomplished. A girl from Staten Island who turned into the ultimate fashion fairy tale, Patti worked with the great photographers, graced the cover of every major fashion magazine, and starred in massive campaigns—all before turning 30.

As one of the industry's first-ever supermodels and as a muse for some of the most talented and esteemed designers and photographers, Patti has come to define a generation of fashion through her work. From the seventies through the new millennium and beyond, there's at least one photograph of Patti that symbolizes the culture, music, style, and fashion of each decade.

Beyond the camera, Patti is a loving mother, fierce advocate for women, brave cancer survivor, rock-star wife, and ultimate cool girl. She has handled her success with grace and prioritized the love she has for her family at every step along the way. She represents strength, resilience, and the American Dream.

Coming full circle, I eventually followed in Patti's footsteps and worked with the esteemed Arthur Elgort. On set, he often praised her magnetic personality and radiance—those ineffable qualities that were captured in that iconic image that once hung in *Vogue*'s lobby. This book commemorates her timeless brilliance by collecting all the joyous moments, untold stories, and inspirations behind the photographs. A memoir told through beautiful visuals, it's a celebration of the strength and beauty of women through the story of America's ultimate fashion icon: Patti Hansen.

KARLIE KLOSS

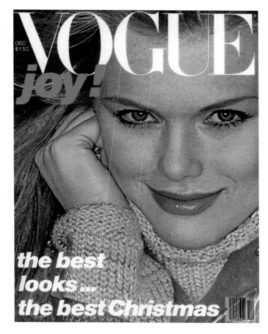
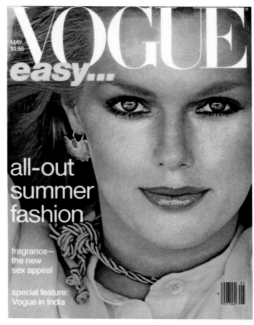
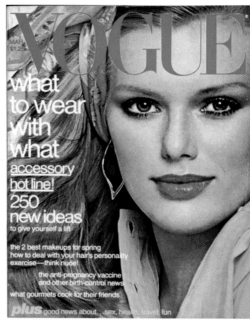
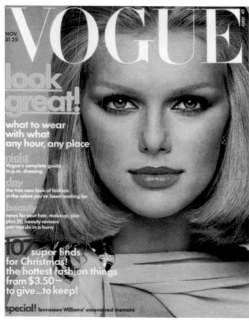
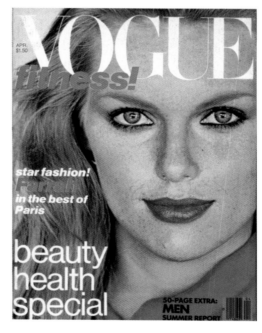
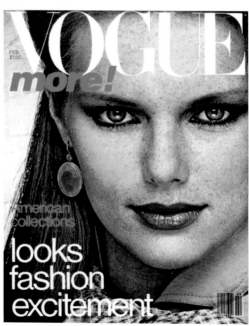

TOP ROW
Patrick Demarchelier, December 1977;
Francesco Scavullo, May 1978;
Arthur Elgort, March 1977.

BOTTOM ROW
Francesco Scavullo, November 1975 and April 1978;
Albert Watson, February 1978.

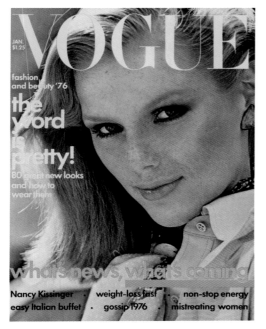

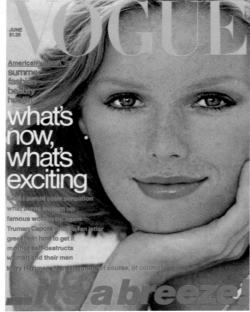

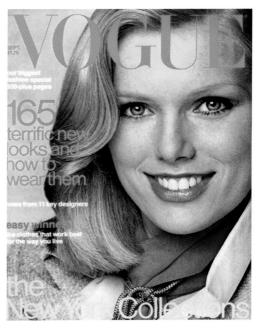

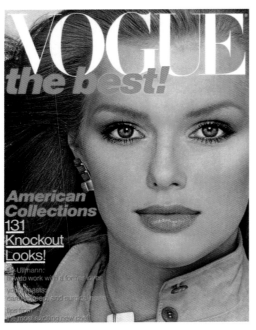

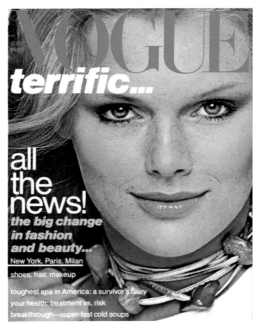

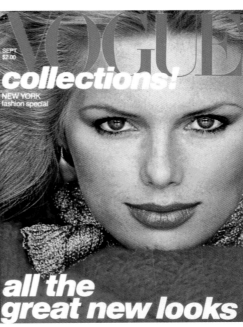

"IT FEELS LIKE YESTERDAY"

IVAN SHAW

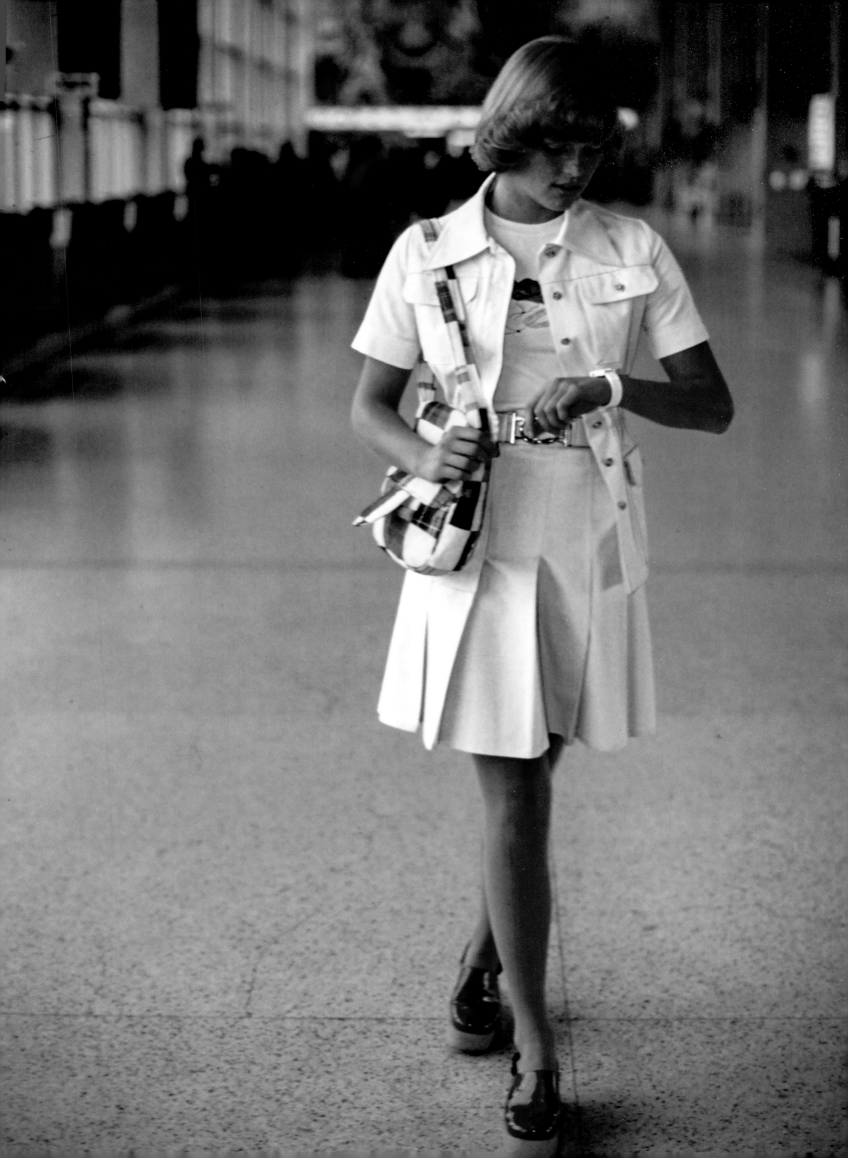

The evening before I was scheduled to meet Patti Hansen for the first time, I had a sleepless night. She was coming to Manhattan for a workout session, and we had agreed to meet at a juice bar near Wall Street. In my extreme nervousness—I was meeting an icon, after all—I arrived way before the scheduled time, so there would be no chance that I would be late (and then decided to stand in front of the doors, so there would be no chance that she would miss me). A black car pulled up, and out strode Patti.

She bounded up the steps and gave me a hello hug—this despite the fact that we had had only one brief phone call and exchanged but a few emails. But that, I discovered, is Patti in a nutshell: strong, honest, open, and warm.

After ordering green smoothies (I had what she was having), we sat down at a table and I explained my idea for this book, which focuses primarily on the editorial work Hansen did for Condé Nast during a short but enormously prolific period of the 1970s. My pitch was accompanied by printouts of Hansen's most memorable stories from *Vogue*, as well as some of her earliest work from *Glamour*. "It feels like yesterday," said Patti as she looked through the pictures, and her eyes started to water. This summed up how I felt, too, after having spent months poring over pictures of Hansen. When we met, it seemed that time had collapsed on itself—that this Connecticut wife, mother, and grandmother and the freckled teenager who became an icon of American style existed just minutes apart from each other.

———

HANSEN'S STORY STARTS on Staten Island. Patti is the youngest of seven children; her father drove a bus, and her stay-at-home mother kept the family organized. During the summer, Hansen sold hot dogs at her father's stand at a local beach and was, she said, "in love with the boy next door." She

was more enthusiastic about drawing than school and thought she "probably wanted to be a hairdresser." Fate intervened in the form of a close friend and neighbor, Ross Decker, who, Hansen told *Vogue* in 1999, "just decided I should be a model" and took some pictures of her at the beach, which he showed to photographer Peter Gert, who recommended that Hansen meet model turned agency owner Wilhelmina Cooper.

Hansen hopped into Gert's VW Bug and the two drove across the Verrazano-Narrows Bridge to the agency's fifth-anniversary party, at which Gert delivered on the promised introduction. He took some test shots, which were successful, and within weeks Cooper made the reverse trip to Staten Island to meet Hansen's parents. "Your baby is going to make $100,000 a year," she told them. "Don't worry; I'll take good care of her." Hansen's father agreed to let Patti, then sixteen, sign with Wilhelmina with the proviso that she continue her schooling. Hansen was soon at the head of the modeling class: "I started working from day one," she recalls. "I was that lucky."

Hansen arrived on the scene in the wake of wide-eyed sixties beauties like Jean Shrimpton and Twiggy and before the Amazonian supermodels. Athletic and sunny, Hansen was also able to smolder (witness her late-seventies Calvin Klein jeans ads), a requirement in the heady, innocence-lost 1970s. It can be argued that Hansen's all-American look became the definition of capital-B beauty during that era. Certainly it inspired photographers like

PREVIOUS PAGE
Rico Puhlmann, *Glamour*, May 1973.

12

Arthur Elgort and Patrick Demarchelier, who were shaping the look of the decade with more natural, spontaneous images that captured movement and energy.

Although Hansen was technically still living at home, she was rarely there: Modeling, with its requisite travel, was rapidly taking over her life. Being on the road was something Hansen was familiar with from family vacations—and, of course, a few years later she'd tour with the Rolling Stones. One of her early assignments, though, was closer to home—a 1972 film shot in the Hamptons by Rico Puhlmann for *Glamour* in which Hansen, accompanied by model Keith Gog, frolics on the beach in the season's latest swimsuits. The thirteen-minute film was not simply behind-the-scenes footage. Rather, this day at the beach was a meditation on life and the fleeting beauty of youth that perfectly captures the beginning of Hansen's career, on which the sun was shining.

Hansen started working regularly with photographers such as William Connors; Bill King, whose work had a palpable energy; and Mike Reinhardt, who helped pioneer the louche, mid- to late-1970s look before abruptly checking out of the business in the brash eighties. One of Reinhardt's shots for the February 1974 issue of *Glamour* is an exemplar of Hansen's early work. The straightforward snap, taken outdoors, depicts the grinning model holding a hand-lettered sign that reads SMILE. Capturing Hansen's unspoiled girl-next-door charm, it is the kind of image that was a welcome antidote to the unrest and pain left by the Vietnam War.

Hansen had a lot to smile about. Having already moved to Manhattan, she soon was on her way to Paris. "Everyone made fun of me all the time because I ate Wonder Bread; I ate hamburgers. Here I am in Paris, looking for a hot dog," says Hansen, recalling her first trips to the city. "It was a learning experience." While the model was a quick study, it took a while for her parents to catch up. Once, when Hansen returned home from a beach shoot, she relates, "my parents realized that I didn't have any tan lines. That was a total shocker for them."

Hansen documented those heady days in cut-and-paste scrapbooks. Most of them include a collage of images from magazine shoots, and one has an earlier photo taken at Sears, shown on page 15 (TOP RIGHT). On other pages Hansen has pieced together images from different shoots as though she were assembling fragmentary experiences into a coherent new identity for herself, essentially constructing an "adult Patti."

THE MAN WHO WOULD HELP Hansen solidify this new identity was Arthur Elgort. In a sense, the pair grew up together in the pages of *Vogue*. In his recent book *Arthur Elgort: The Big Picture,* the photographer includes a portrait of Hansen that was taken on her first go-see with him. Though she looks like she stepped out of the classroom and into Elgort's studio, Hansen's potential is clear as she stares straight into the camera as if to communicate that she is ready to work hard. (She laughingly remembers buying the outfit she wore when she met Elgort, which included a pair of platform shoes from Booteria on Thirty-fourth Street.)

By the mid-seventies, Hansen had hit her stride, and her look was becoming the look of the decade. As was the custom at Condé Nast then, the best talent from *Glamour* and *Mademoiselle* "graduated" to *Vogue*. Alexander Liberman, the company's editorial director at the time, spotted Hansen in *Glamour* and knew he had a winner, and Hansen was promptly introduced to the legendary fashion editor Polly Mellen, whose advice was to "go to Europe and come back next year." And so she did, returning to work with Mellen as well as Reinhardt and Elgort, who had also received the Liberman seal of approval.

Not a shy new girl anymore, Hansen had at her disposal a repertoire of looks that ranged from sunny exuberance to steely

determination. The world had changed dramatically in the years between 1974 and 1976, and the country was facing both an economic crisis and a new kind of social turmoil. Hansen, now heading into her 20s, was in tune with the changing and multifaceted world around her. There was change, too, at *Vogue* as Diana Vreeland was replaced by Grace Mirabella, who rejected the fashion fantasies of the sixties in favor of a more practical, modern minimalism. No longer were models whisked away to pose like exotic statuary amid far-flung ruins; Mirabella preferred a modern woman able to stand her ground. The editor wasn't looking for the girl next door but for the woman who had just bought the house across the street.

Just two years after Reinhardt's innocent SMILE photo for *Glamour,* Hansen would emanate power in a story shot by Bob Richardson for a 1976 issue of *Vogue.* Hansen, work bag in hand, leans on the engine of a long American luxury car, her left hand on her hip, as a male companion pops out of the sunroof—most definitely the passenger on this ride. Jade Hobson, who styled the shoot, believes that Richardson had a way of communicating with Hansen that "brought out her sensuality."

Richardson wasn't the only photographer to play up Hansen's allure. In one of her best-known pictures, the model is wearing a white maillot that is more revealing than it is sporty. Taken by Elgort for a 1976 issue of *Vogue,* in some ways it presages the groundbreaking beach shoot that Corinne Day would do with Kate Moss in 1990. Both sittings changed definitions of beauty.

Much of the impact of these images comes from their candidness. As Elgort tells the story, the makeup artist was taking a very long time with Hansen's look, and he was worried about losing the light as sunset neared. As he walked over to the makeup station to complain, Elgort saw Hansen quietly sipping a frozen cocktail and instantly knew he had his picture—one that conveyed strength along with sexual undertones. A second image from this shoot shows Hansen standing poolside gripping a lawn chair with her right hand, again glaring into the distance. One imagines her male prey swimming along helplessly, waiting to be overtaken. The sexually assertive image was controversial at the time of its appearance—America still wasn't entirely comfortable with all that Hansen represented.

———————

IN 1976, HANSEN TRAVELED to the South of France to work with the fabled Helmut Newton, who paired the American with the Swedish model Gunilla Lindblad for a series of images that are a study of feminine power and sexual intrigue. Newton was never shy about playing with taboos, and Hansen, recognizing Newton's transformative abilities, was game. "This is not Patti," she explains, "but somebody I sure like to play."

In 1977, her beauty was documented by two great masters of photography: Irving Penn and Richard Avedon. The extraordinary creative and technical brilliance of both artists had the effect of molding Hansen into an even more sophisticated self. Gone were the maillots of a year or two past—in these studio images, Hansen was dressed to the nines. (Versace and Fendi were among the labels she wore when working with Avedon in his legendary Manhattan studio on East Seventy-fifth Street.) An outtake from Penn's sportswear story, shown on page 114, meanwhile, conveys a sense of intimacy between the photographer and his subject. Although Hansen has joked about not being the perfect model for Penn, in this unpublished image she exudes confidence—and patience. Photographer and model were seeing eye to eye. Bye-bye, girl on the beach; hello, supermodel.

And hello, too, to Studio 54. That's where Hansen went with her best friend, model Shaun Casey, to celebrate her twenty-third birthday. They found themselves

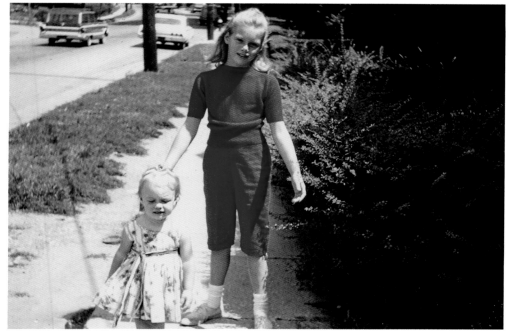

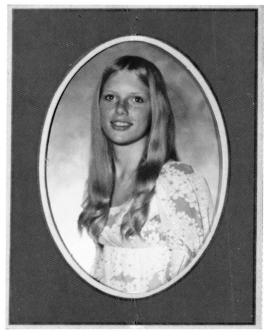

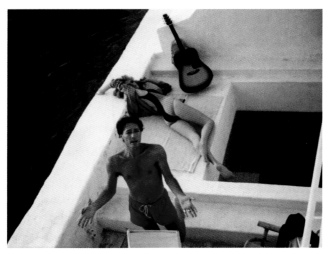

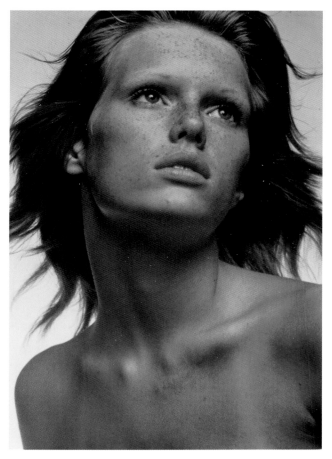

Pictures of a lifetime in
front of the camera.

with nothing to drink at closing time, but Casey spied Rolling Stones guitarist Keith Richards on the dance floor and asked him for a bottle of champagne. She also introduced him to Hansen, and Richards was smitten. He later invited the model to his thirty-sixth-birthday party at the Roxy, a roller rink in Manhattan, and the rest is history; the couple spent the next five days together and have shared their lives ever since.

In 1980 Hansen and Richards flew to Hammamet, Tunisia, so she could work with stylist Jade Hobson and Chris von Wangenheim, a photographer known for the dark intensity of his work, for a *Vogue* shoot. Hansen recalls his directing: " 'Eyes, eyes . . . yes! So intense.' He just wanted angst, something very dark," she says. Contributing to this mood were Hansen's hair and makeup, by Maury Hopson and Sophie Levy, which had an edge that nodded to the drama popularized by the Punk and New Romantic movements. "Patti simply became a part of all the times she has lived through," says Hopson. The thing that sticks with Jade Hobson, though, has nothing to do with style; it was the way Von Wangenheim was able to co-opt the couple's passion. "Richards would sit so that Patti was looking at him while being shot," she says. "He was singing to her and kind of making love to her through his eyes."

By this time, Hansen was ready to flirt with a different kind of exposure. The outspoken photographer Francesco Scavullo, who considered Hansen to be "the Marilyn Monroe of the eighties," told *People* that her beauty made "Cheryl Tiegs and Farrah Fawcett seem old hat" and encouraged Hansen to pursue her interest in acting. She took the plunge, filming *They All Laughed* alongside Ben Gazzara and Audrey Hepburn. Although she'd act in a few more films, Hansen decided Hollywood was not for her.

Hansen with Keith Richards in London, 1986.

"I was not ready for acting at all," she says now. "All my insecurities and shyness came back."

Cheering on Hansen every step of the way was Richards, whom she married on his birthday in Mexico in 1983. Their daughters, Theodora and Alexandra, were born in 1985 and 1986. A charmed life as a full-time rock-'n'-roll mother seemed to be in the cards until, says Hansen, "a Clairol ad started things going again." By the early nineties, Hansen had become the go-to model for a new generation of photographers, including the prolific and influential Steven Meisel, who snapped Hansen for the cover of Italian *Vogue*'s June 1993 issue. At 37, the model radiated a mature, easy beauty that resonated with the era's anti-glamour aesthetic.

VOGUE FASHION DIRECTOR Tonne Goodman brought Hansen and Meisel together again for the August 2004 cover of *Vogue*. The model seems entirely comfortable in her skin in these images, retaining the air of American chic she embodied when she started. And in a thoughtful piece in *Vogue* in 2010, Jonathan Van Meter celebrated Hansen's career and her triumph over bladder cancer. Annie Leibovitz shot the accompanying portrait, styled by Phyllis Posnick. Hansen, her endless legs clad in black leather thigh-high boots, reclines in a cozy chair at home in Connecticut with her beloved French bulldogs by her side. It's an intimate look at an icon with an edge.

The beat in Hansen's career goes on. For her next *Vogue* appearance, in 2012, the model opened the door of her home in Turks and Caicos to Bruce Weber, who, with stylist Camilla Nickerson, captured three generations of the Richards family. "Just get out there and have a party, and I will film you" was Weber's only direction, which was carried out to a T. For Hansen, discovered by the seaside in Staten Island, life is still a beach.

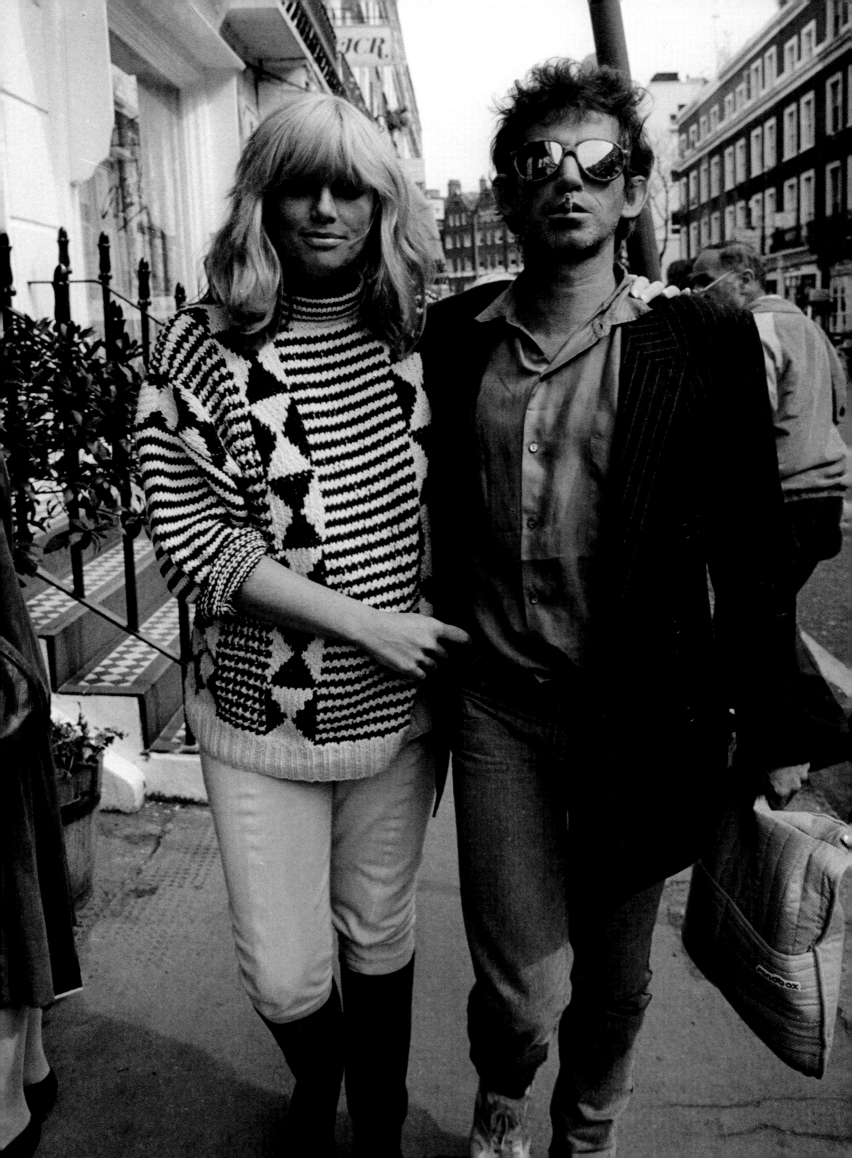

CLOTHES AND THE ALL-AMERICAN WOMAN

LAIRD BORRELLI-PERSSON

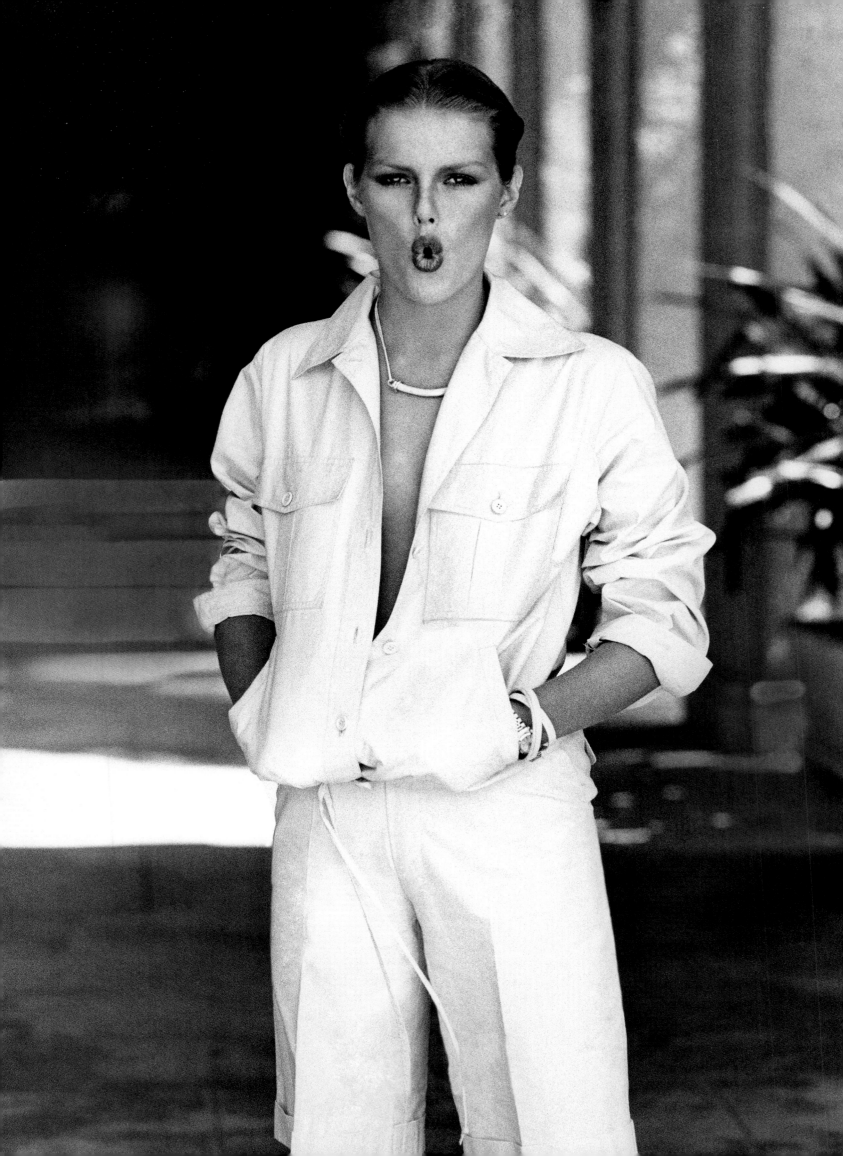

American fashion and American models came into their own in the 1970s, and nowhere were they more at home than at *Vogue*. By the time the no-nonsense Grace Mirabella succeeded Diana Vreeland as editor in chief in 1971, the Youthquake movement had lost its tremor, and the fantasy and exoticism that had defined the magazine for almost a decade were played out.

It was time again to address reality—and for women to find new ways to look and to be. Helping them into this new groove was *Vogue* (which was big on advice-giving do's and don'ts columns), as well as a homegrown crop of American designers who were putting sportswear on the map.

The likes of Halston, Calvin Klein, Geoffrey Beene, Diane von Furstenberg, and Norma Kamali became household names. All aimed for ease and championed separates dressing—a democratic way of putting oneself together that had, noted *Vogue* in 1972, "nothing to do with hemlines, waistlines, or with anything forced or contrived." (A subtle reference, perhaps, to Christian Dior's flattering but constricting New Look.) We now take casual ease for granted—Casual Friday has evolved to Casual Every Day—but that wasn't always the case, as evidenced by the surprise success of the Americans at the Battle of Versailles.

Organized to raise money for the palace's restoration, this charity fashion show had a clever marketing ploy: Five American designers would vie against the same number of French ones in Paris, historically the capital of world fashion. As was soon clear, the verve, diversity, and modernity of the "away team" made the French clothes look stuffy and overdone. It was the disco age, after all: Women wanted clothes that moved with their bodies. They wanted to exercise

their right to choose—in the bedroom, in the boardroom, in a boutique. The day of the fashion dictator was over.

Just as garments changed, so did ideas of beauty. The one-monikered child-women of the 1960s—beauties like Twiggy, the Tree, the Shrimp, with their painted-on freckles and false lashes—conveyed a youthfulness that was then new in fashion. By the 1970s, though, fashion had become "all about women, not children," as *Vogue* stated. "A young woman, an older woman—but a woman. A woman dressed. With finish, style, glamour, sophistication . . . things that have been out of our lives for a long time. They are *In*."

———————

PATTI HANSEN, WHO WOULD come to embody all of these qualities touted by the magazine, often on its cover, was not yet a woman when she started modeling in 1972. Back then she was a beach-loving, freckle-faced teenager from an outer borough of New York with long, sun-kissed hair who was "trying to be Jean Shrimpton," as she recalled in *Vogue*'s November 1999 Millennium issue (in which she racked up her thirteenth cover credit). "I thought those Yardley commercials were absolutely it—you know, the knee socks and miniskirts and white lips and black eyes and really high pigtails. Actually, I think my awareness of the world outside of Staten Island started at that point, with that image of Jean Shrimpton." Hansen would later cite the elegant Karen Graham and earthy, gap-toothed Lauren Hutton as models she admired, but Shrimpton was a relatable teen dream for Hansen, who at

that point was modeling junior fashions—a trench from Sears, pink velvet from Betsey Johnson's Alley Cat line—for magazines like *Glamour* and *Seventeen,* which were aimed at a younger audience.

In those publications, which catered to college and high school girls, Hansen was cast as the tomboy next door. "I was always the energetic one—the model they'd hire to leap over fences . . . I'm so outdoorsy," she'd later say. With her short hair and wide grin, Hansen represented an apple-pie innocence, a guise that she soon found constricting. So she spent some time in Europe, adopted a smoky eye, and returned home, where, in 1975, the nineteen-year-old Hansen "graduated" to *Vogue*—soon becoming, in the opinion of Harry King, a hairdresser who worked for the magazine at that time, "*Vogue*'s pinup girl, *Vogue*'s sex symbol."

Sometimes referred to as the Me Decade, the seventies sizzled with sex and were defined by freedom, glamour, indulgence, and decadence. "I'd much rather look sexy than chic," model and actress Rene Russo once said—and she wasn't alone in feeling so. "It was all about clothes and music, and the girls were very young and they were very hot, and they wanted to look the way they felt," explains Sandy Linter, a makeup artist who worked with Hansen at *Vogue.* Helmut Newton, Chris von Wangenheim, and Bob Richardson were among the photographers defining the look of the decade with images that didn't shy away from sexual innuendo. It was clear, when Patti was romantically paired with another model on this type of shoot, that she would get the guy—or, in Newton's images, the girl.

Clothes, of course, contributed greatly to the mood of seduction. Diane von Furstenberg's easy-on, easy-off jersey wrap dress, an icon of the era, was tryst-friendly by design. Gone was the cookie-cutter structure of early-1960s fashions, along with the stiffer fabrics they were made of. Hippie bohemianism, meanwhile, was cleaned up, given a sporty twist, and softened. Body-caressing materials like silk, jersey, mohair,

and cashmere were à la mode—and best worn without underthings to avoid VPL. Tailoring yielded to *flou.* Designers like Sonia Rykiel and Karl Lagerfeld, then at Chloé, introduced a certain she's-come-undone quality to fashion, with exposed inside-out seams modeled by Hansen for a Newton shoot in Nice. Pajama- and pants-dressing emphasized ease and mobility and liberation. (Who from that time can forget the confident stride of the Charlie girl?) Clothes wrapped and tied, and drawstrings made their way from the locker room to the runway. "Softness and slide" were the words *Vogue* used to describe one look Hansen modeled for Irving Penn, but the phrase could be applied to many of the decade's clothes.

———————

HANSEN, WHO WAS ONCE described as "Marilyn Monroe without the neuroses," is undoubtedly sexy, but she was more than that: She never lost the tomboy quality she first showed in teen magazines. The model, who describes her signature pose as "running through water, [with] a big open smile," exuded strength and was often cast as an exemplar of health. (The caption that accompanied the famous Arthur Elgort photo of the model sipping a cocktail read, "Be wise, like the young woman drinking milk; eat and drink complete proteins"!) In 1978, Hansen flew to Petit Saint Vincent to capture the "gutsy look" *Vogue* admired. "This is how we see a woman today," read the accompanying copy: "strong, fit, beautifully alive—with a whole new sensual awareness of her body."

Hansen's body is famously on display in some now-iconic images taken by Elgort for the magazine, where the only thing that came between the model's skin and the camera was a "swimmer's dream of a perfect maillot." Designed by Calvin Klein (who would become a friend and would cast the model in ads for his designer jeans), this white tank bathing suit was as thin as an onion skin and almost as revealing. The naturalness of the picture, though, has

something to do with the almost-candid, off-the-cuff style Elgort used, but also with the way Hansen wore clothes. "Whatever you gave her, she treated it like it was her own clothing," says Linter.

Two years after the Elgort shoot, *Vogue* ran a portfolio of its top models—Hansen, Beverly Johnson, Russo, and Rosie Vela—whom Richard Avedon collectively referred to as the "four heart attacks." In his accompanying essay, "The Cover 'Girl' Is a Woman," Cleveland Amory noted the rise of the American (versus European or exotic-looking) model, and described her look as being one "that is perilously close to that of a real person." Artifice might be the heart of fashion, but the times called for a more approachable look. Over time, Hansen's freckles were allowed to show on her cover shoots, a move she applauded. "It said to women that they should feel comfortable in their own skin," she says. As Hansen always appeared to be.

The reality was a little bit different. In 1979, she told the journalist Marian Christy that she lived in a Greenwich Village apartment furnished only with a bed. "My work is show," she admitted, "and when I'm home I have a need for starkness. I require a peaceful environment." Not to mention time for a disco nap. A self-described "night person" and "disco freak," Hansen had a rock-'n'-roll edge long before she met Keith Richards, her husband since 1983. Still, there was always a sense that Hansen had her feet in the sand. Discovered on a Staten Island beach, she raised her daughters by the sea until they were of school age, and her most recent *Vogue* shoot brought her daughters and grandchildren together with her and Richards on Turks and Caicos.

Ultimately, Hansen is fashion's golden girl—and not only because of her look. "She understood either what she wanted to give or what the photographer wanted," says Linter. "She never missed."

FOLLOWING PAGES
Hansen with Keith Gog,
Rico Puhlmann, *Glamour,* December 1972.

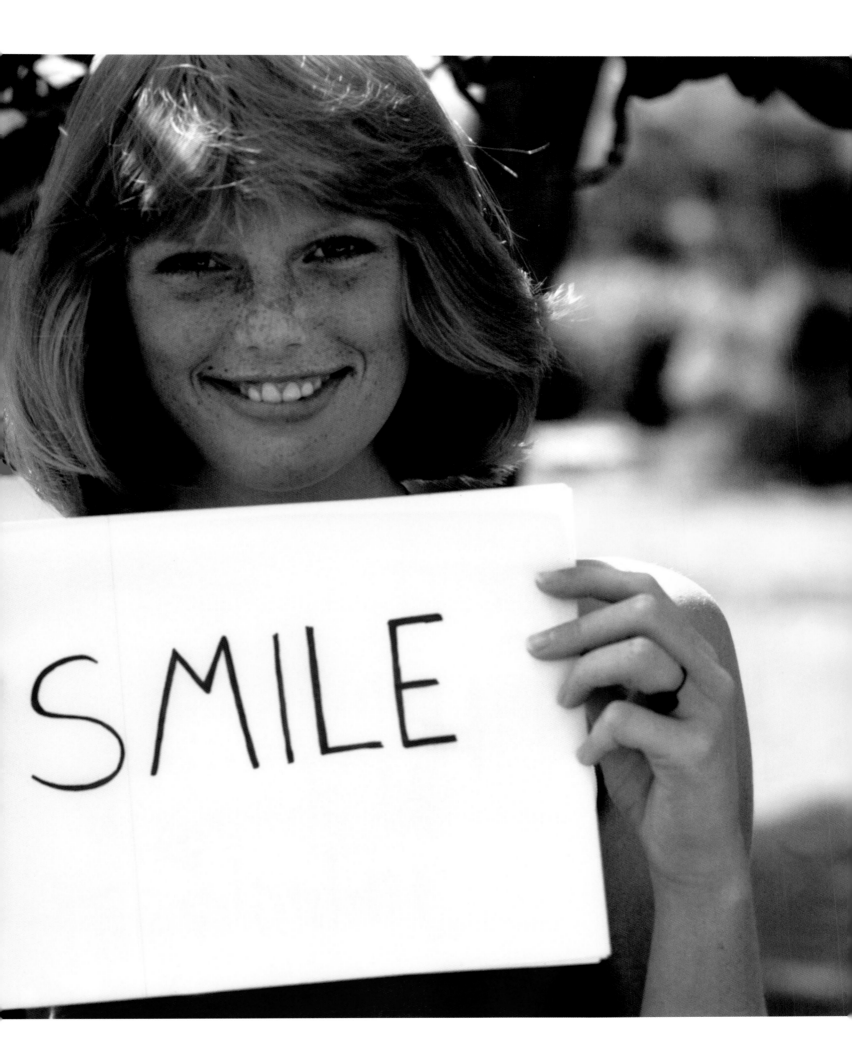

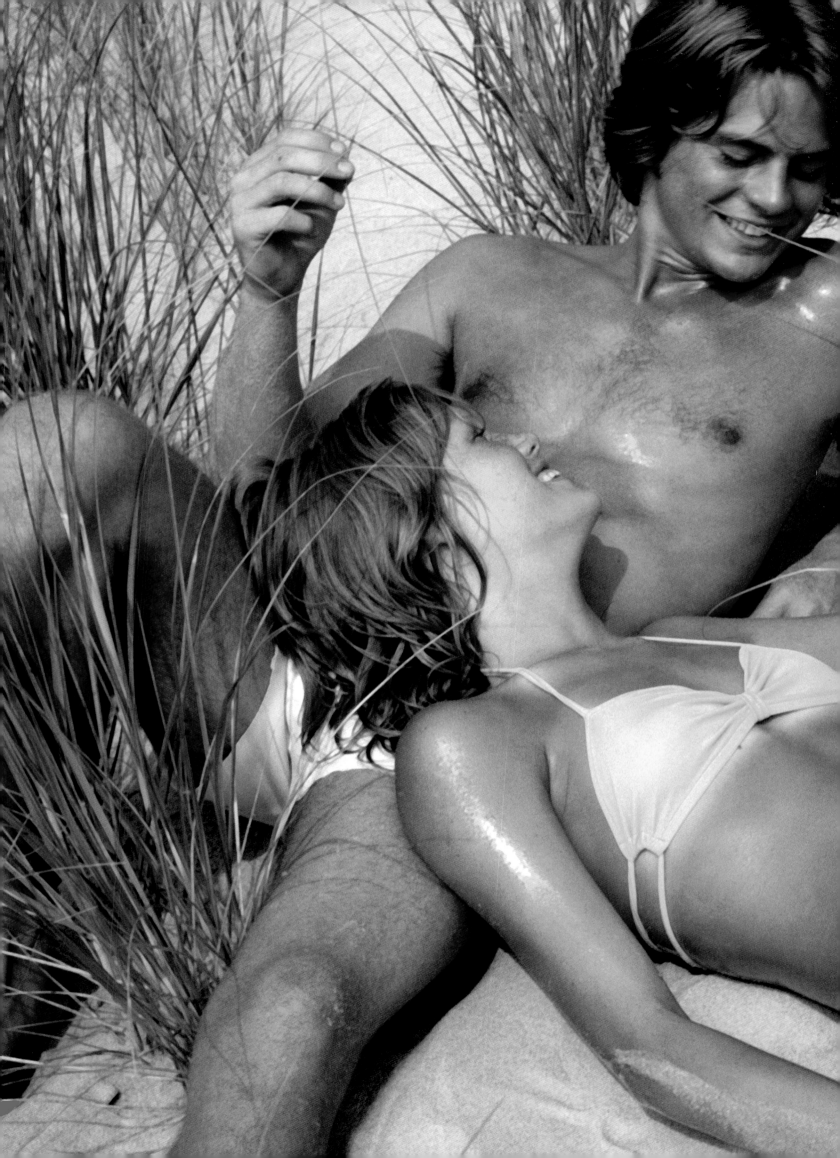

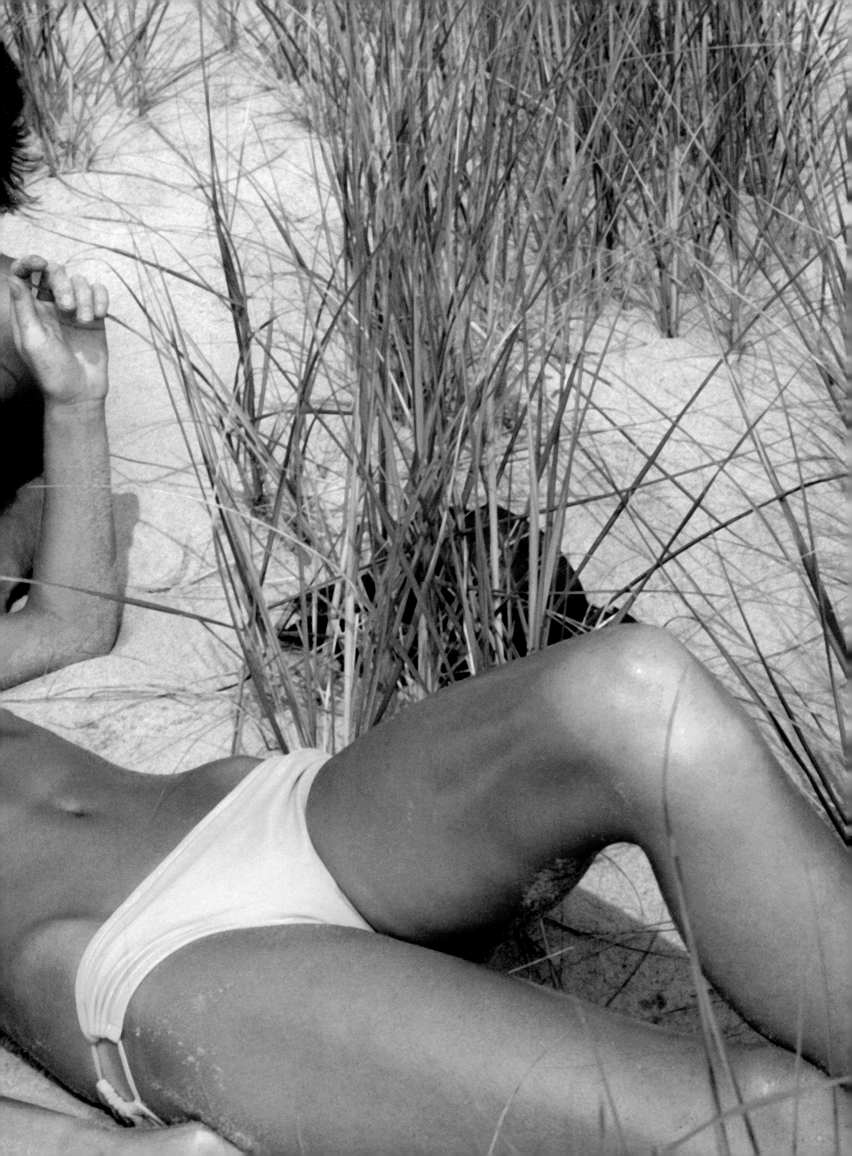

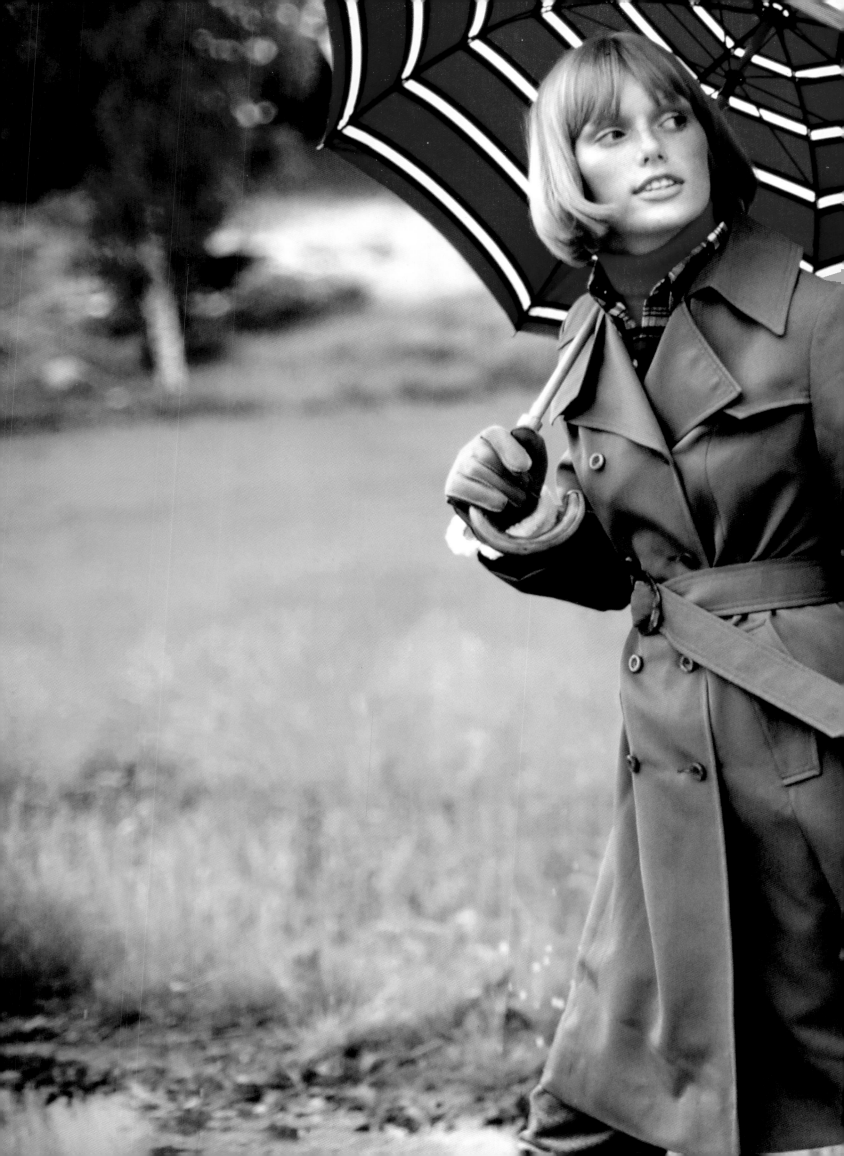

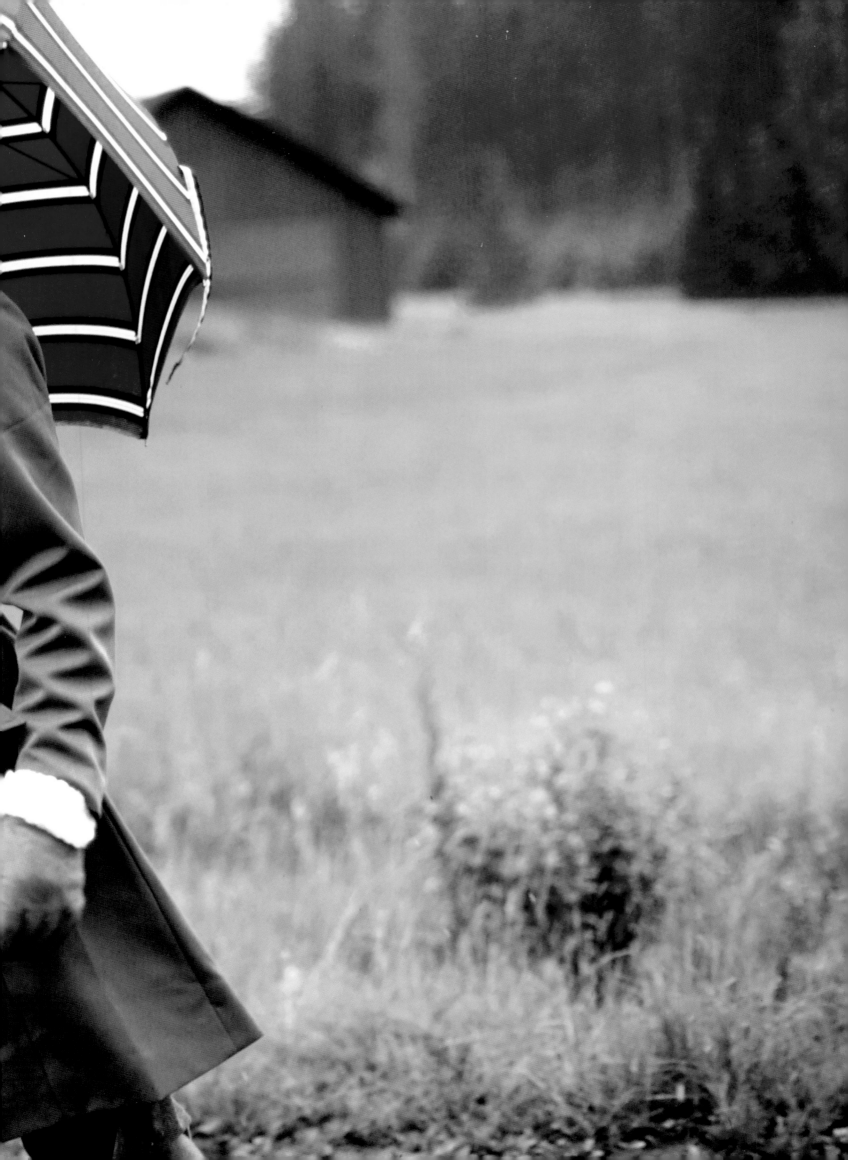

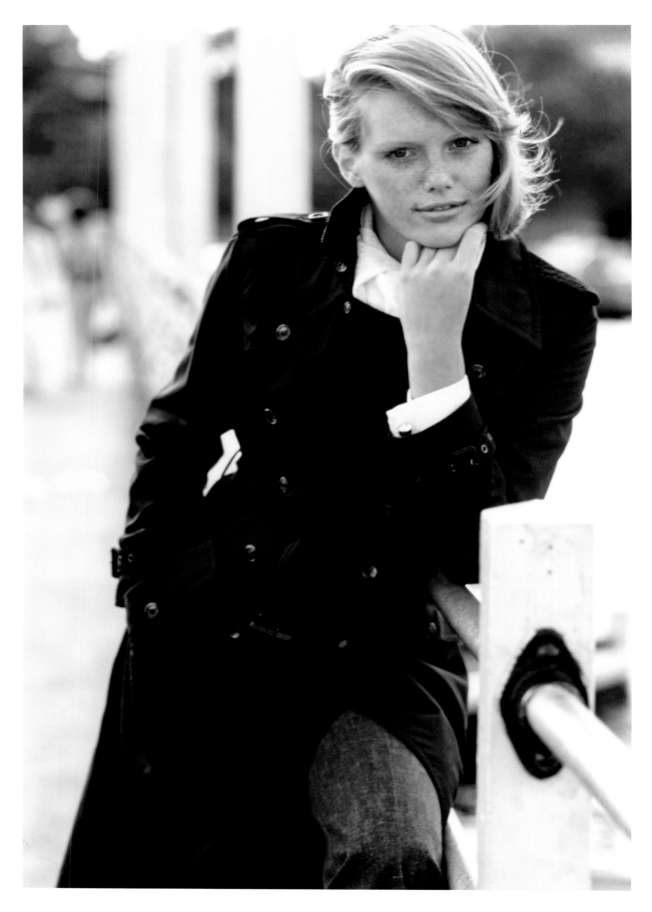

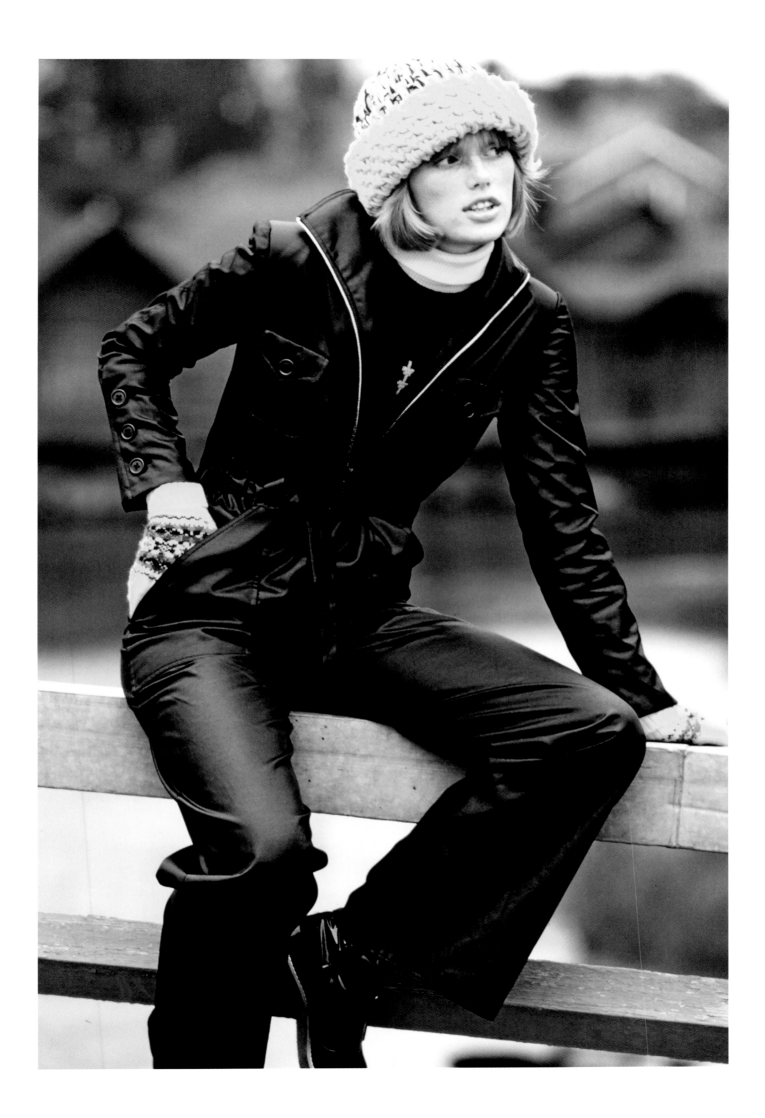

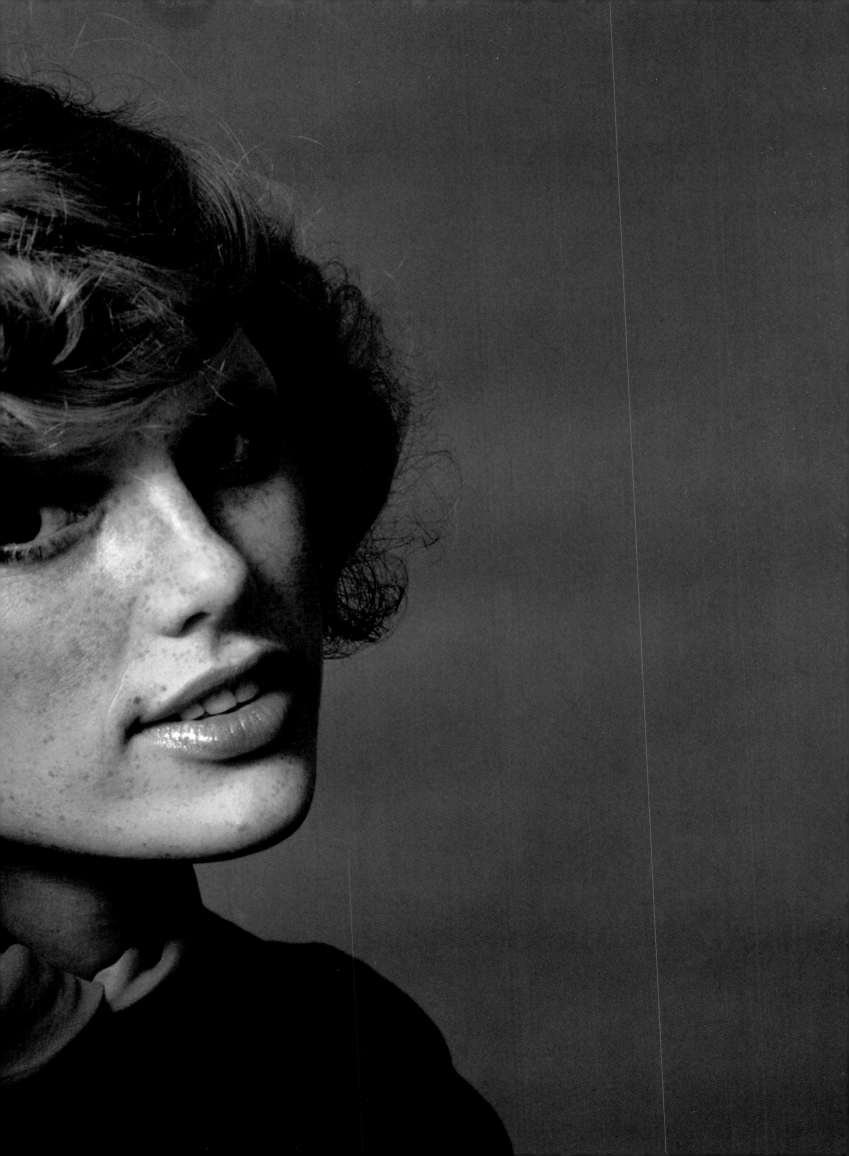

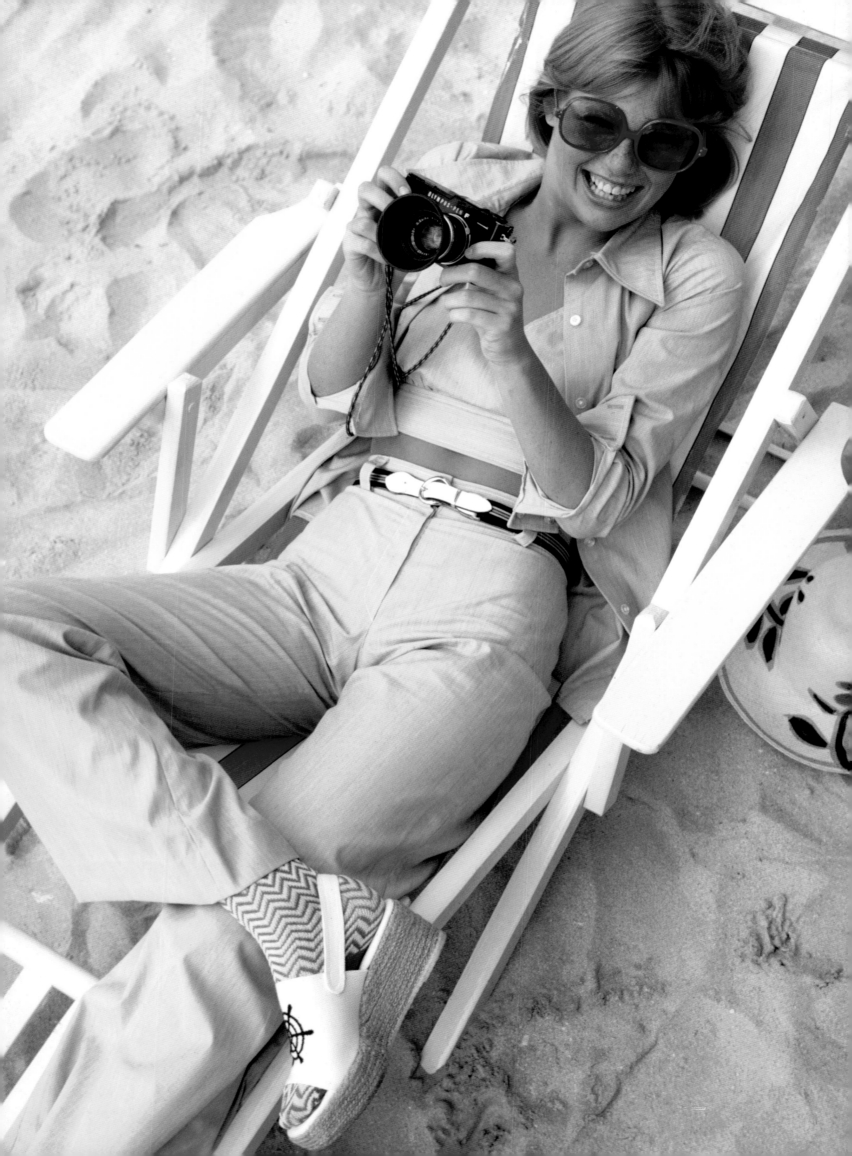

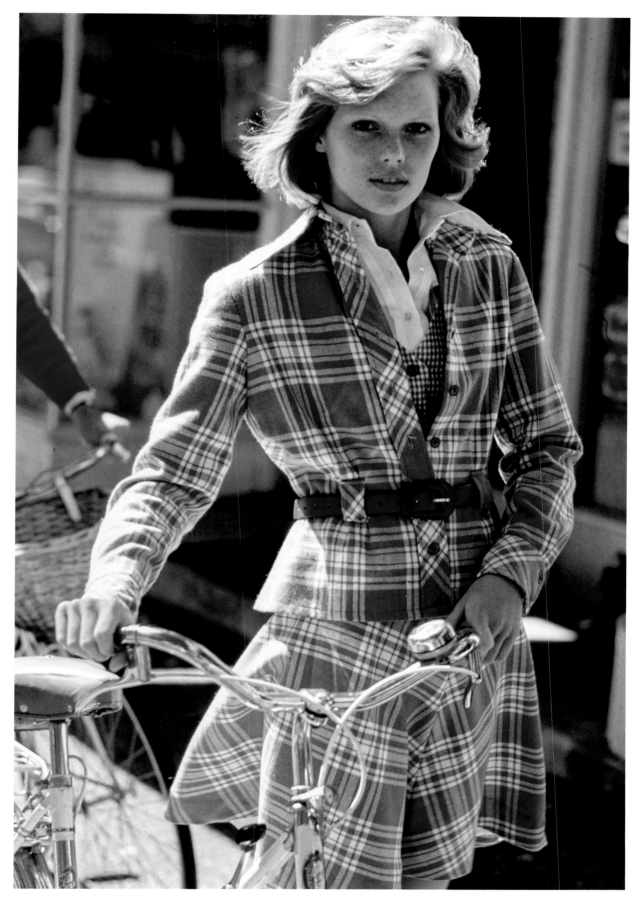

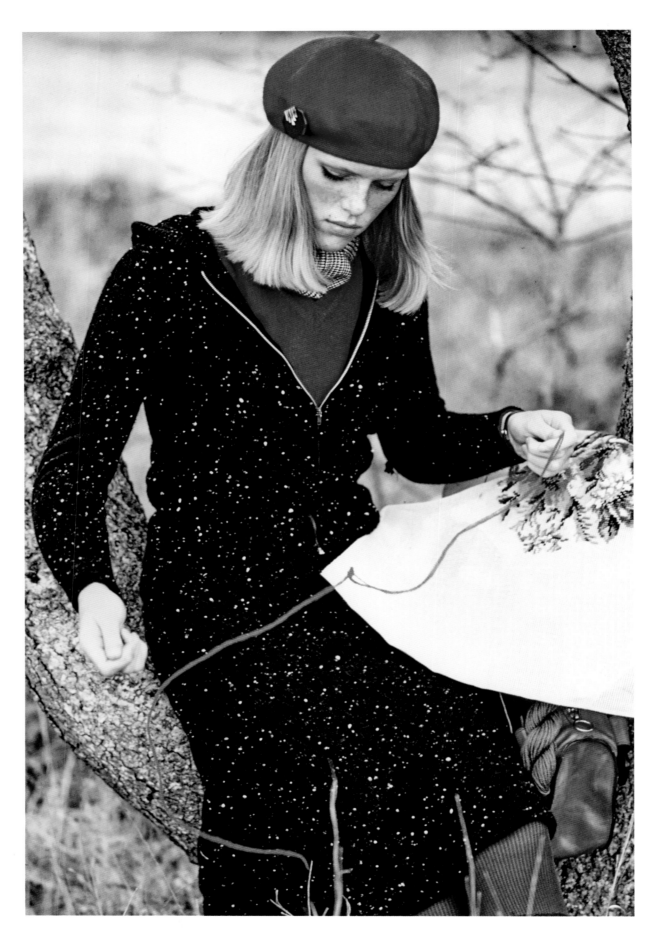

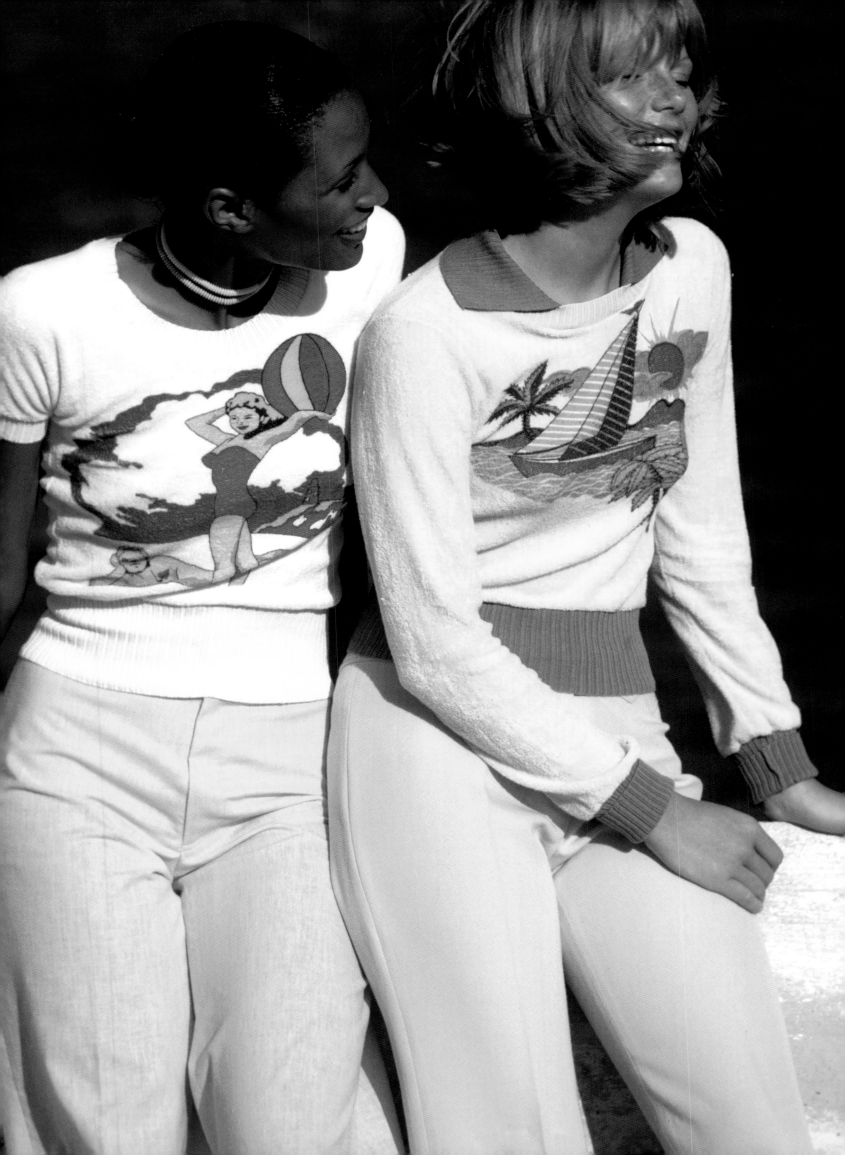

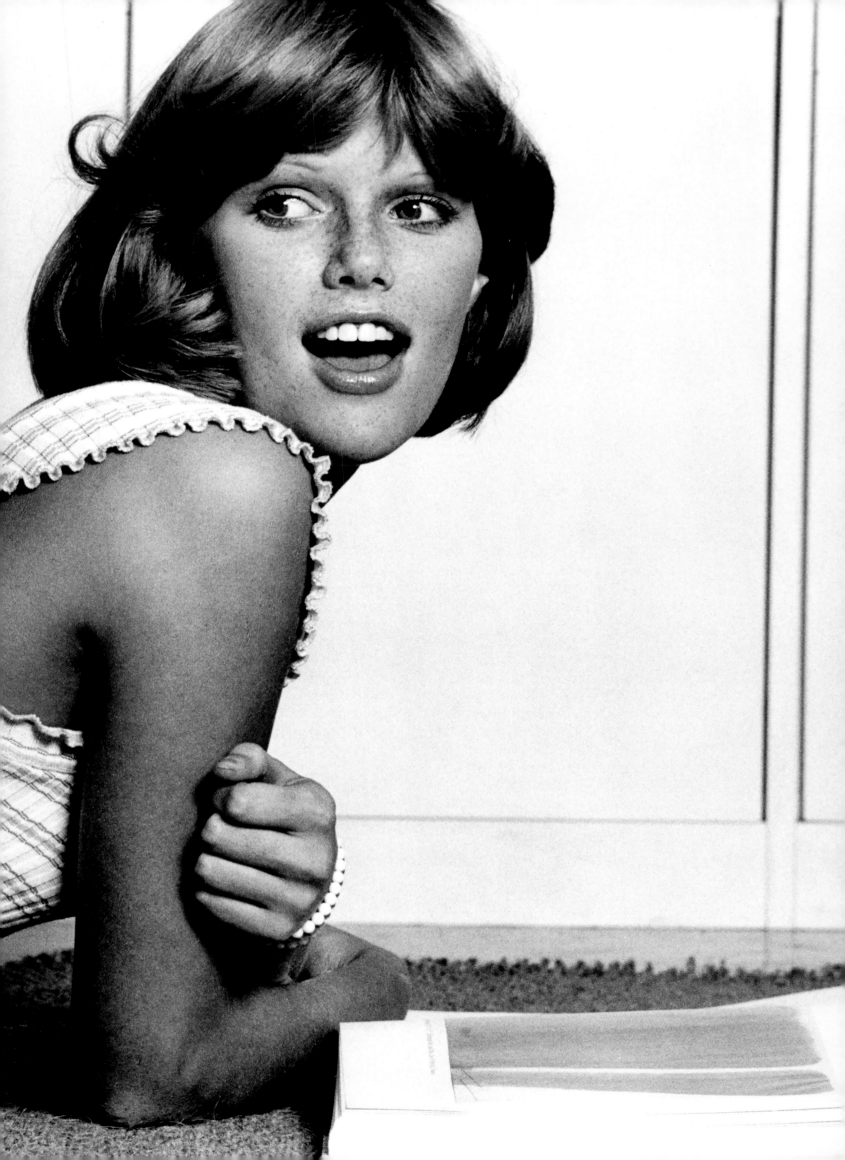

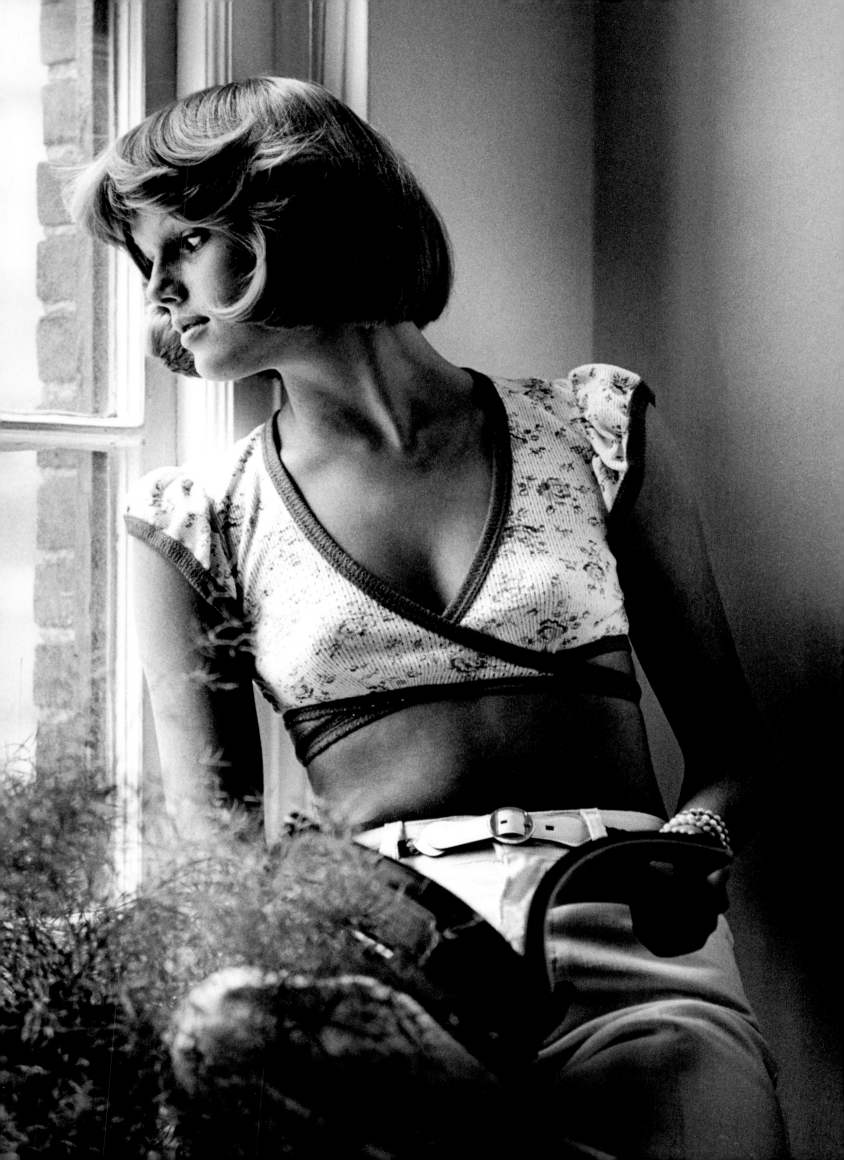

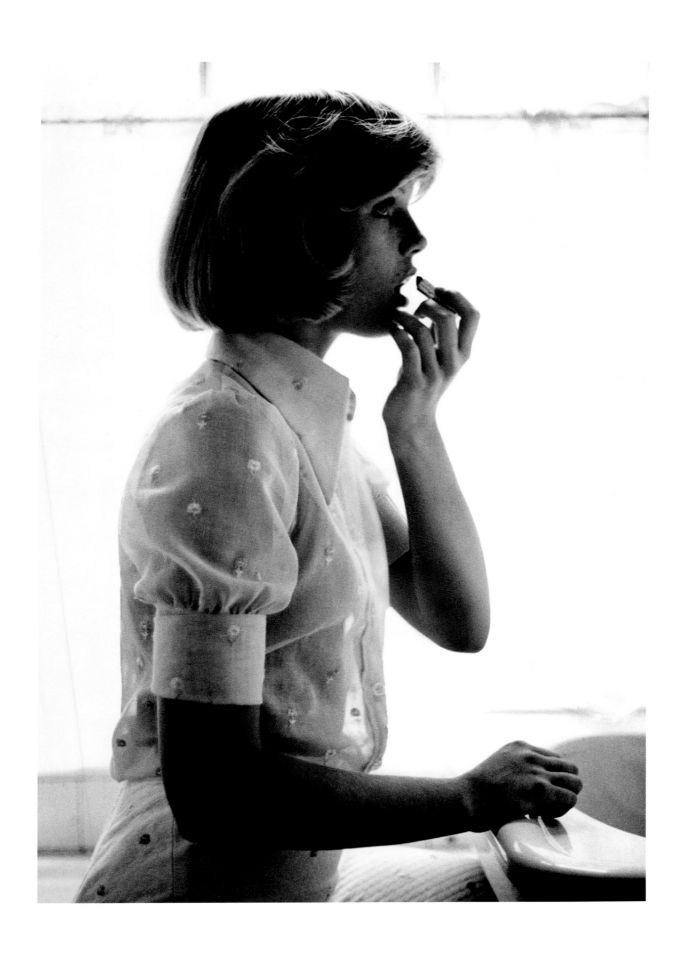

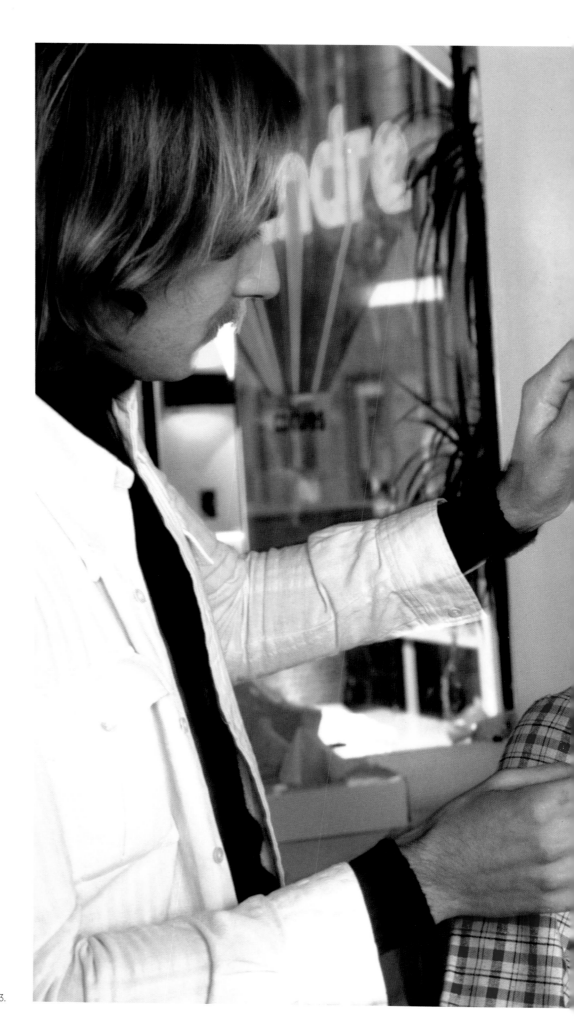

Hansen with Andre Martheleur
of Cinandre.
Mike Reinhardt, *Glamour,* May 1973.

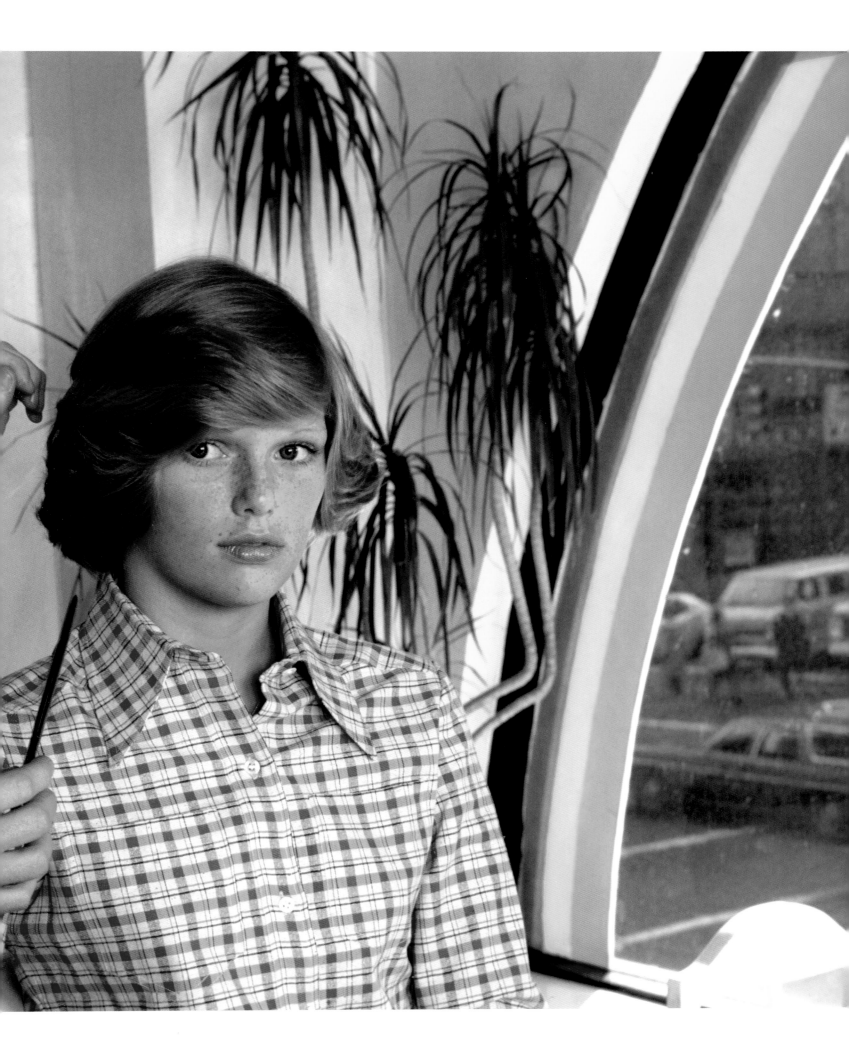

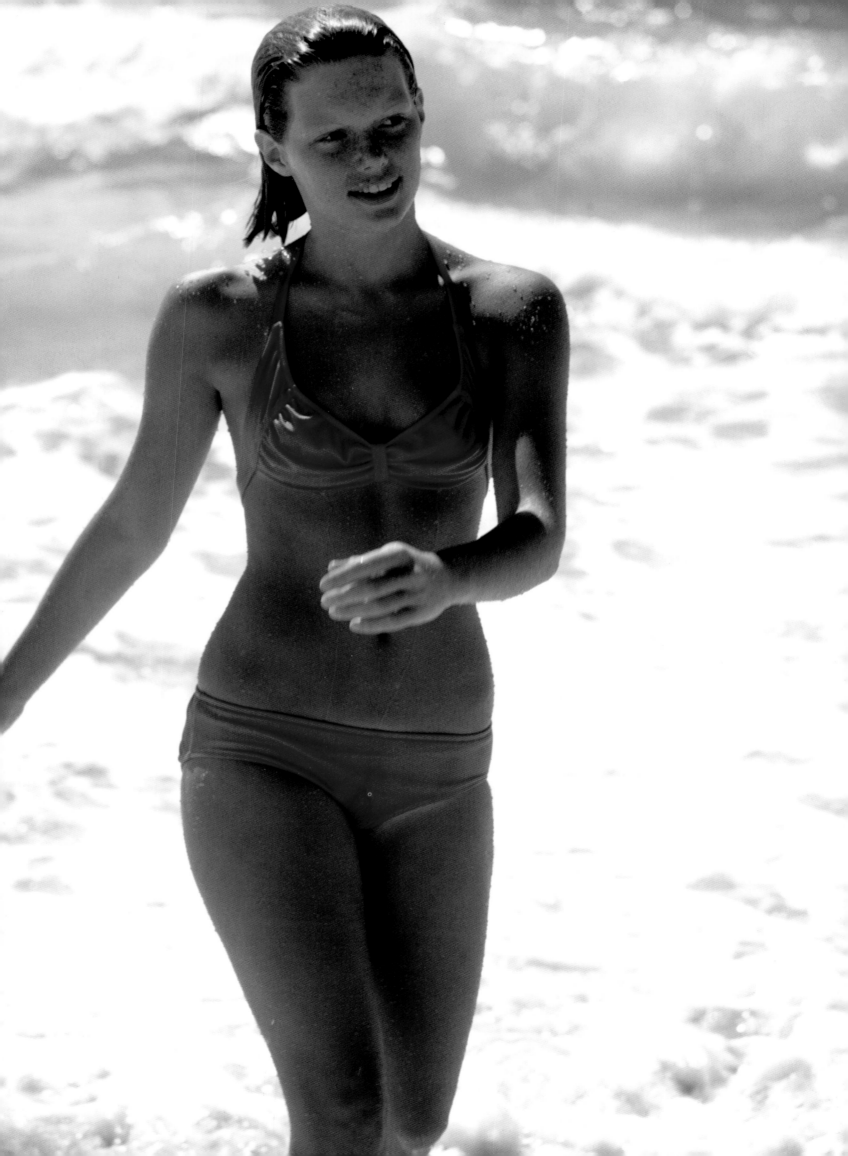

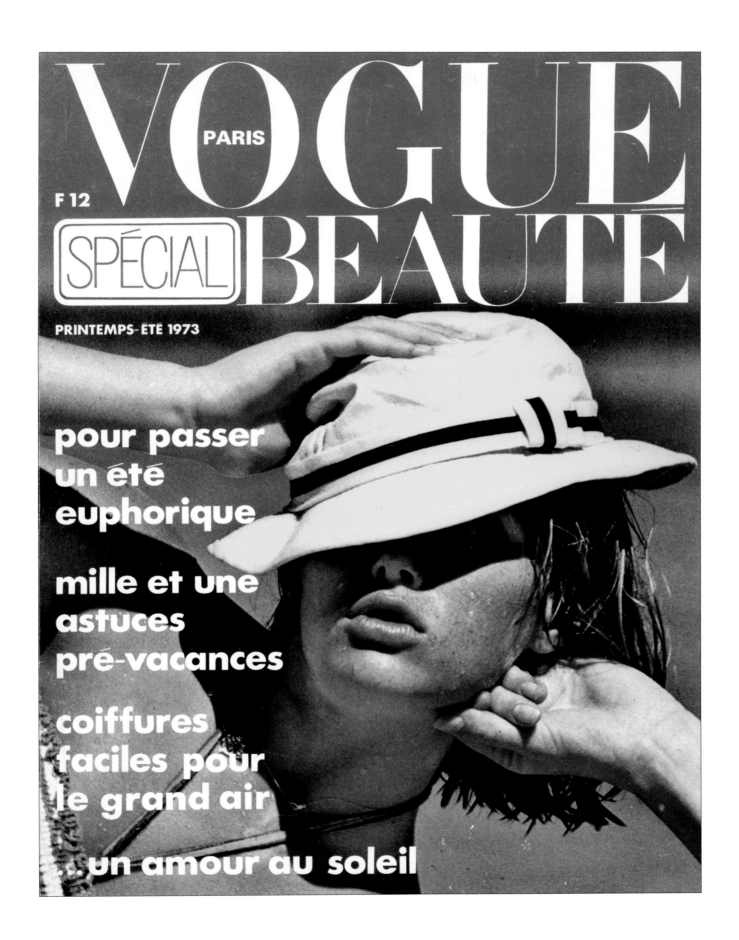

VOGUE PARIS

F 12

SPÉCIAL BEAUTÉ

PRINTEMPS-ÉTÉ 1973

pour passer
un été
euphorique

mille et une
astuces
pré-vacances

coiffures
faciles pour
le grand air

...un amour au soleil

ABOVE
Mike Reinhardt, French *Vogue*, spring–summer 1973.

OPPOSITE
Patrick Demarchelier, *Glamour*, April 1973.

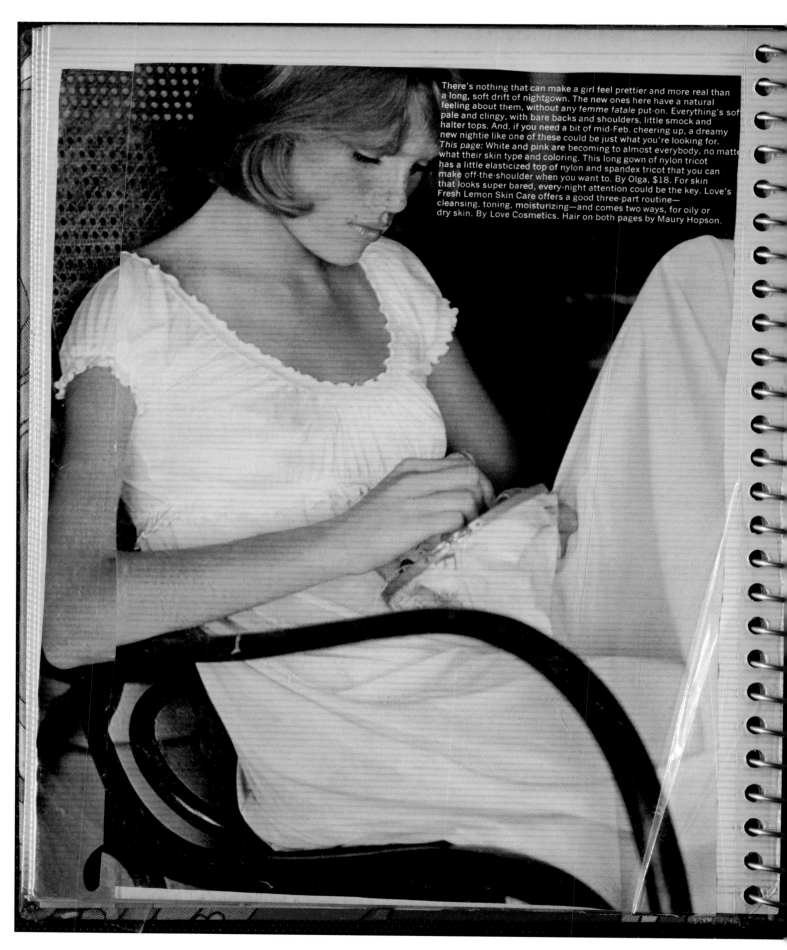

There's nothing that can make a girl feel prettier and more real than a long, soft drift of nightgown. The new ones here have a natural feeling about them, without any *femme fatale* put-on. Everything's soft, pale and clingy, with bare backs and shoulders, little smock and halter tops. And, if you need a bit of mid-Feb. cheering up, a dreamy new nightie like one of these could be just what you're looking for. *This page:* White and pink are becoming to almost everybody, no matter what their skin type and coloring. This long gown of nylon tricot has a little elasticized top of nylon and spandex tricot that you can make off-the-shoulder when you want to. By Olga, $18. For skin that looks super bared, every-night attention could be the key. Love's Fresh Lemon Skin Care offers a good three-part routine—cleansing, toning, moisturizing—and comes two ways, for oily or dry skin. By Love Cosmetics. Hair on both pages by Maury Hopson.

THESE PAGES AND FOLLOWING PAGES
From Hansen's scrapbooks.

And we're doing something about it.

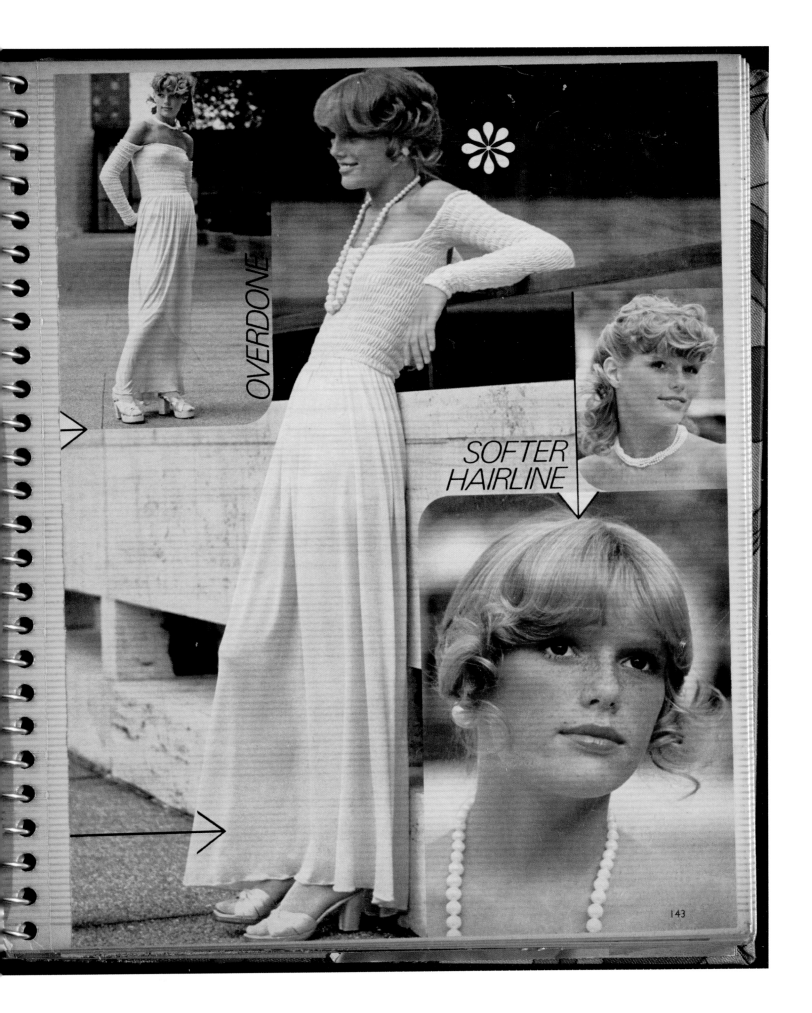

OVERDONE

SOFTER
HAIRLINE

143

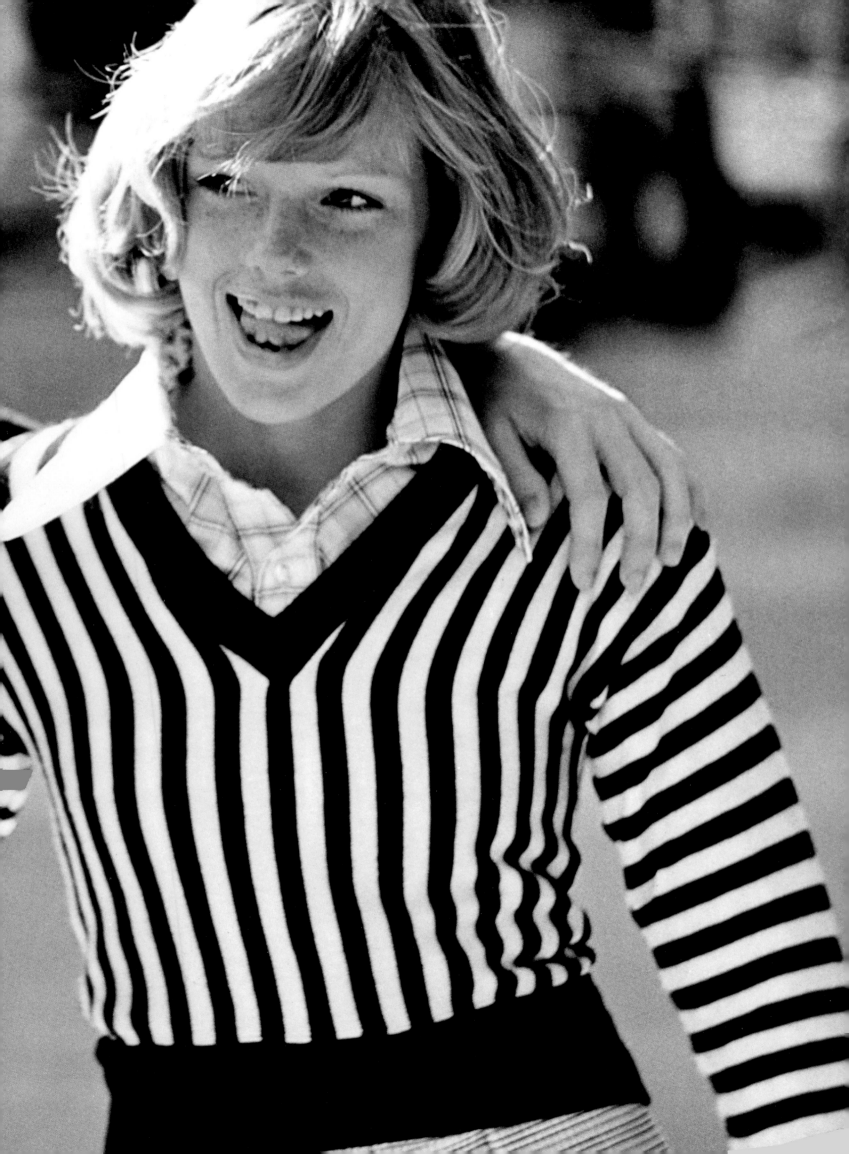

Hansen with actor Simon Ward.
Oliviero Toscani, *Glamour,* February 1973.

Rico Puhlmann, *Glamour,* December 1973.

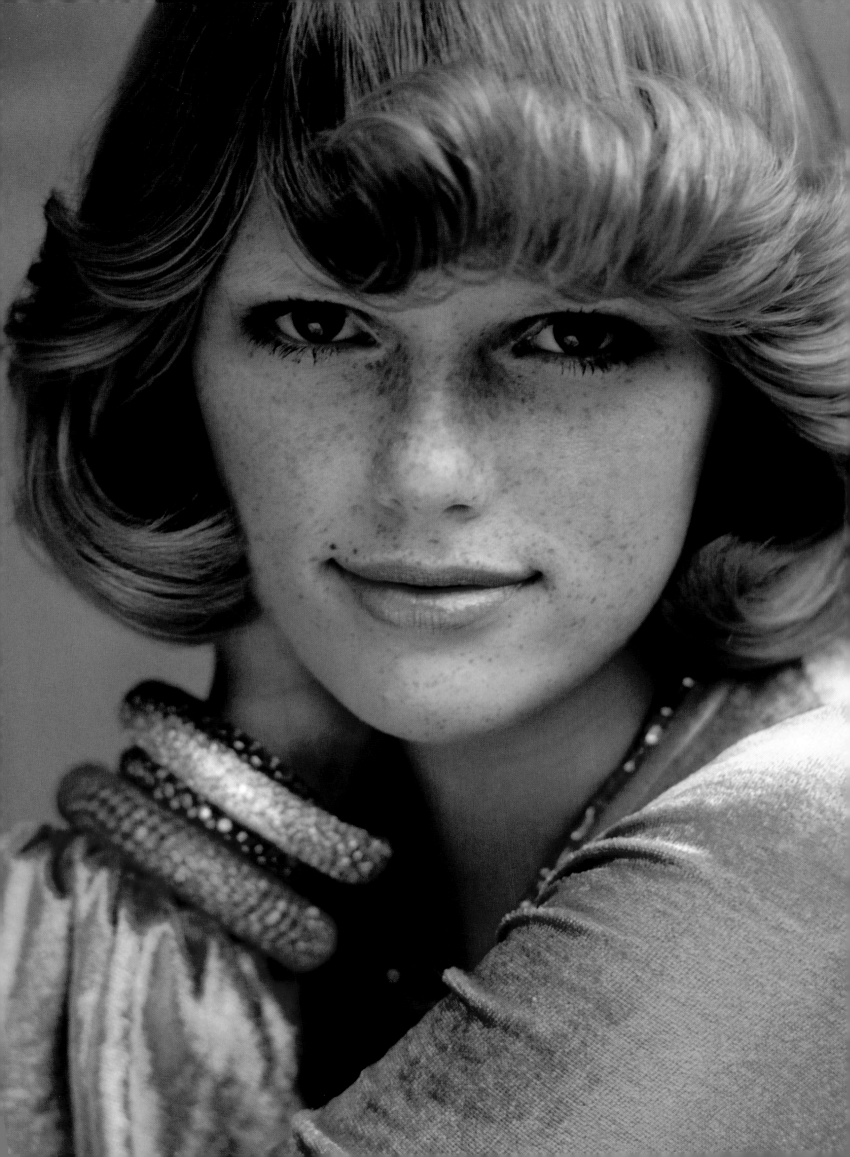

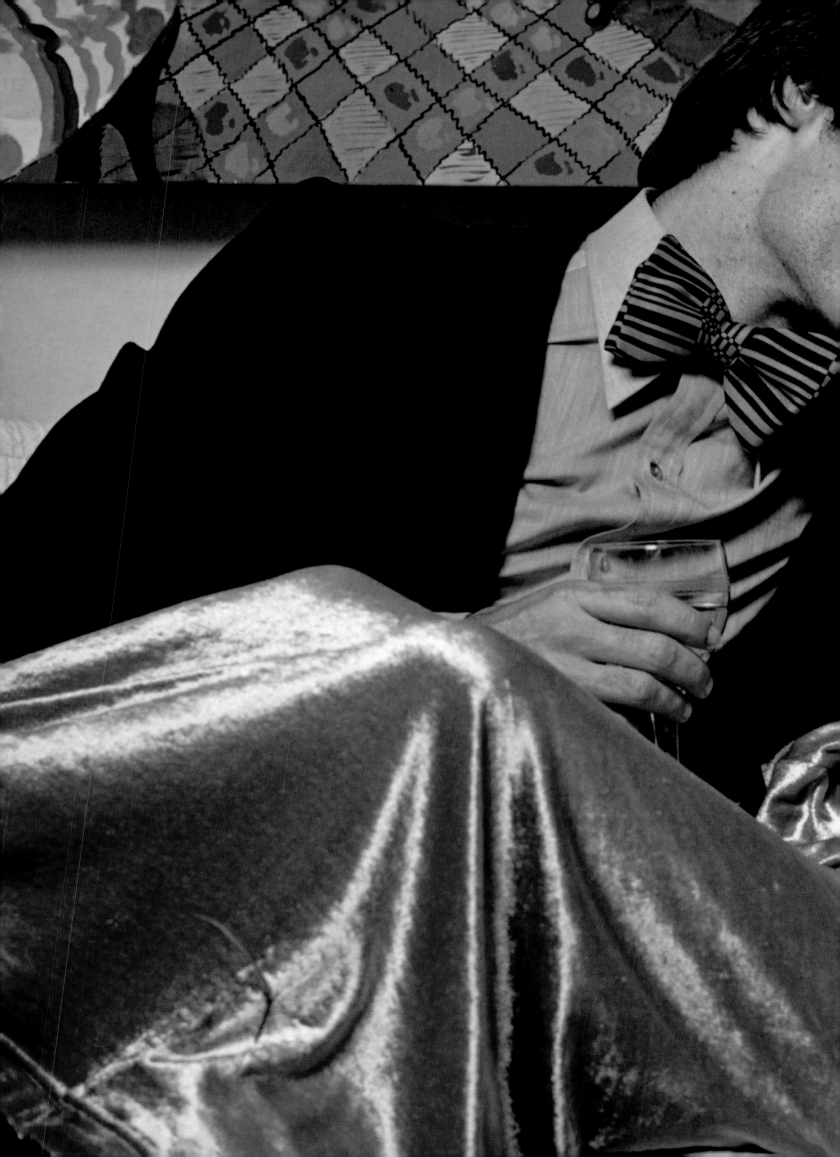

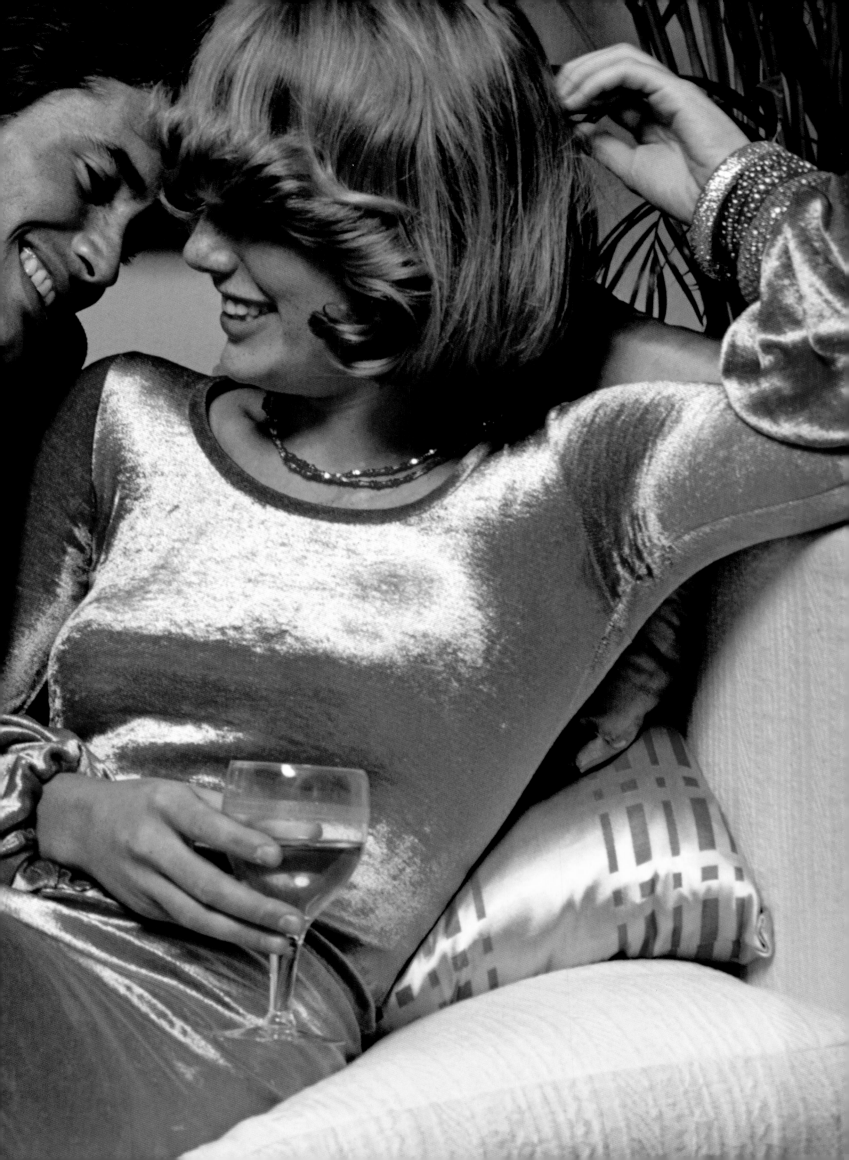

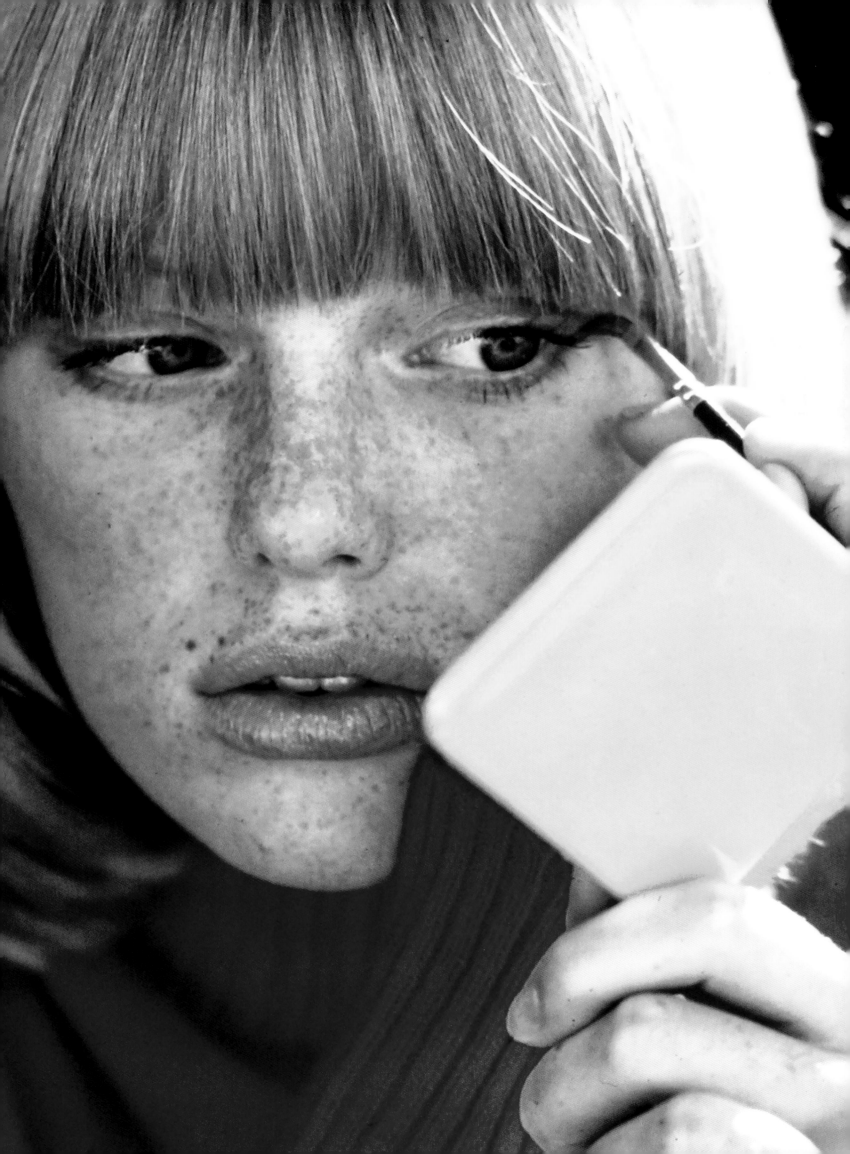

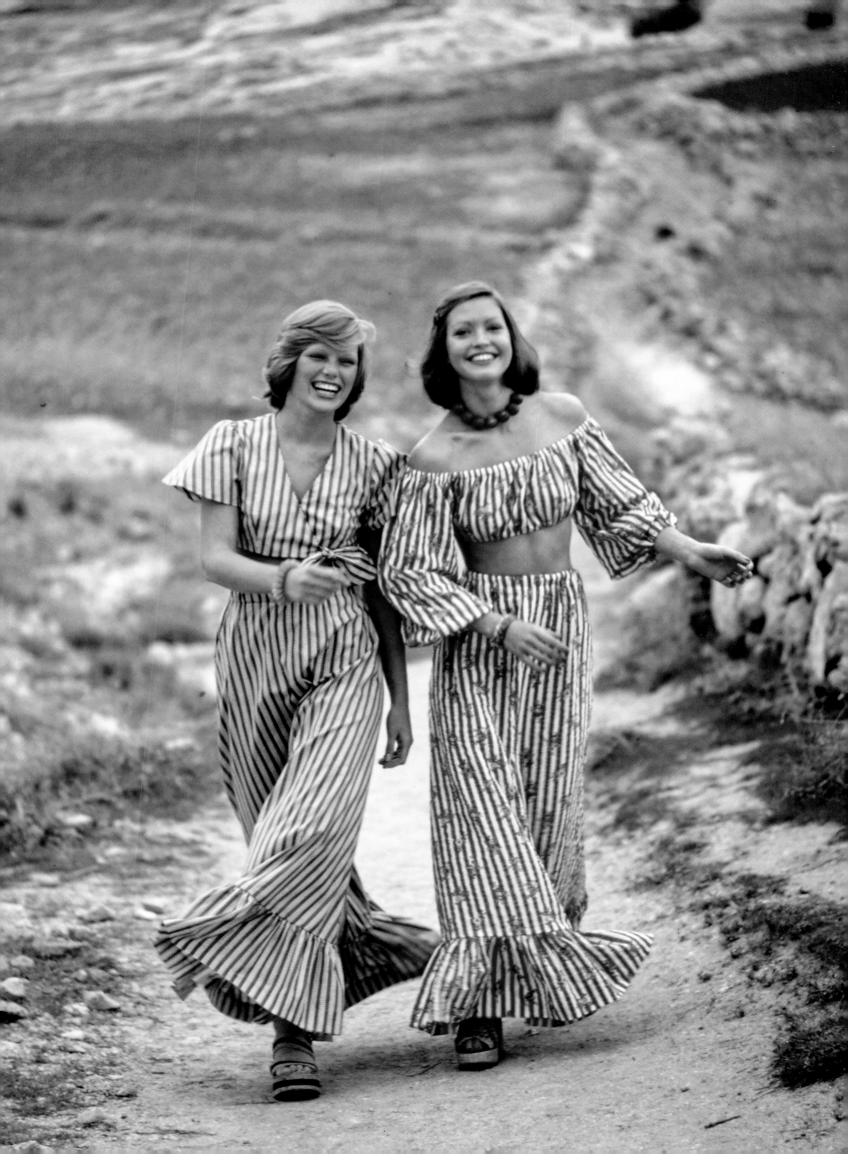

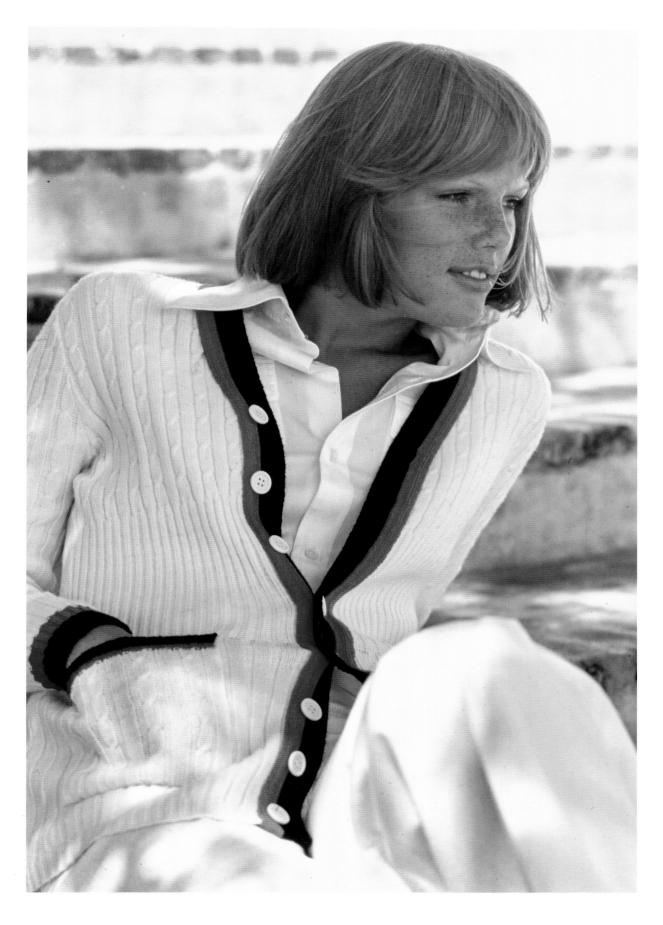

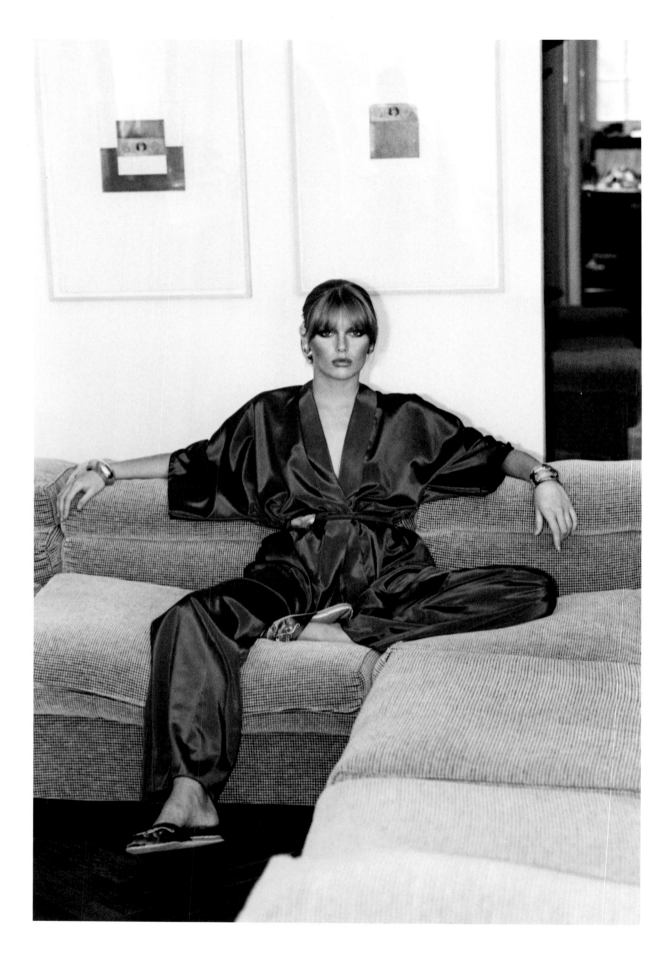

PREVIOUS PAGES
Mike Reinhardt, *Glamour,* April 1974.

ABOVE AND OPPOSITE
Arthur Elgort, *Vogue,* November 1975.

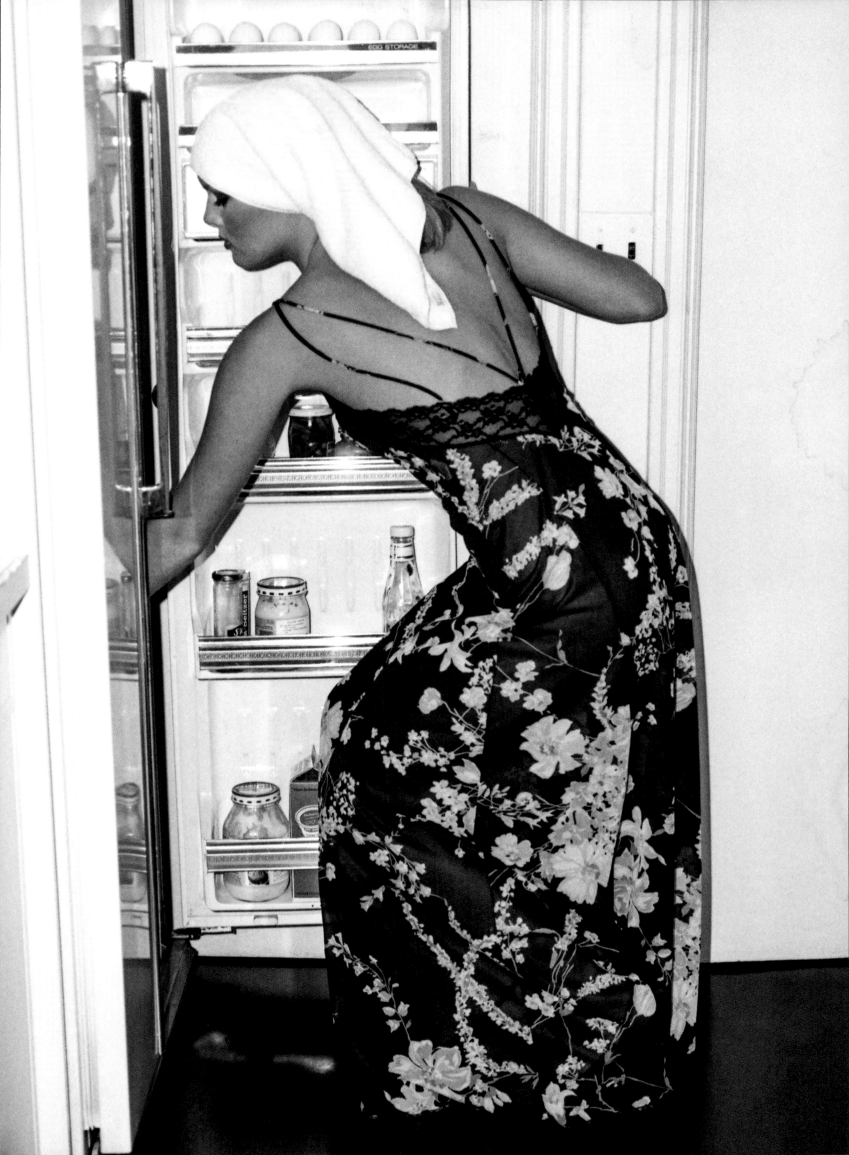

Francesco Scavullo, *Vogue,* November 1975.

Arthur Elgort, *Vogue,* November 1975.

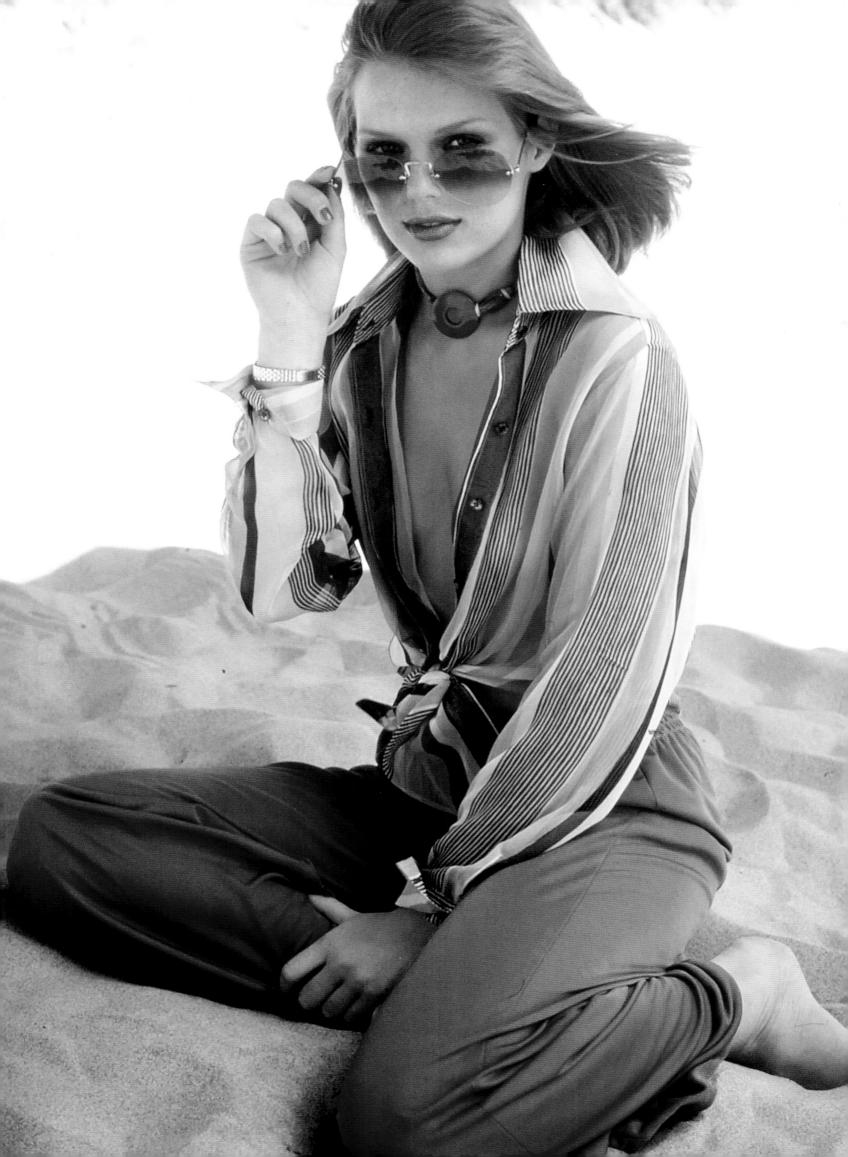

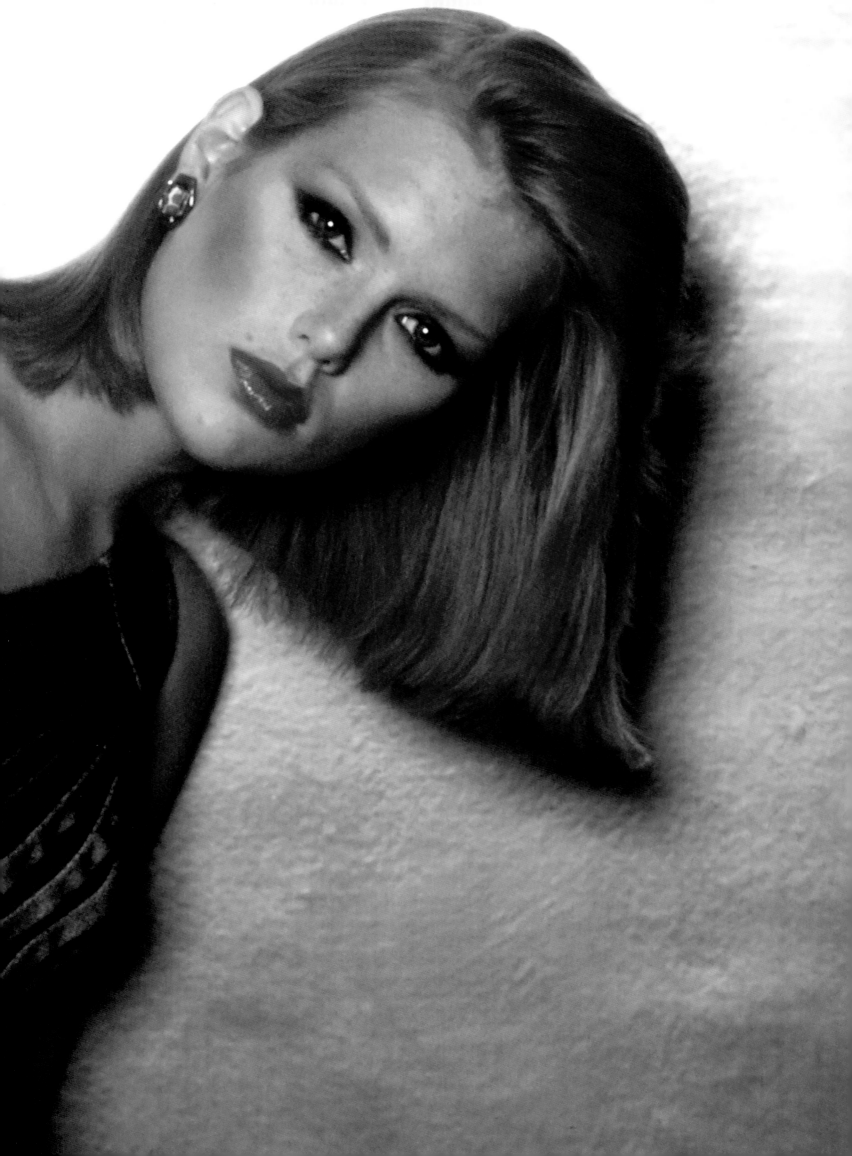

Arthur Elgort, *Vogue,* November 1975.

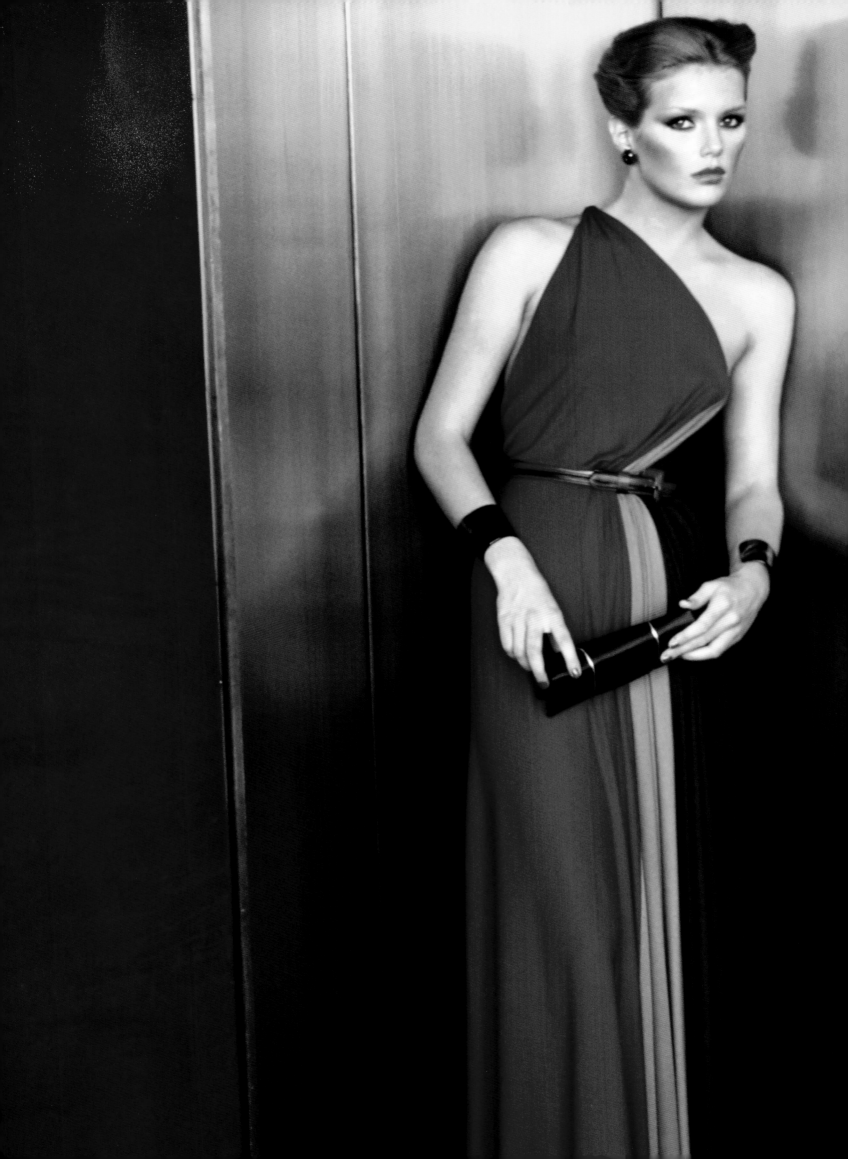

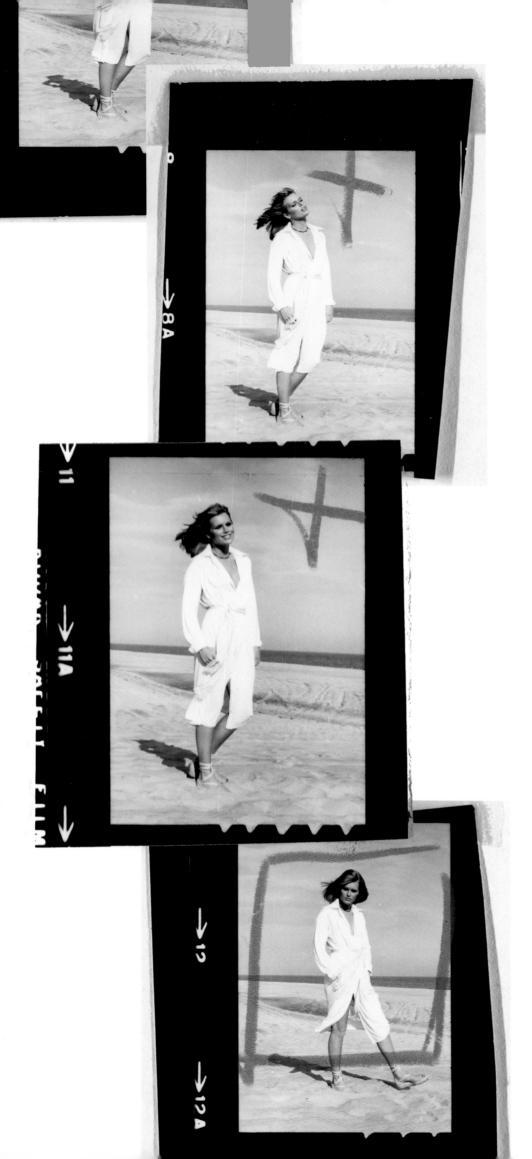

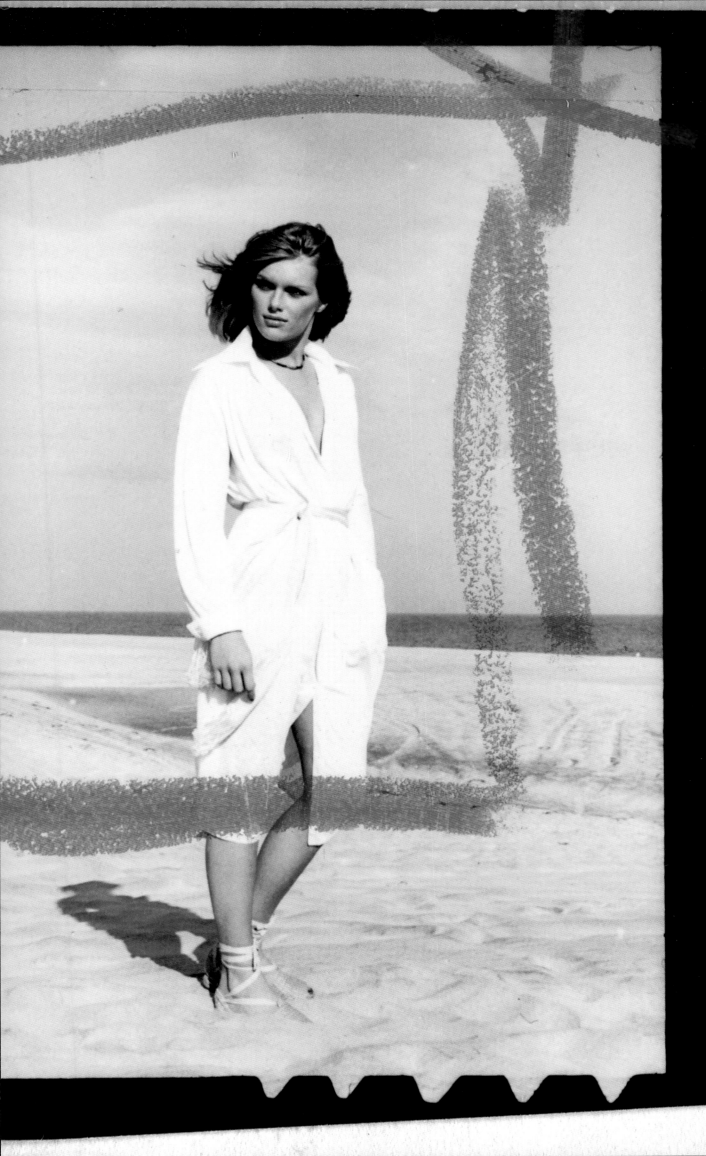

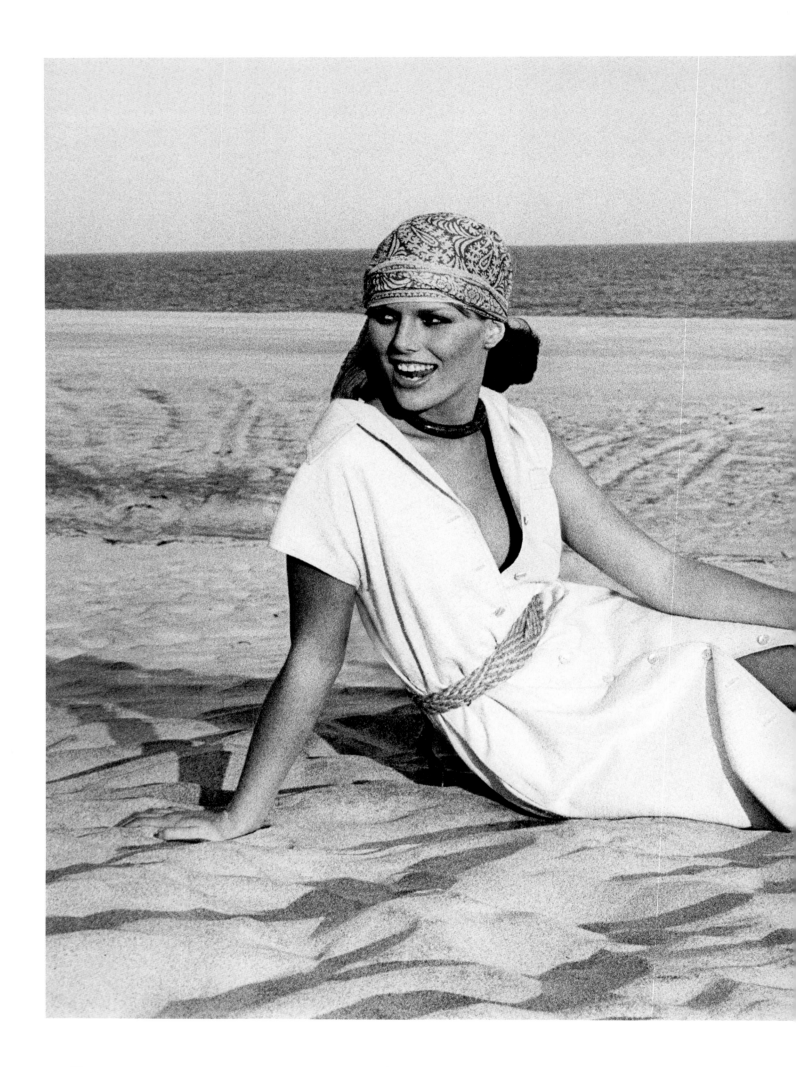

Arthur Elgort, *Vogue,* January 1976.

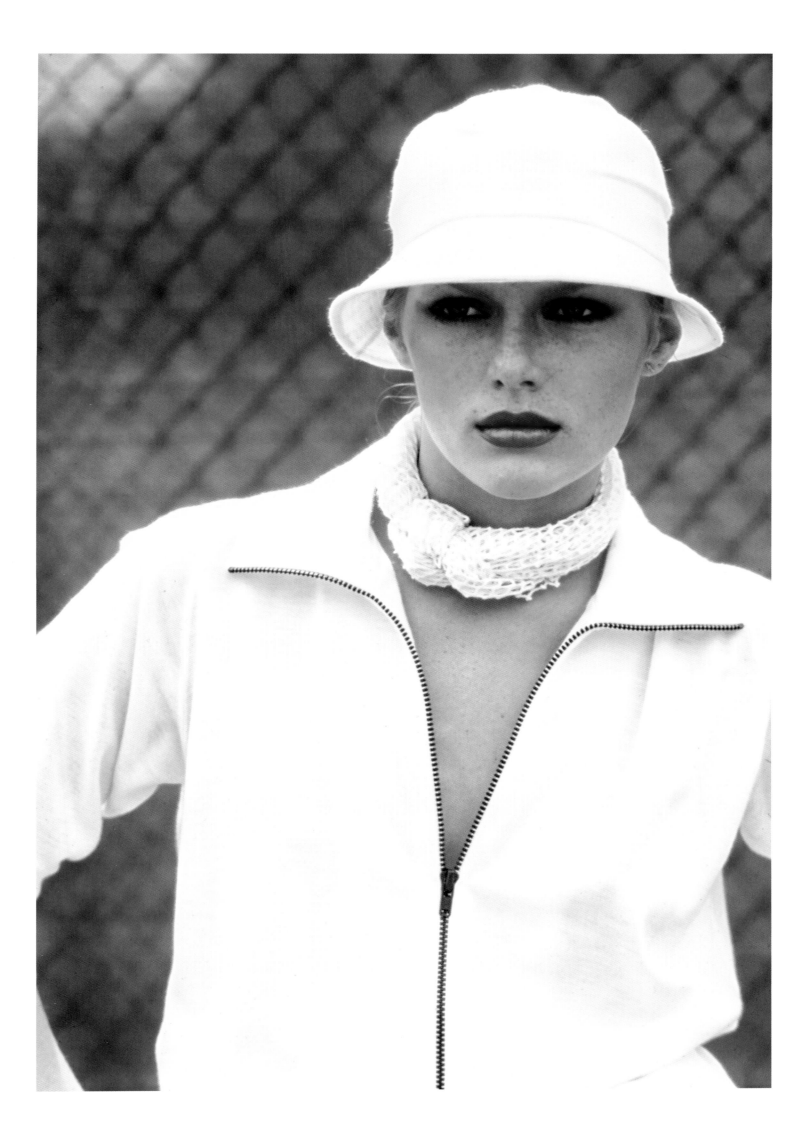

Arthur Elgort, *Vogue*, January 1976.

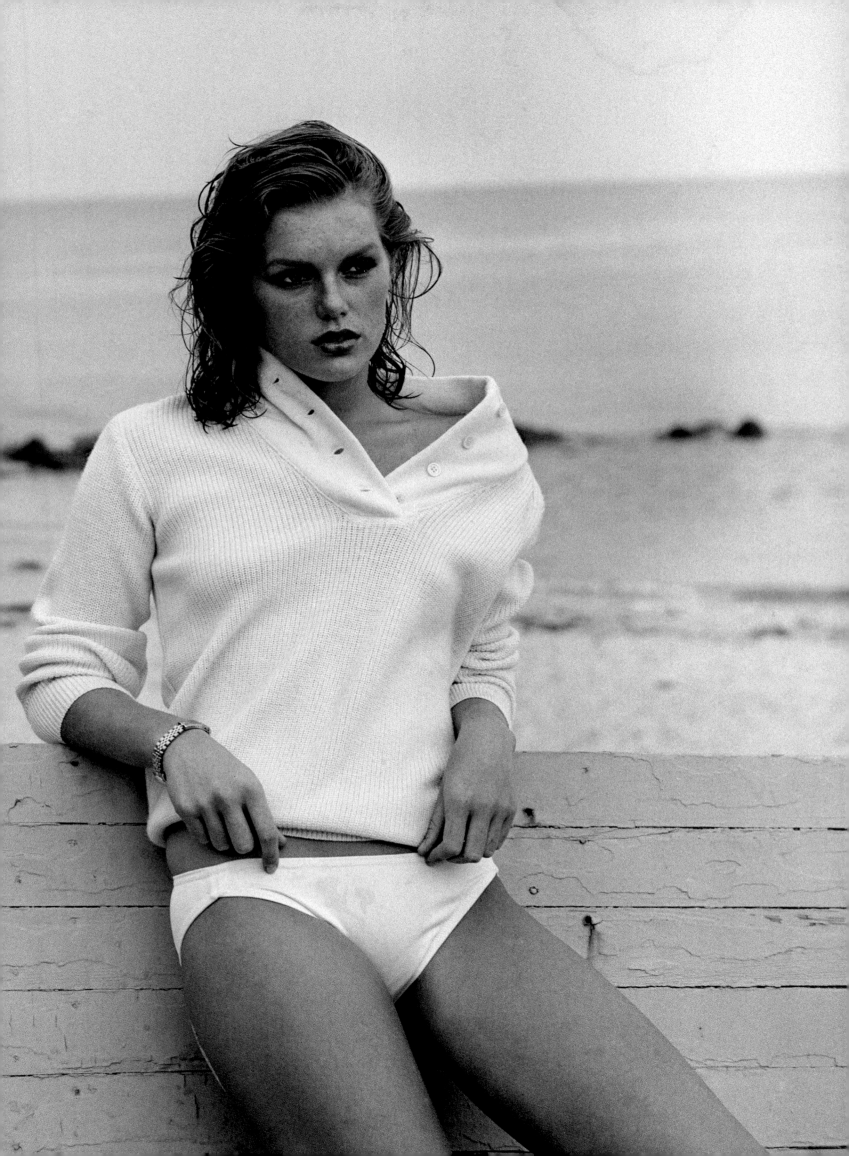

Arthur Elgort, *Vogue*, January 1976

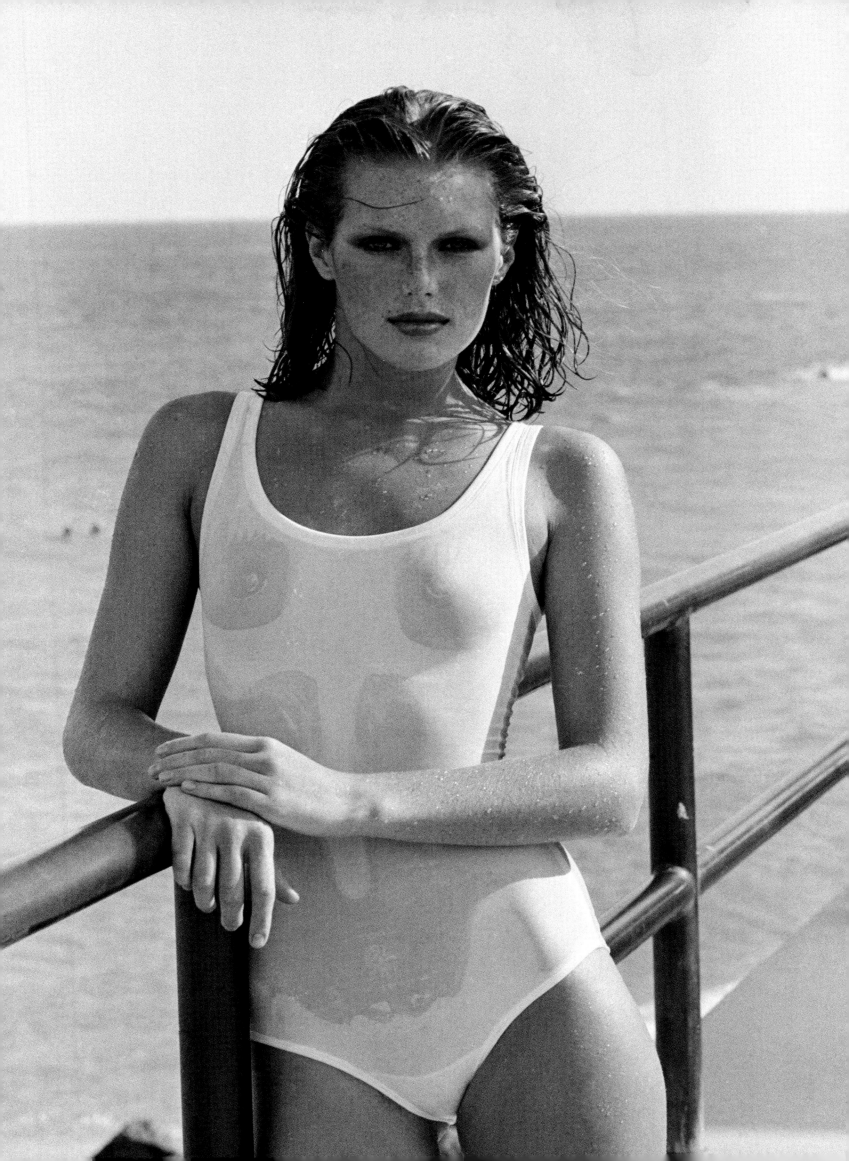

Arthur Elgort, *Vogue,* February 1976.

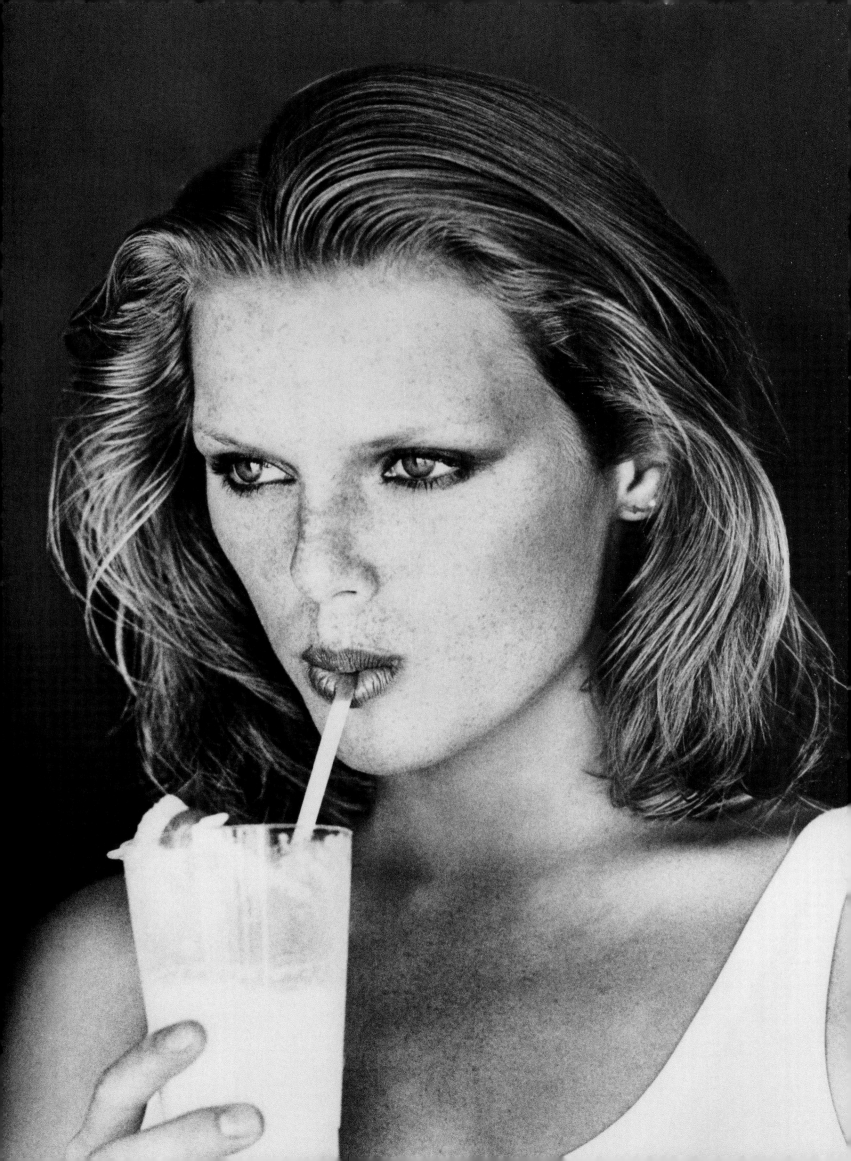

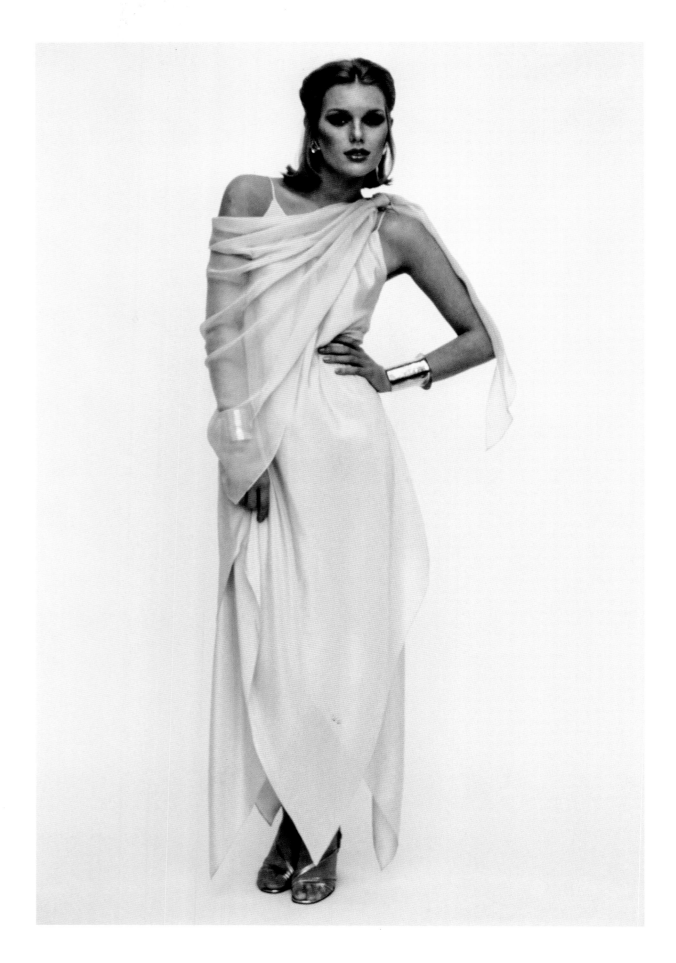

ABOVE

Bob Richardson, *Vogue,* February 1976.

OPPOSITE

Arthur Elgort, *Vogue,* January 1976.

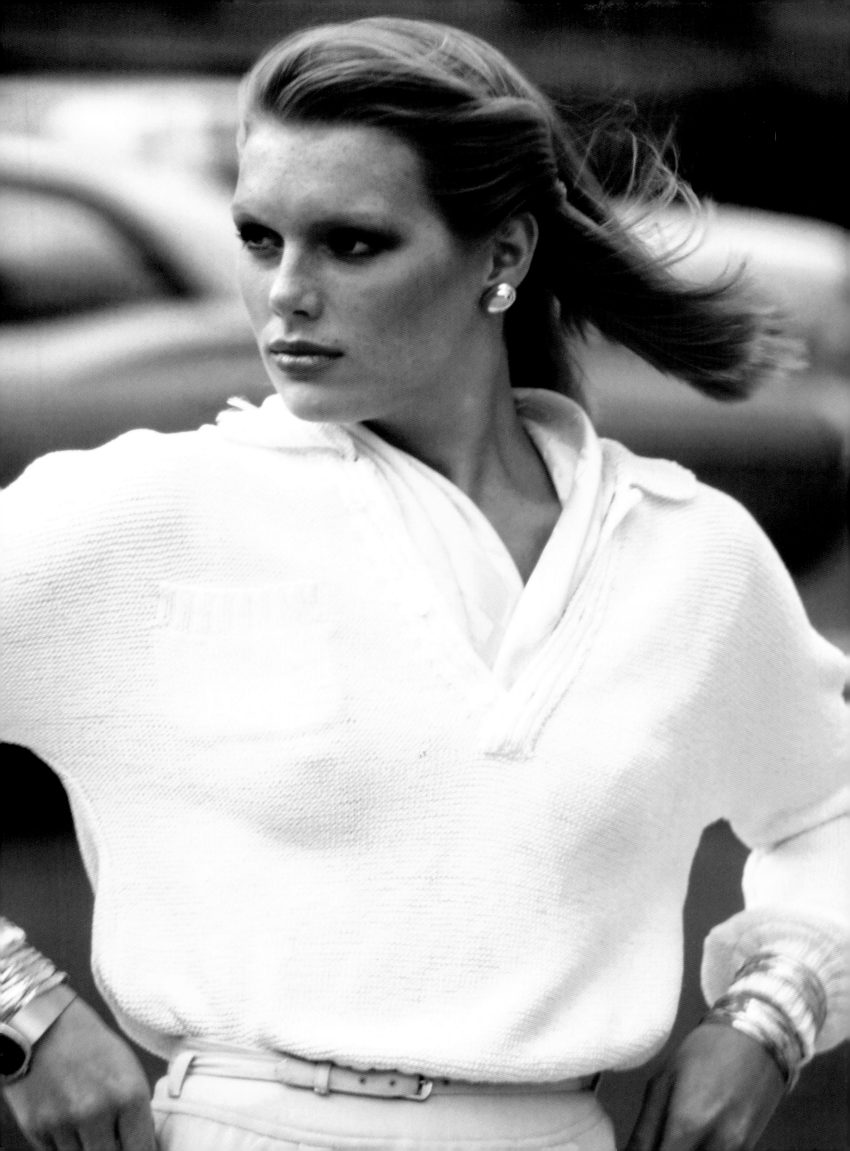

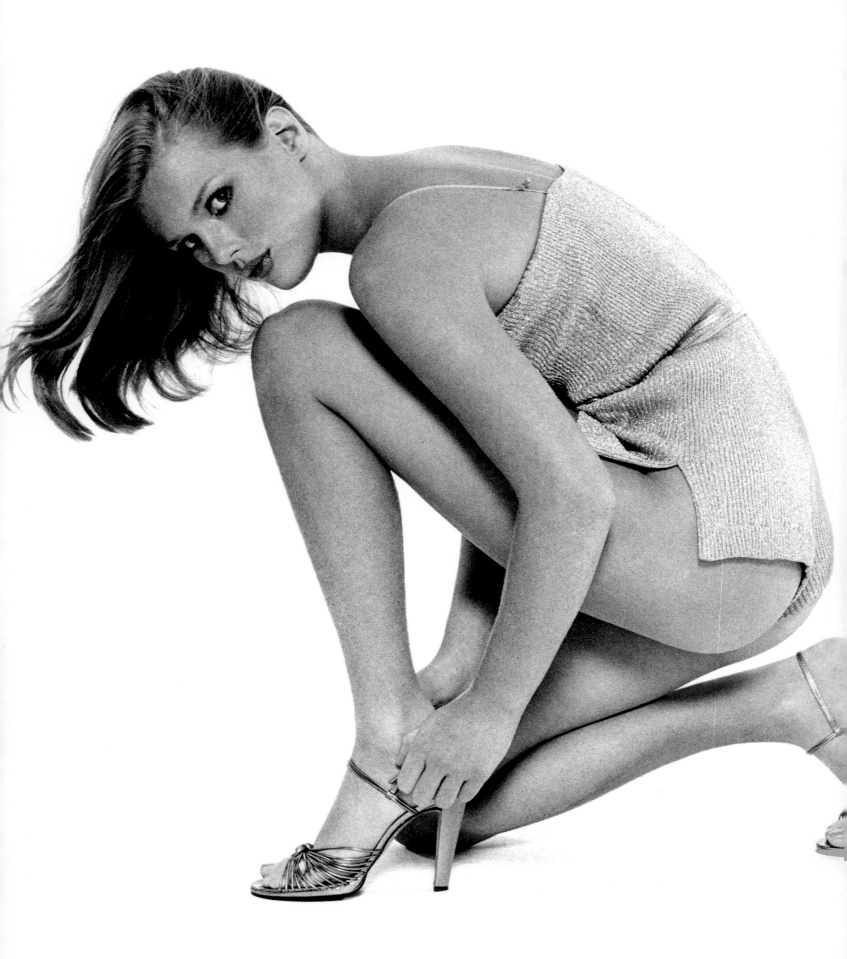

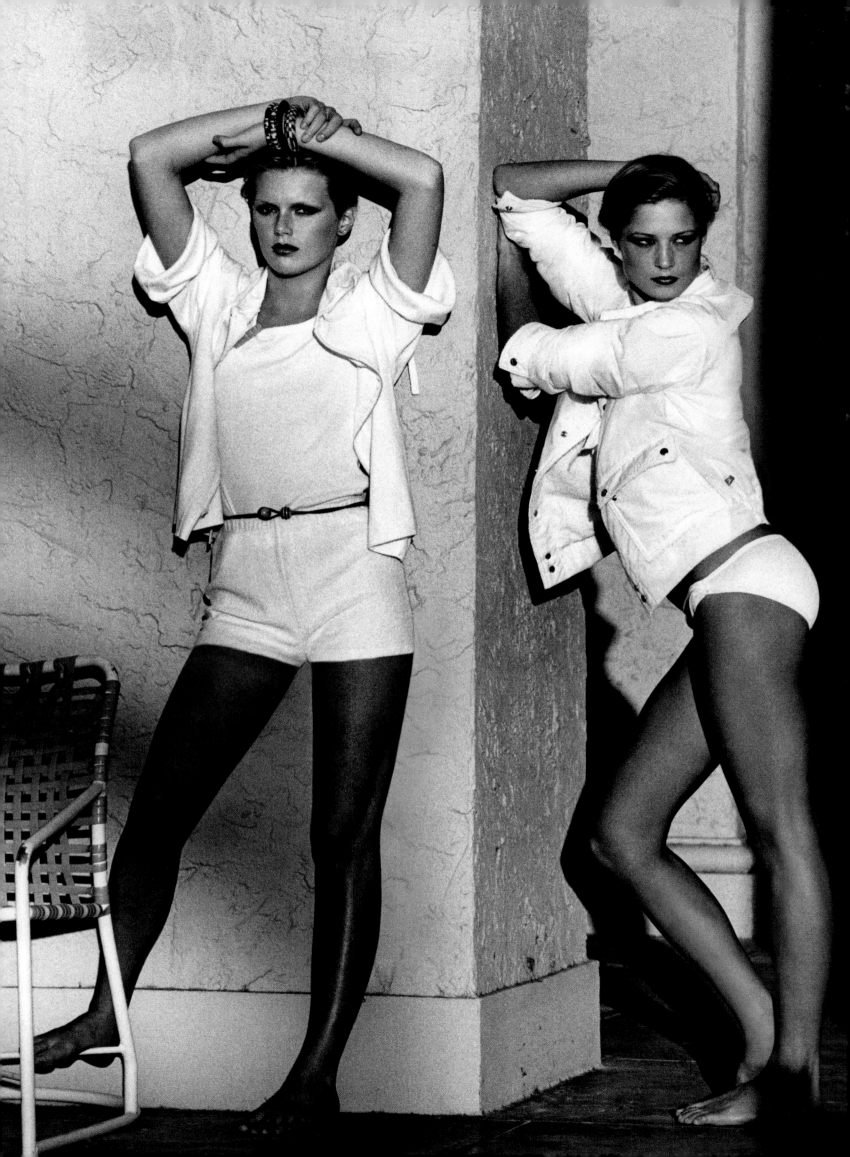

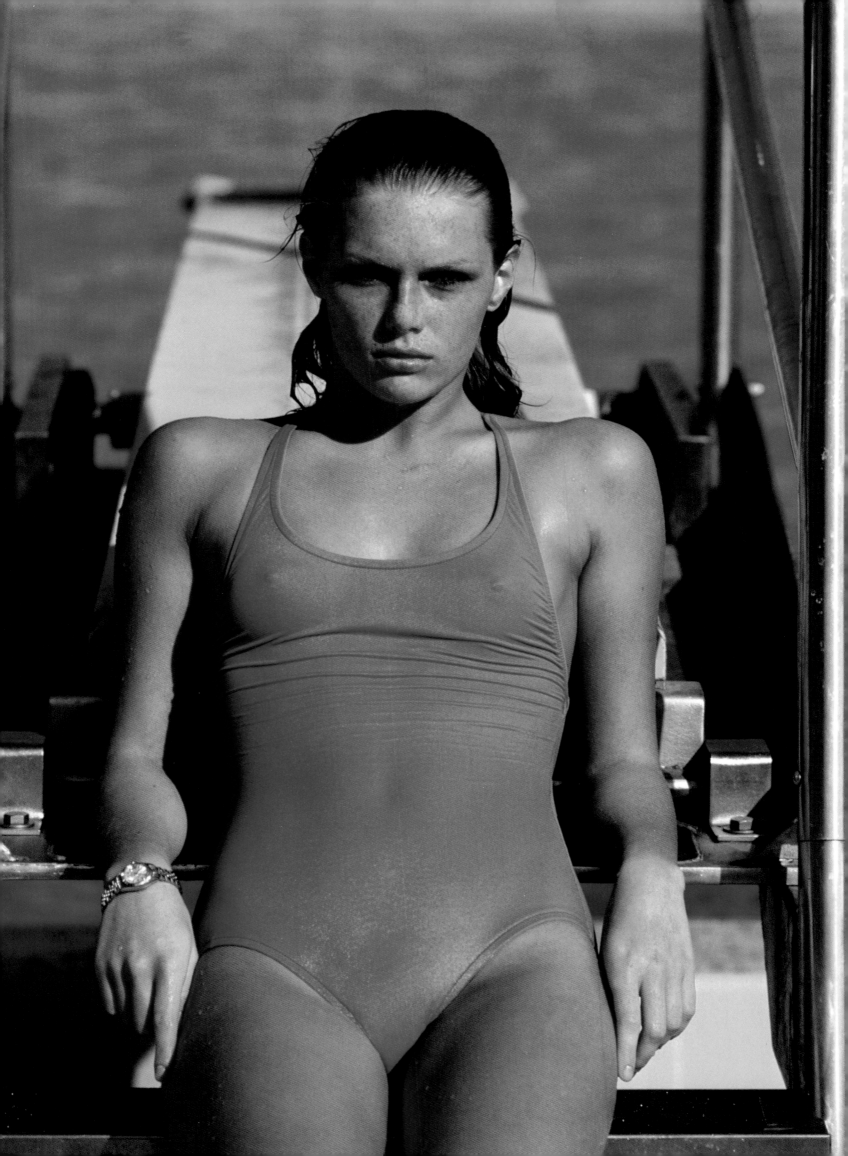

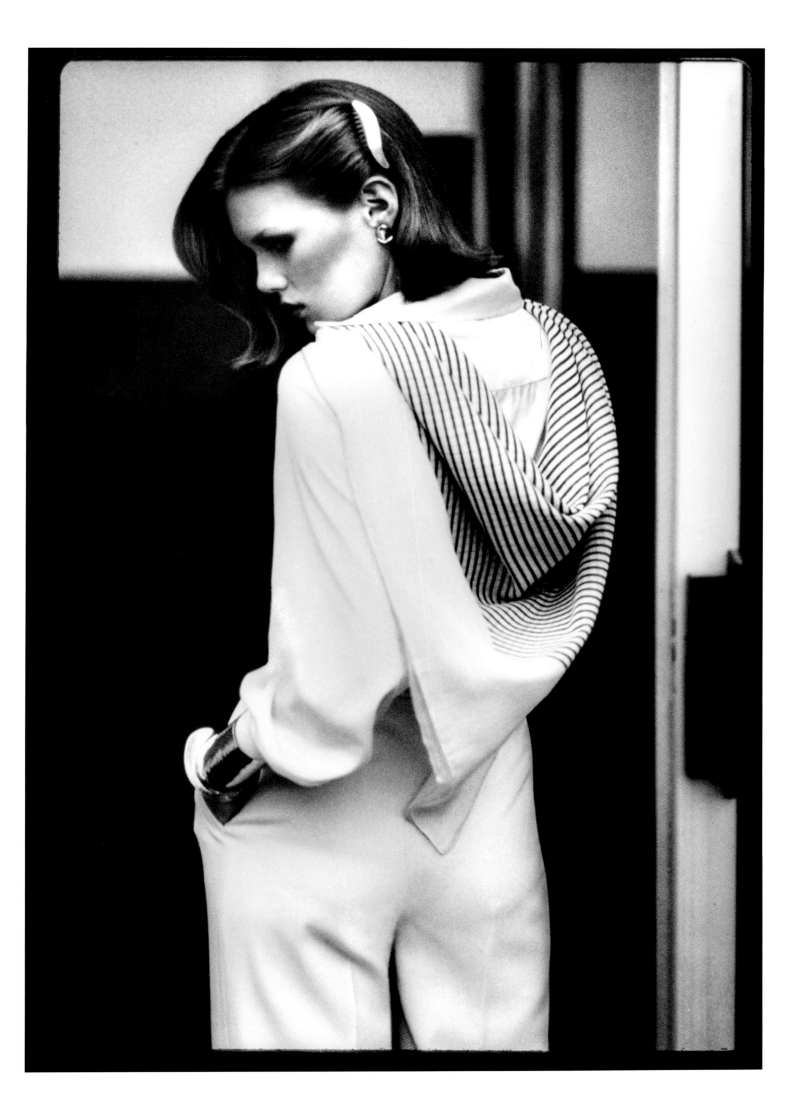

Hansen with Joe MacDonald.
Bob Richardson, *Vogue,* February 1976.

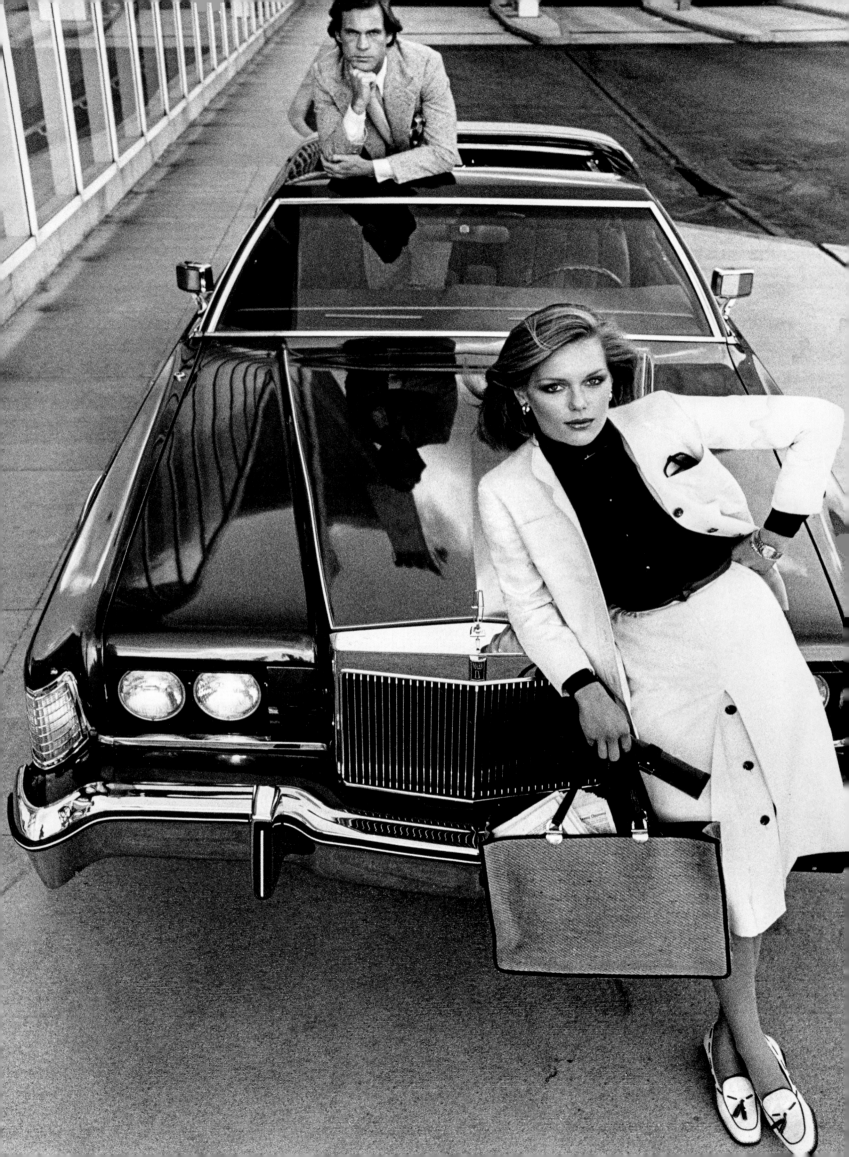

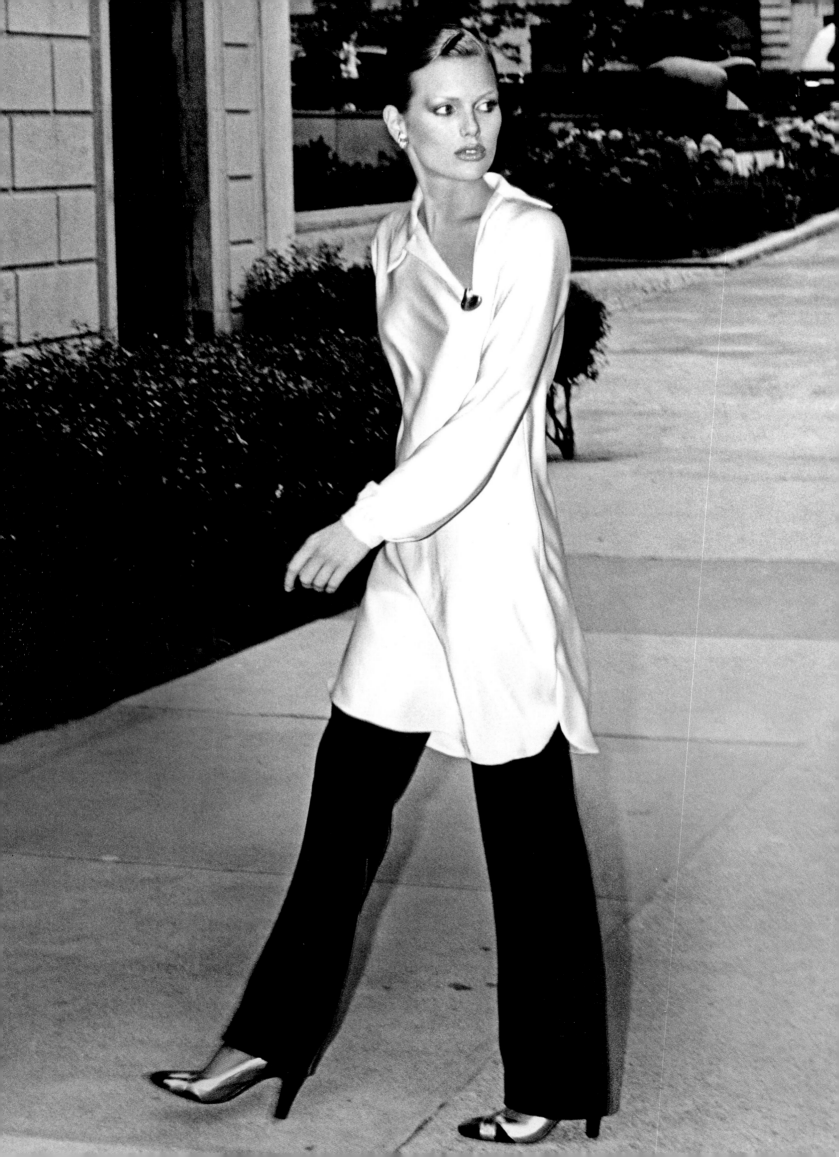

Arthur Elgort, *Vogue*, August, 1976.

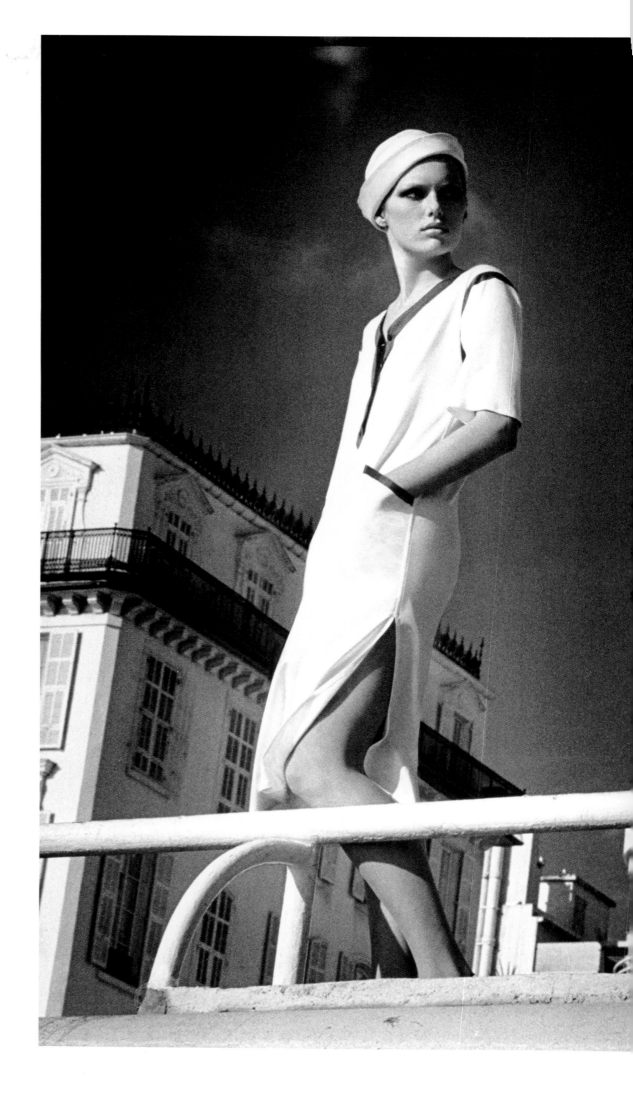

Helmut Newton,
Vogue, March 1976.

Hansen with Gunilla Lindblad.
Helmut Newton, *Vogue,* March 1976.

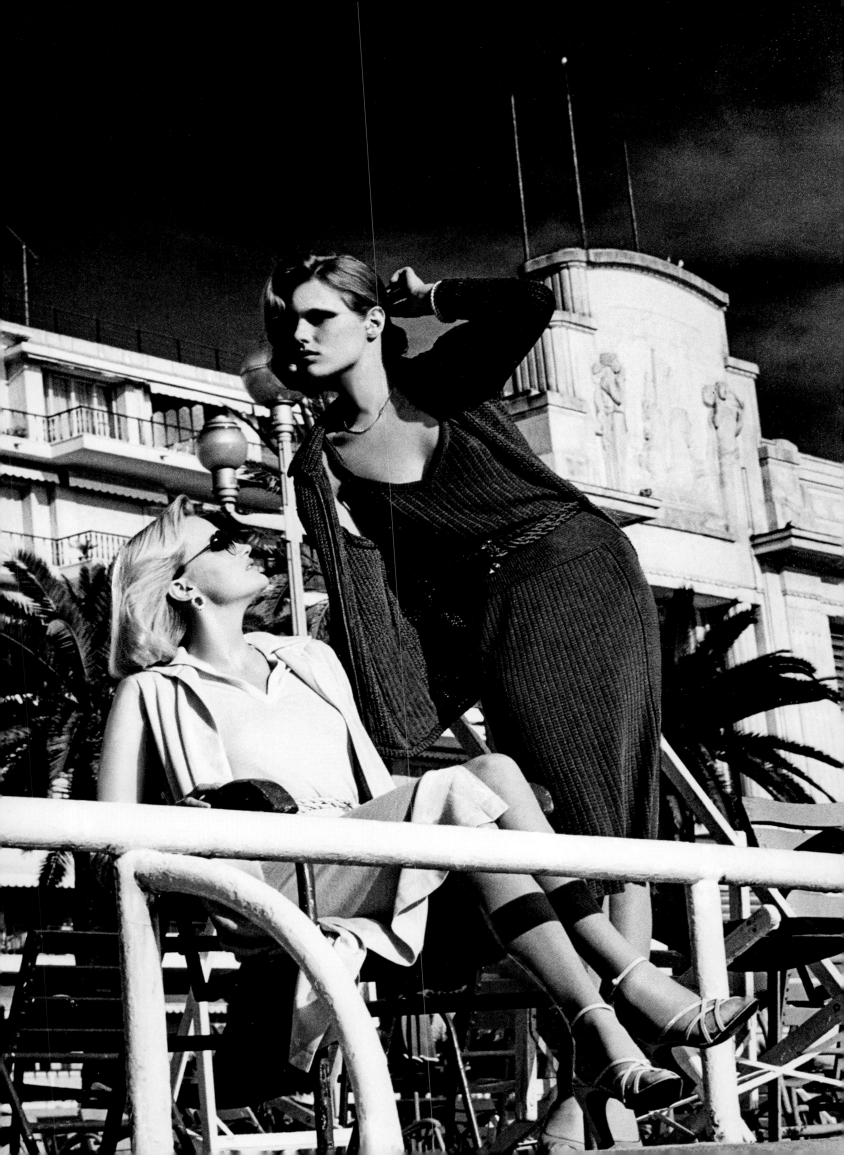

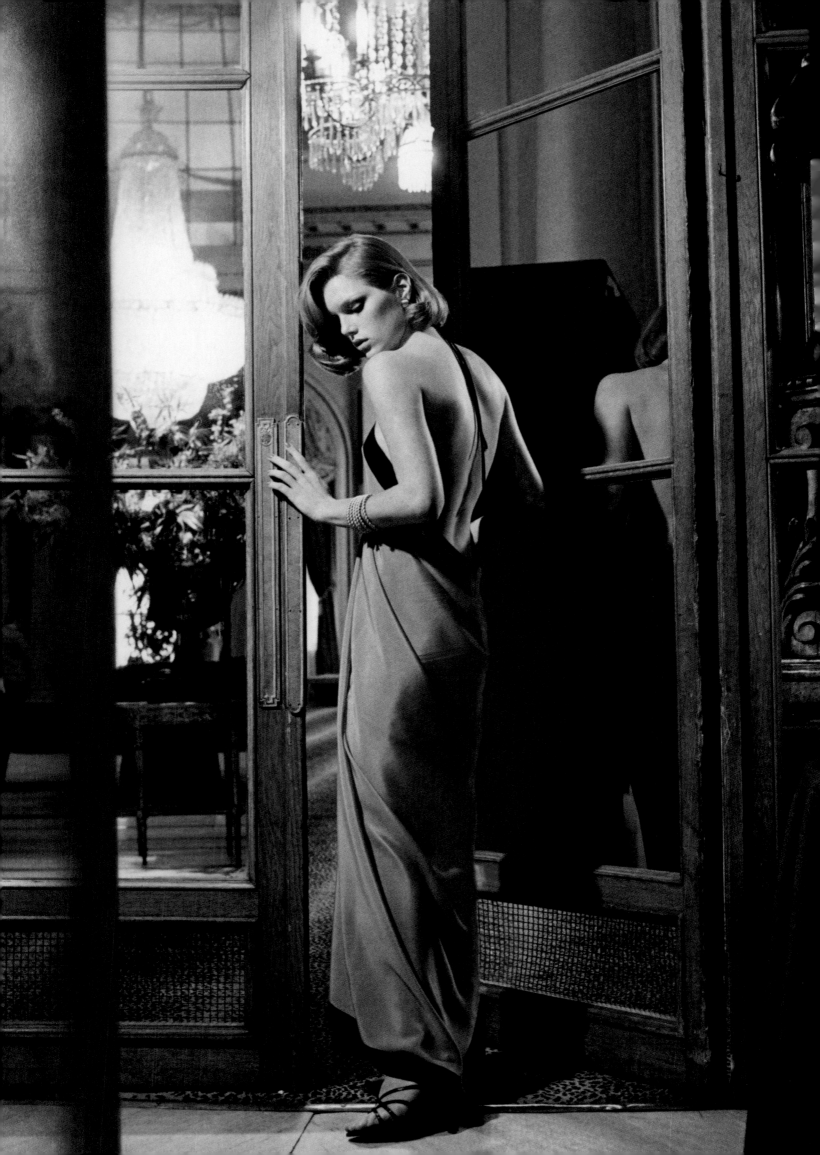

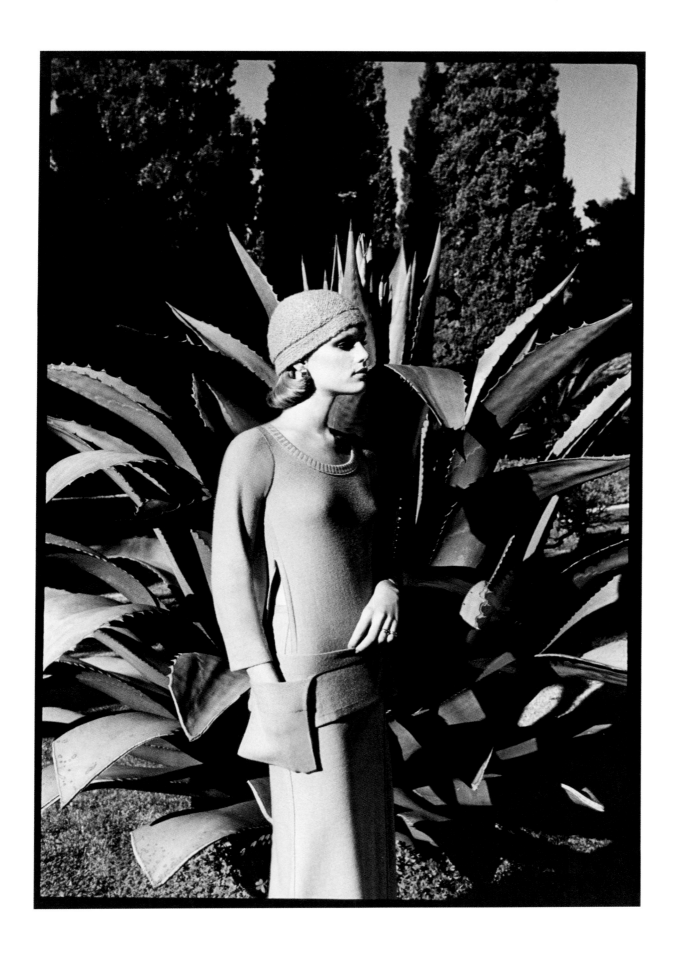

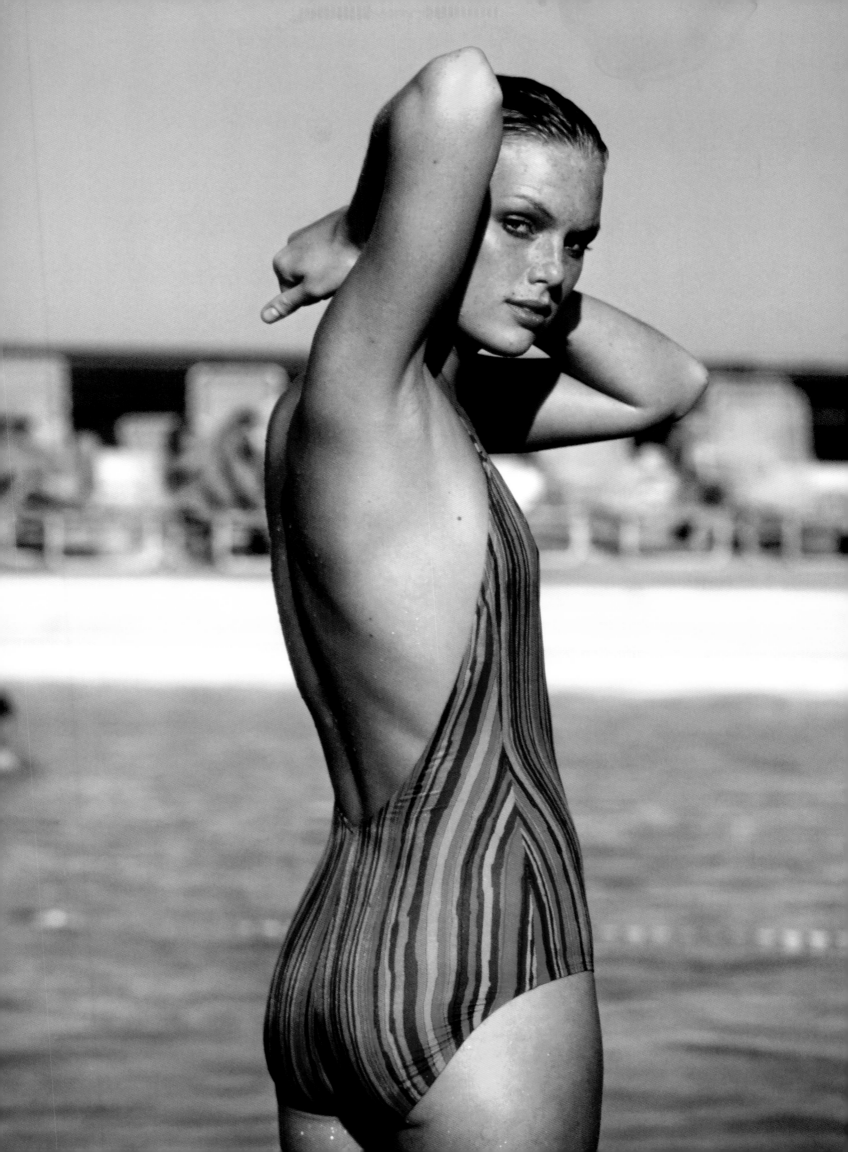

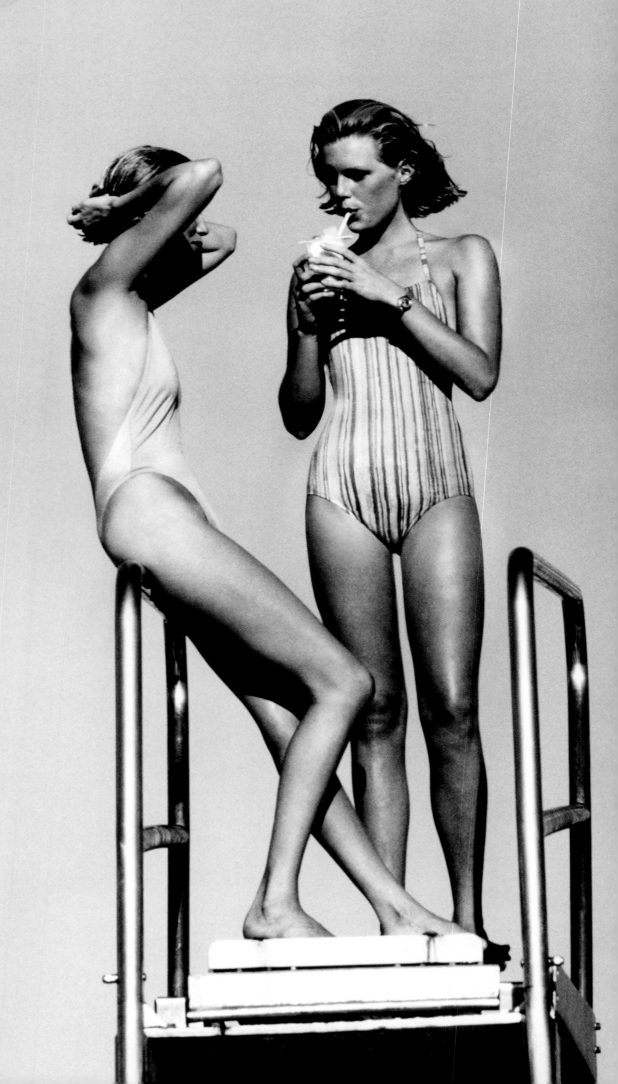

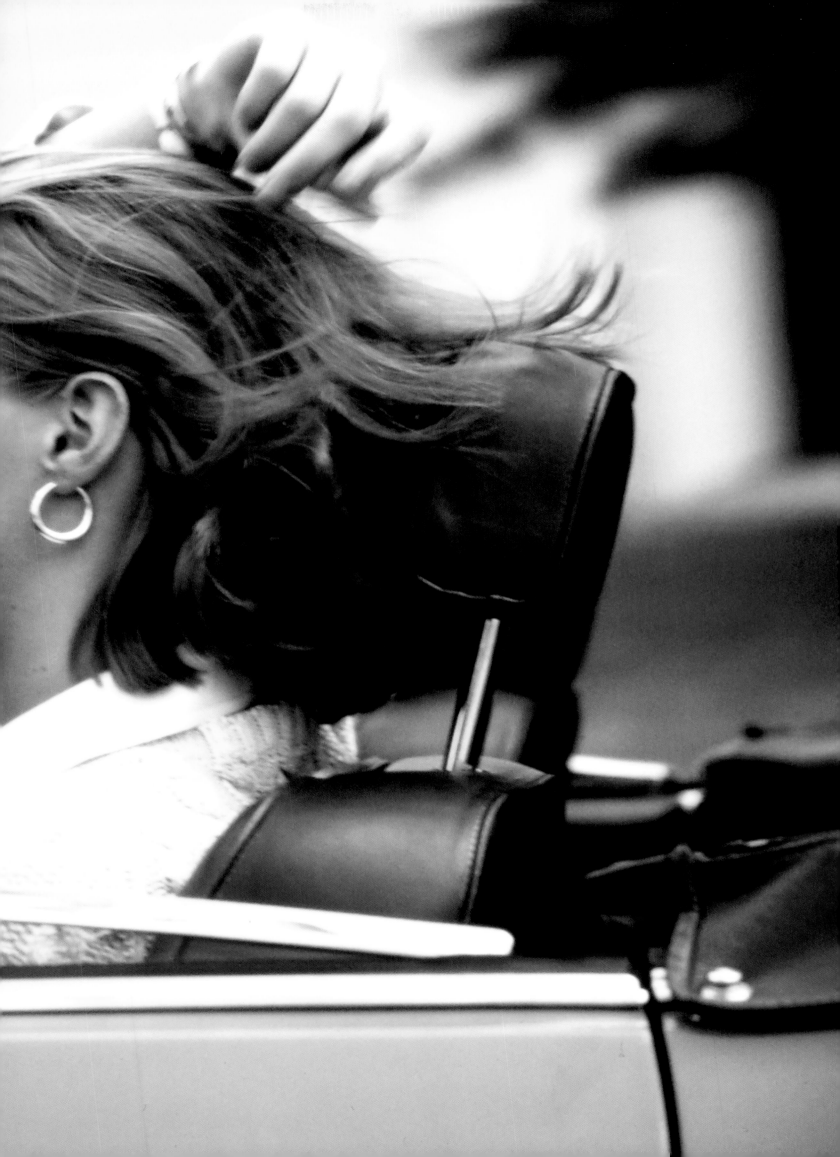

PREVIOUS PAGES AND RIGHT
Arthur Elgort, *Vogue,* June 1976.

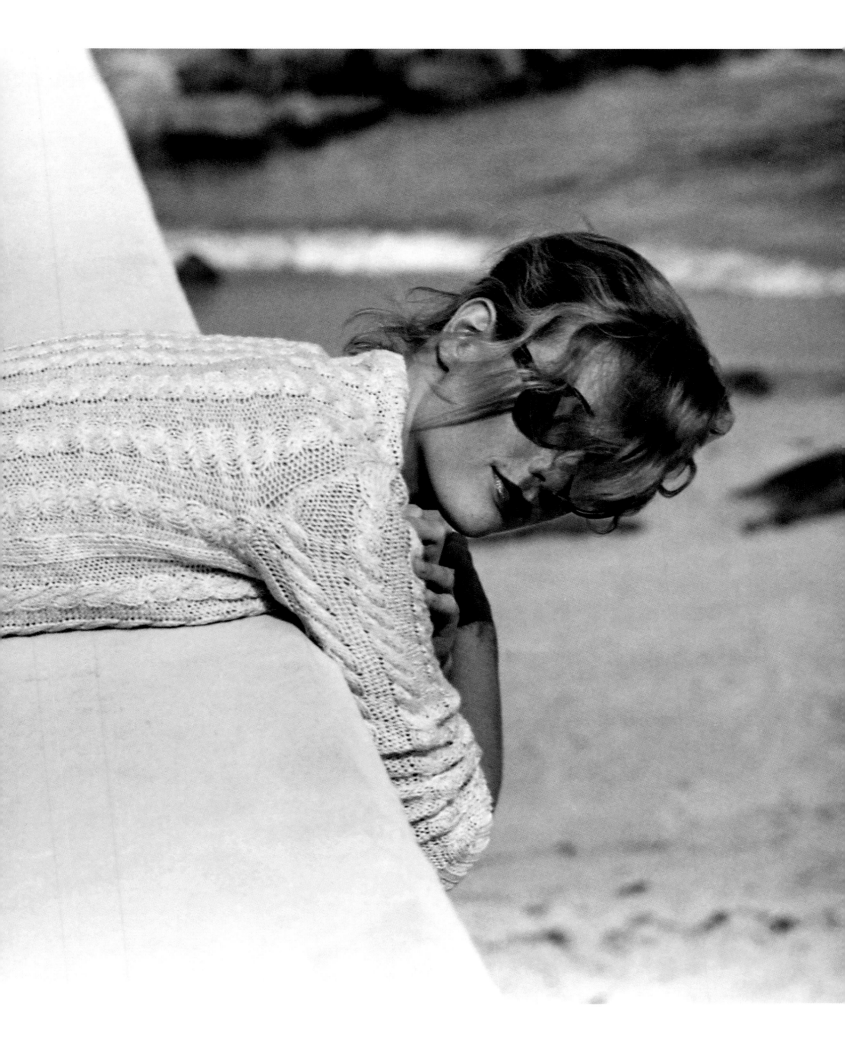

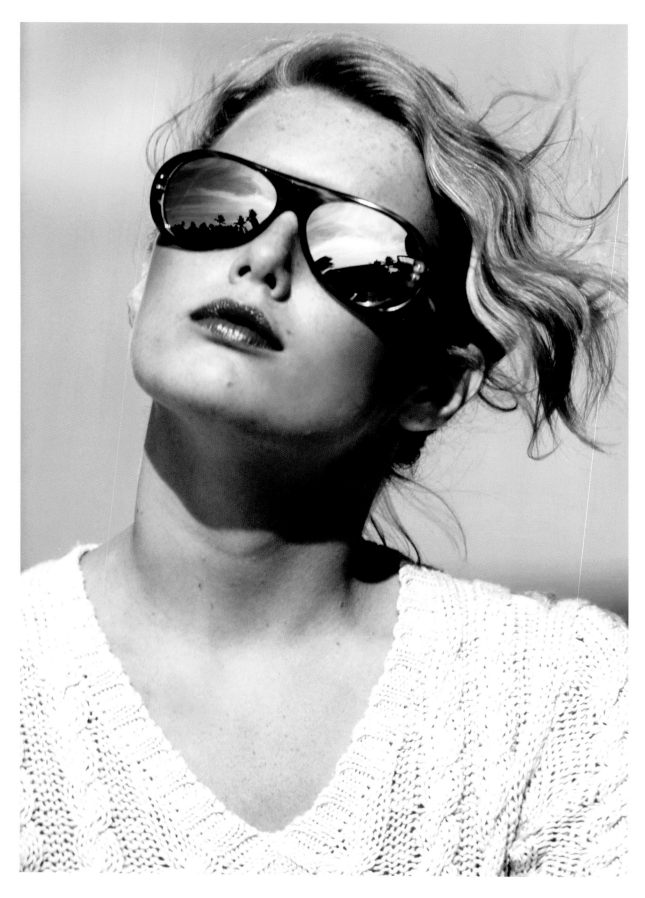

ABOVE
Arthur Elgort, *Vogue,* June 1976.

OPPOSITE
Arthur Elgort, *Vogue,* July 1977.

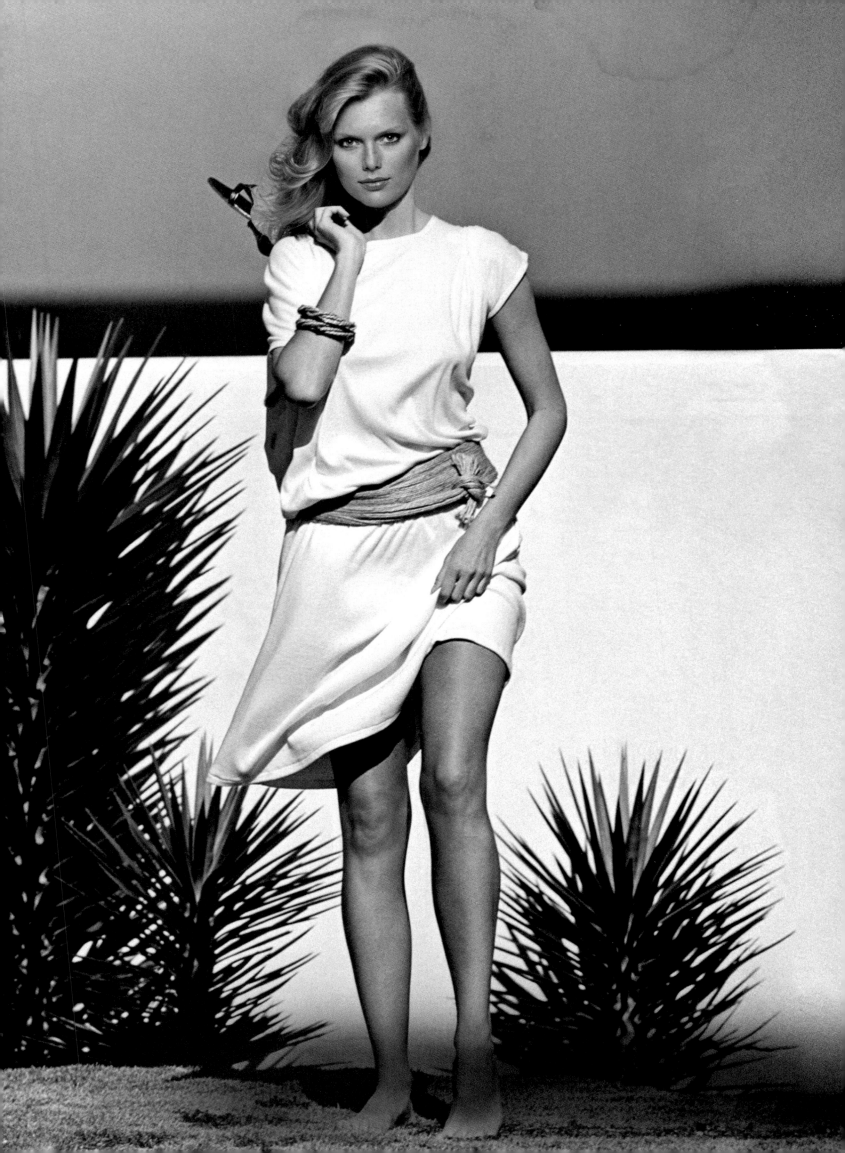

Bob Richardson, *Vogue*, March 1976.

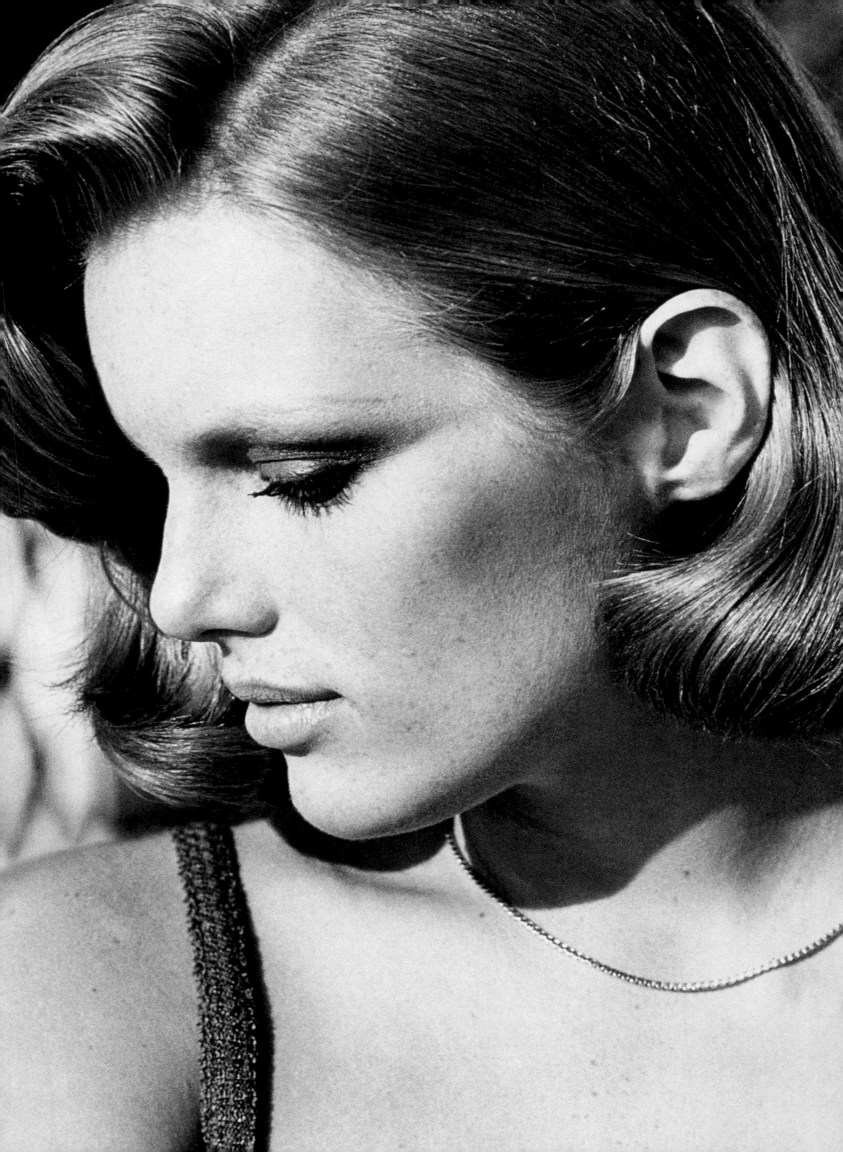

Arthur Elgort, *Vogue,* June 1976.

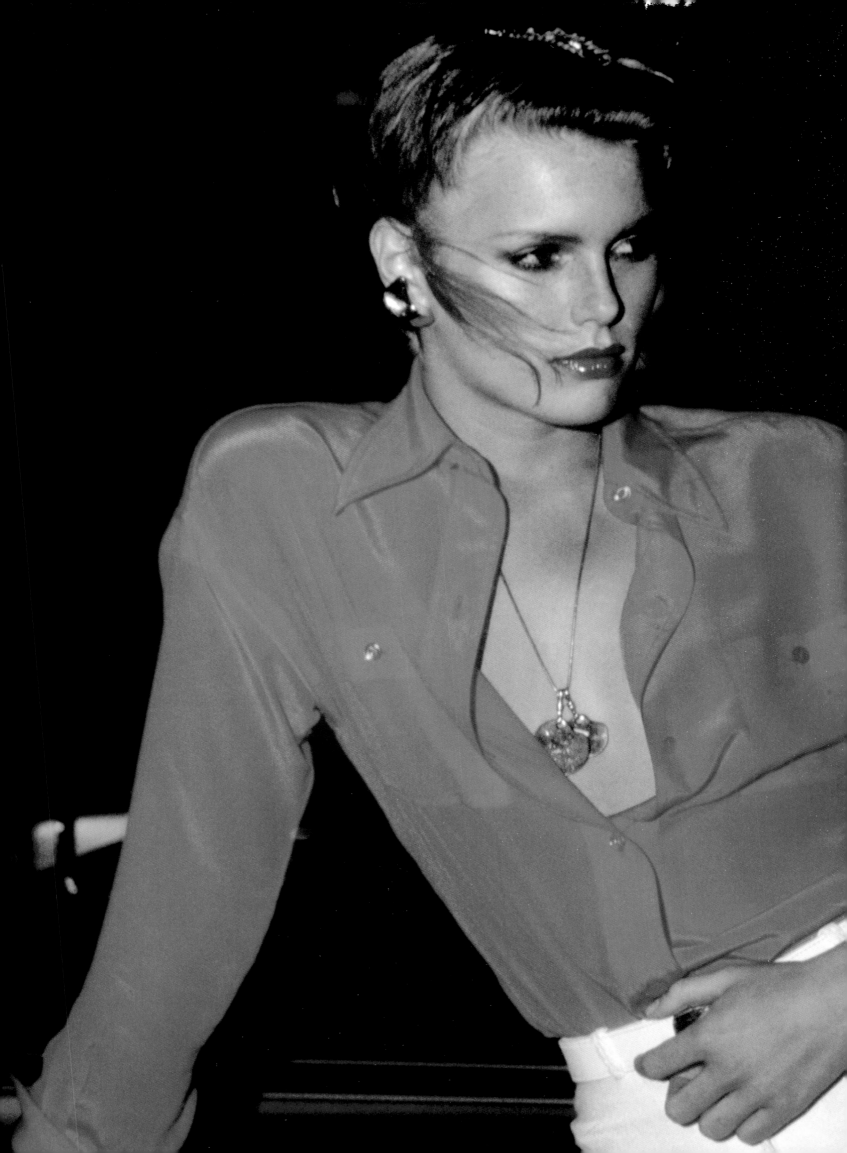

Irving Penn, *Vogue,* August 1977.

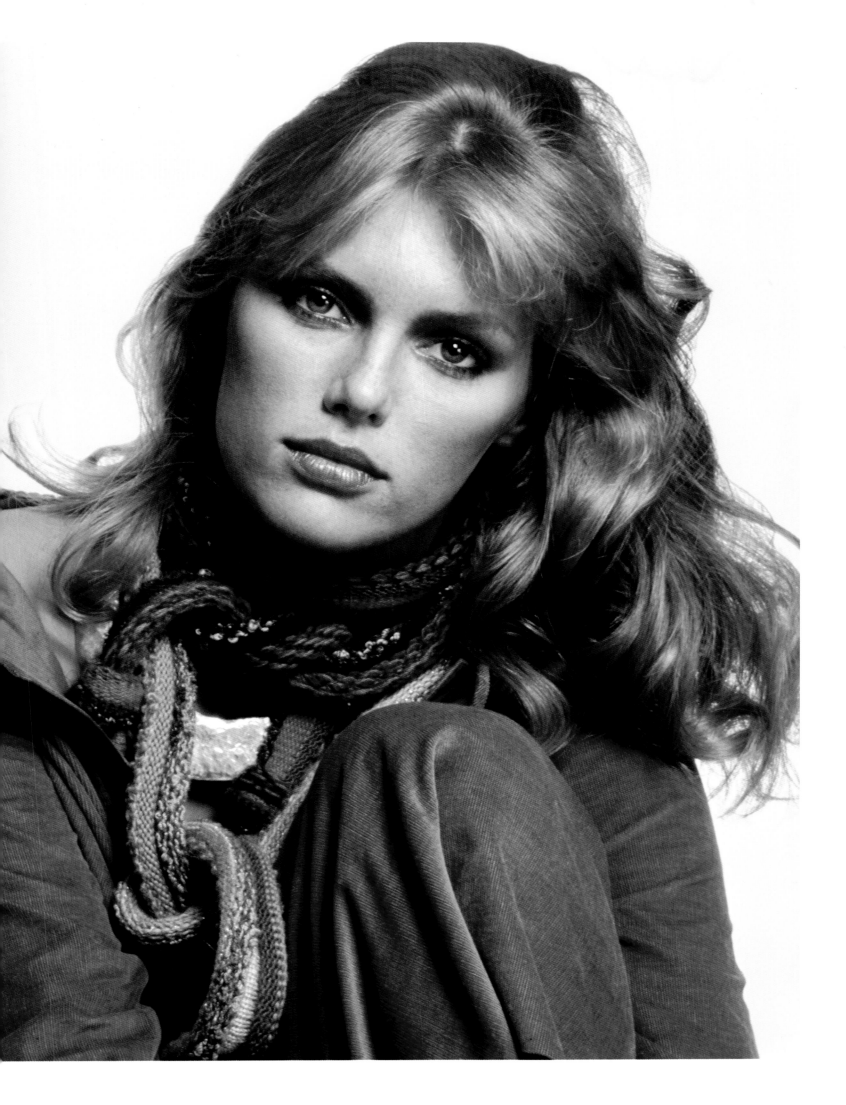

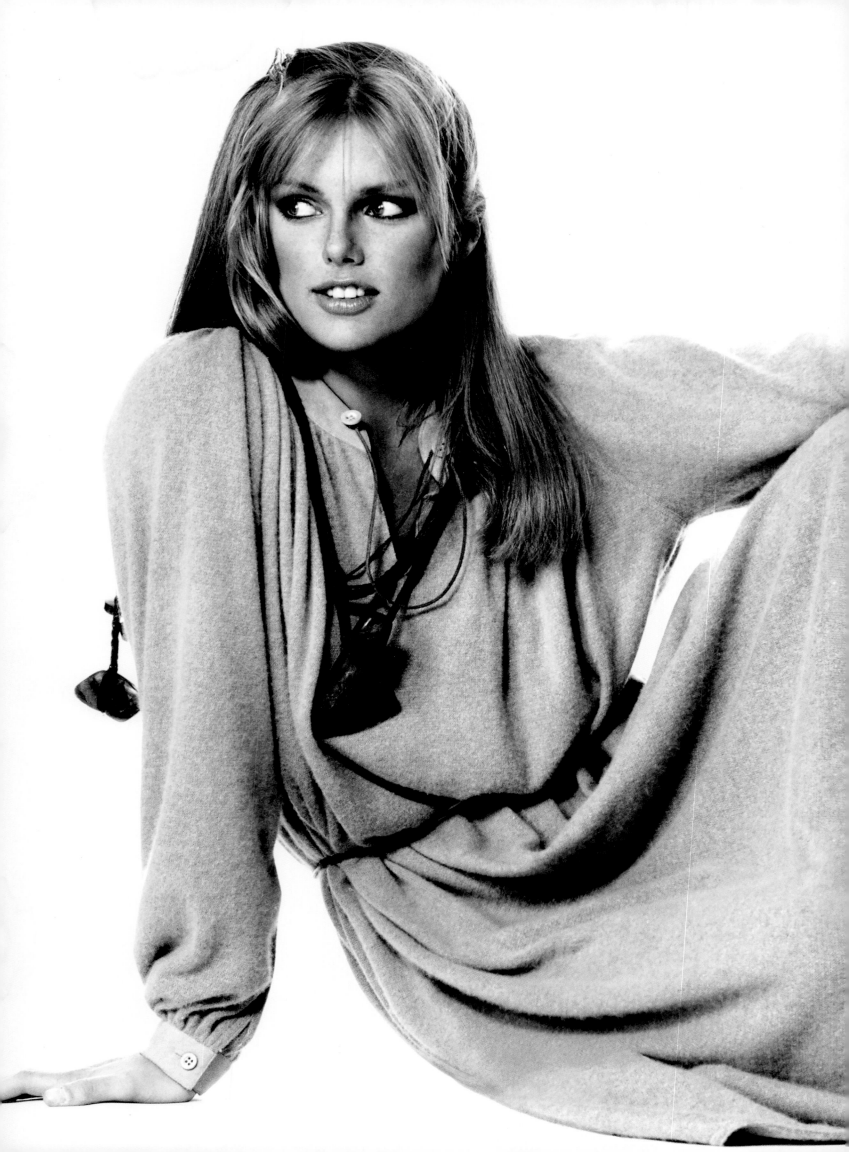

Irving Penn, *Vogue*, August 1977.

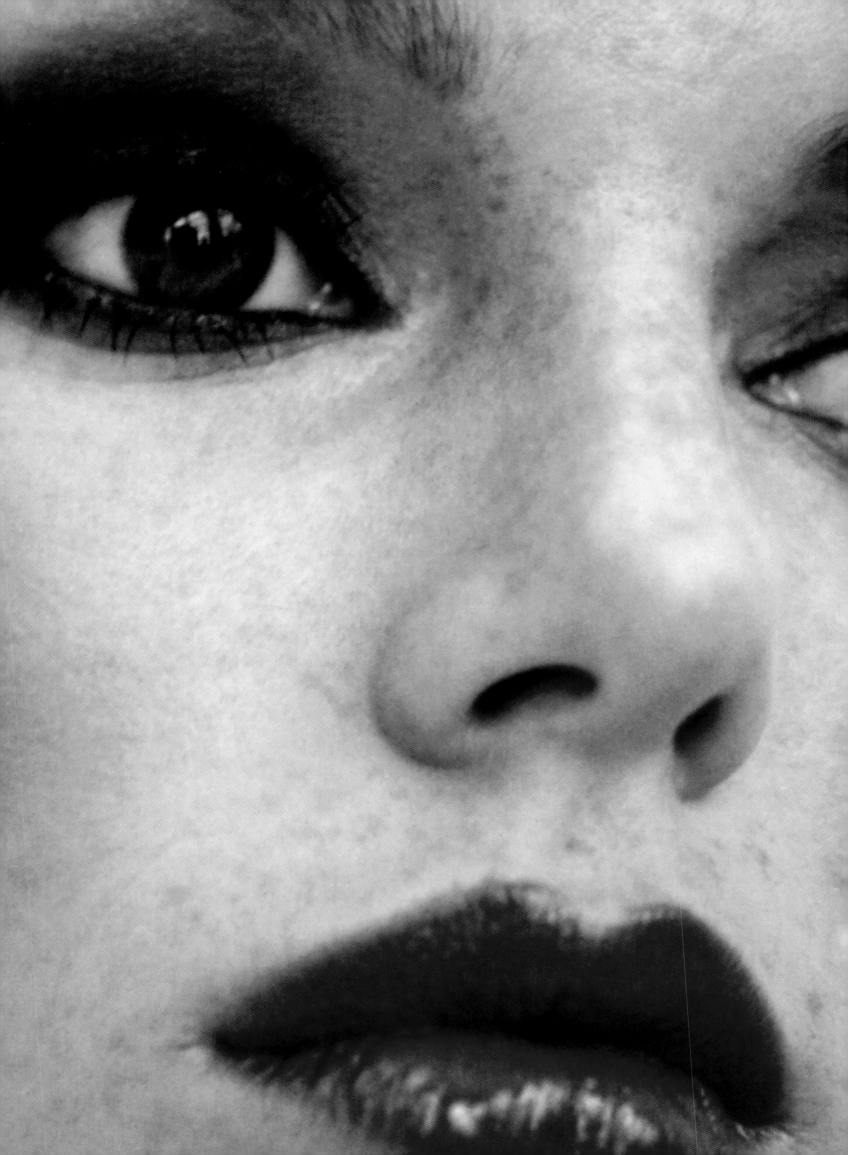

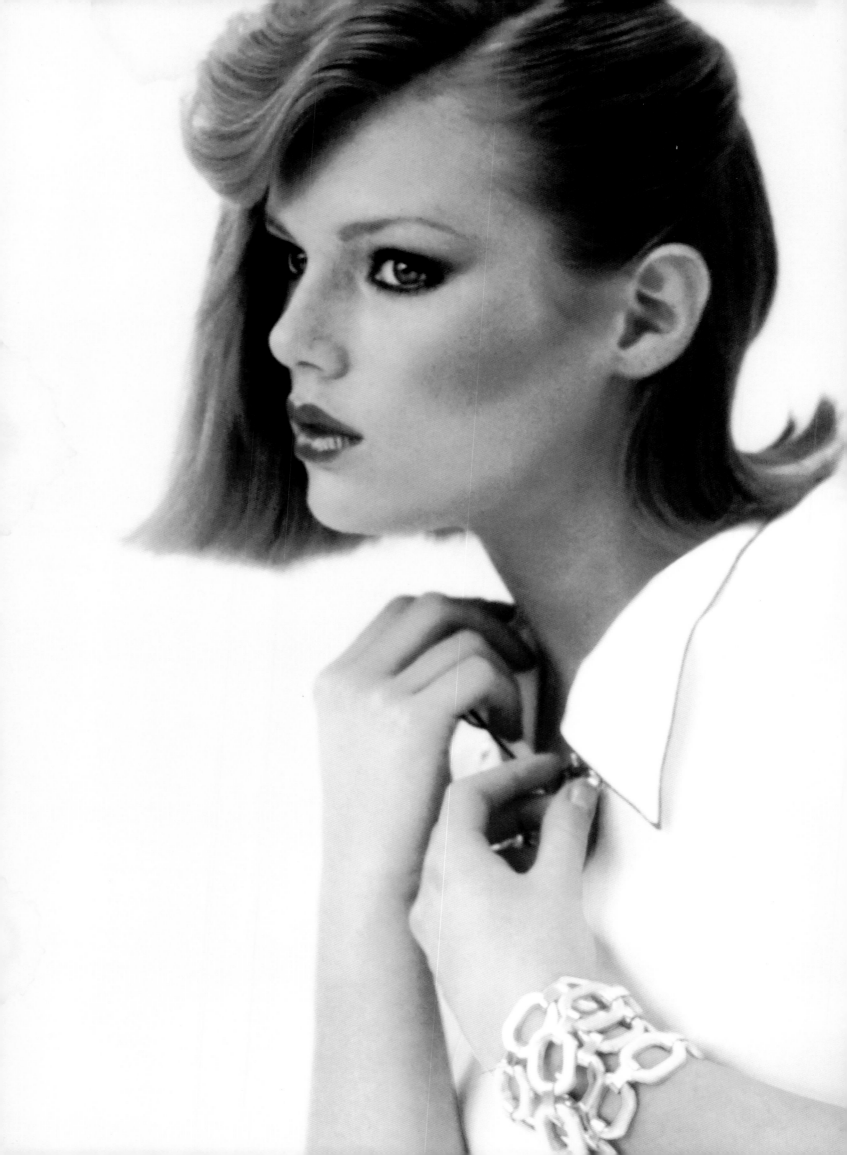

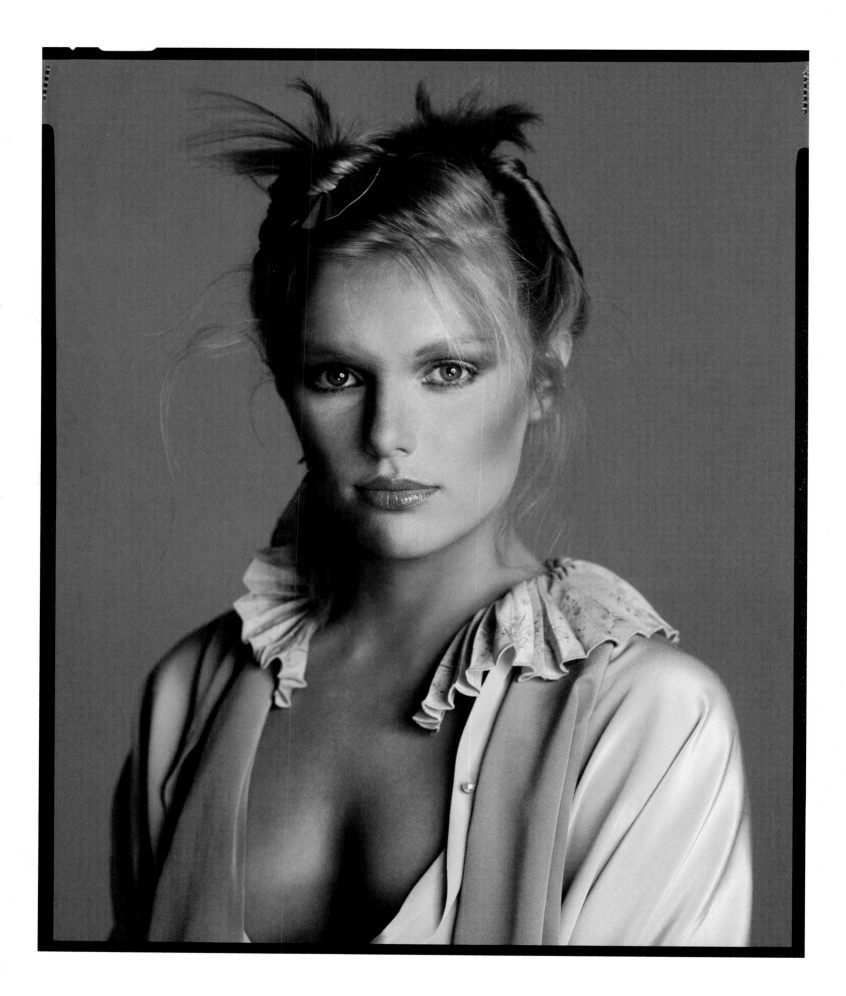

THIS PAGE AND OPPOSITE
Richard Avedon, *Vogue,* July 1977.

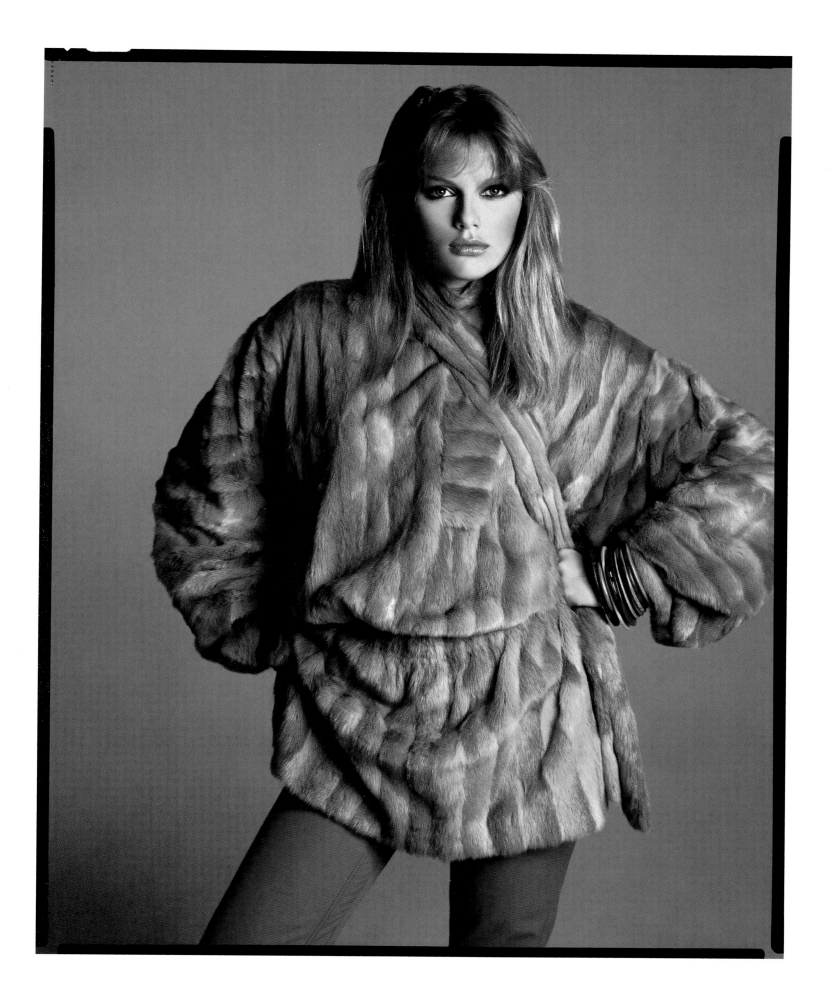

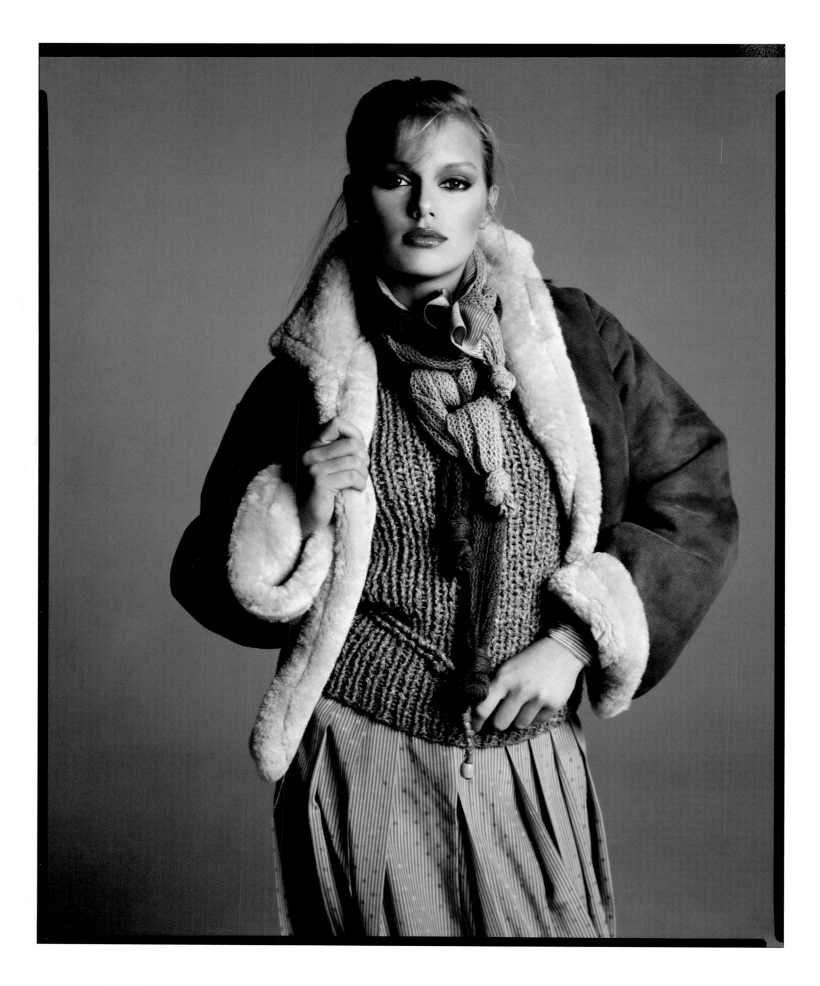

THIS PAGE AND OPPOSITE
Richard Avedon, *Vogue,* July 1977.

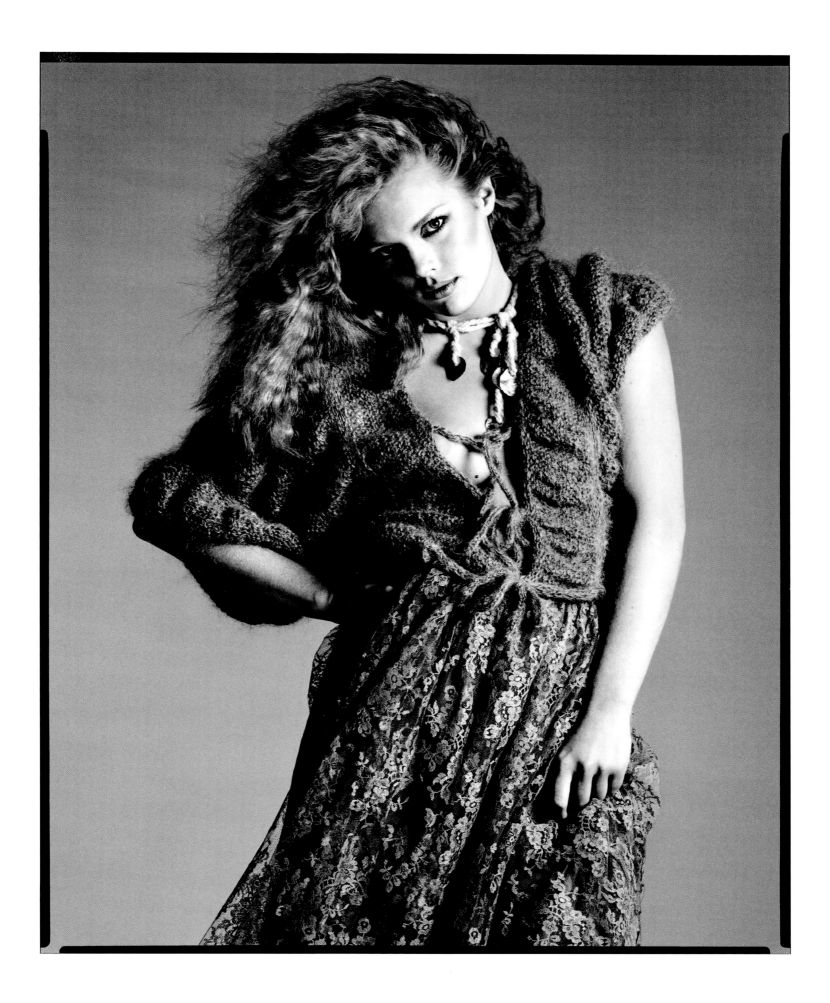

123

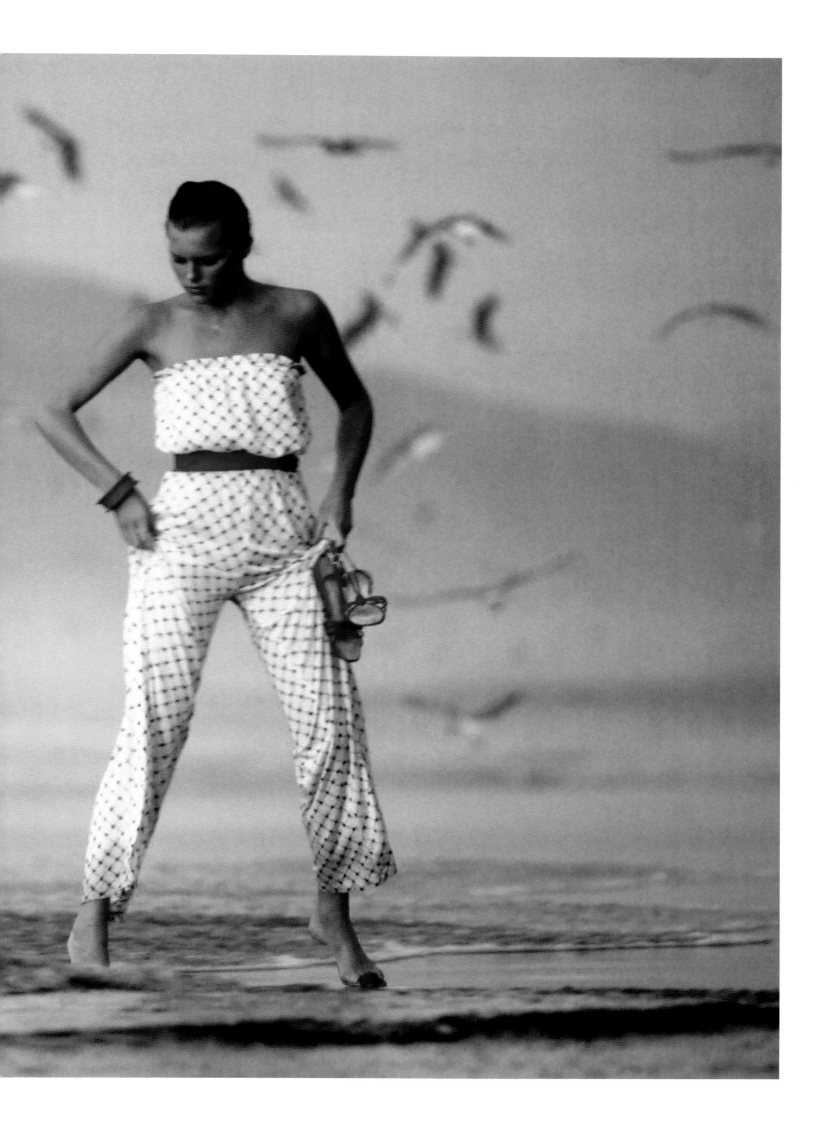

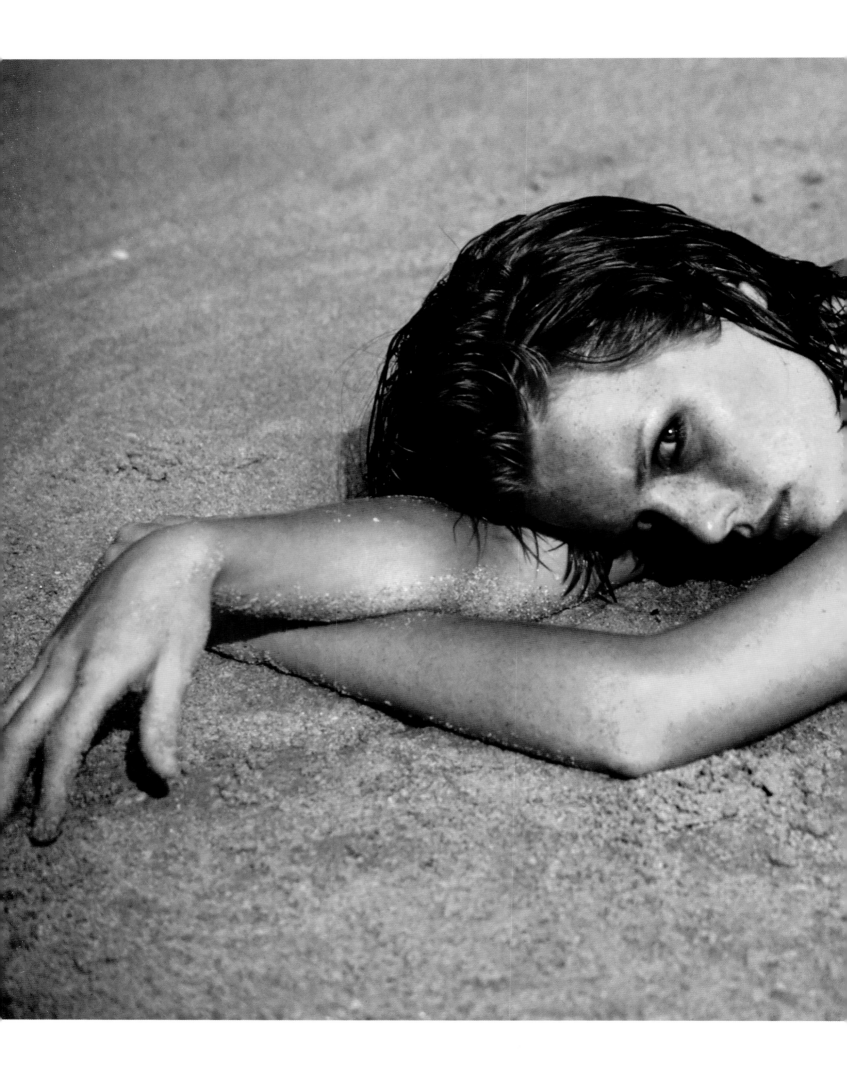

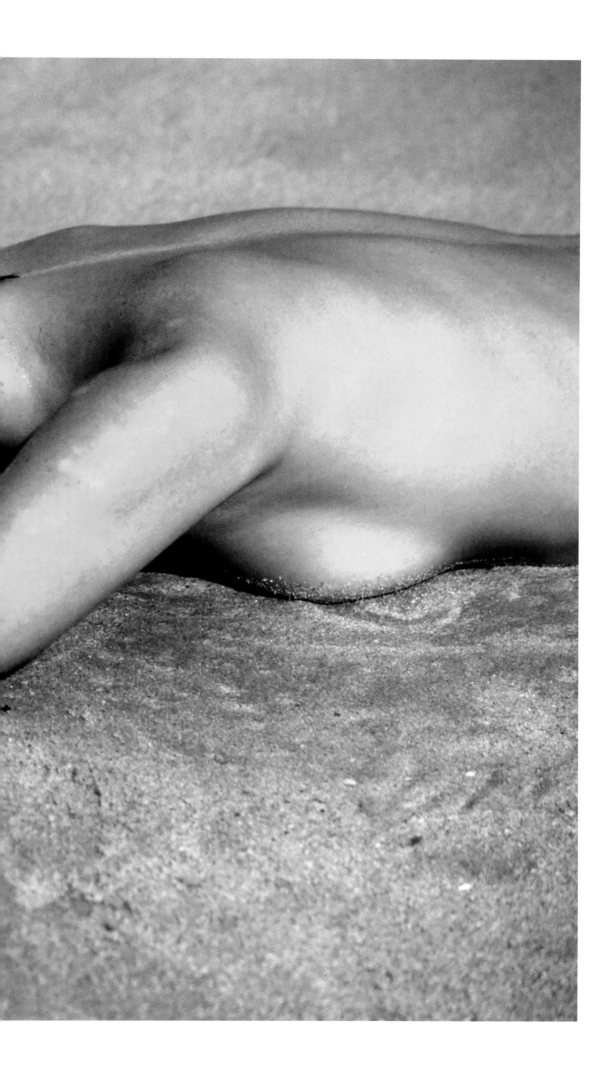

Arthur Elgort, *Vogue,* June 1976.

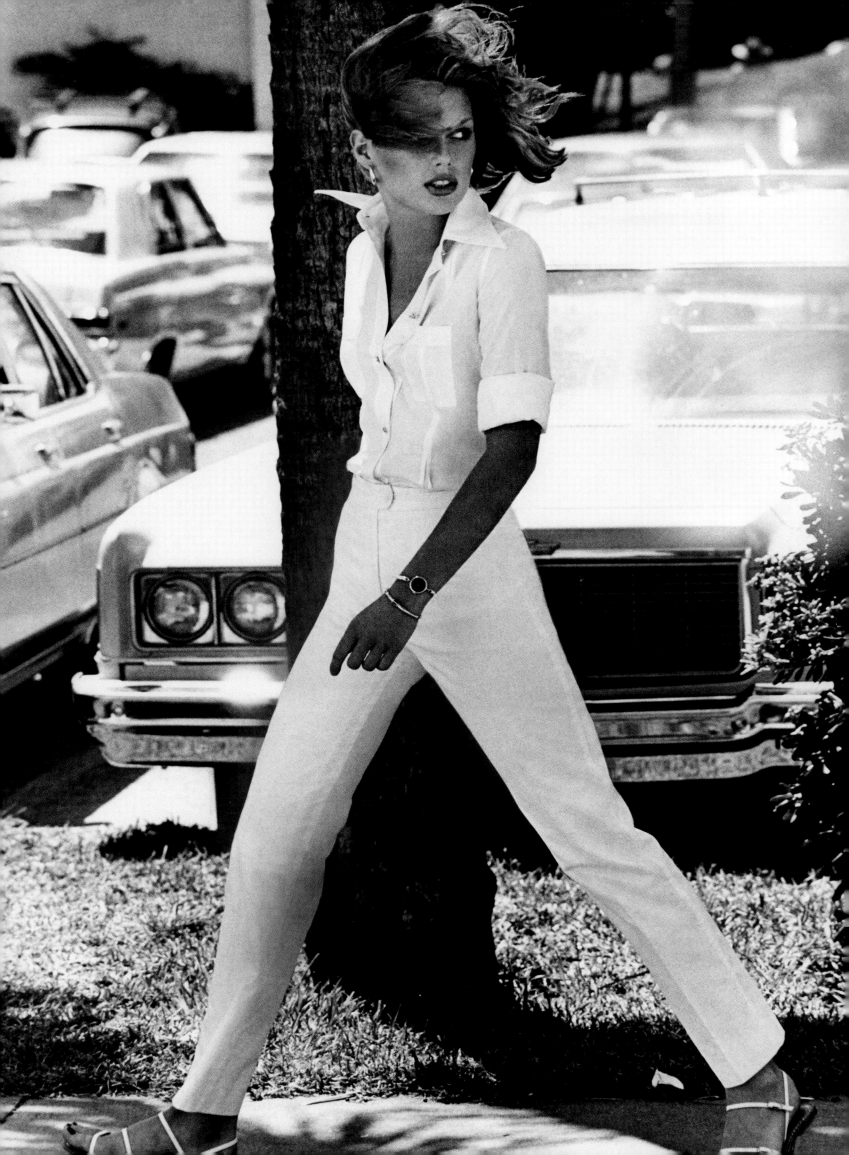

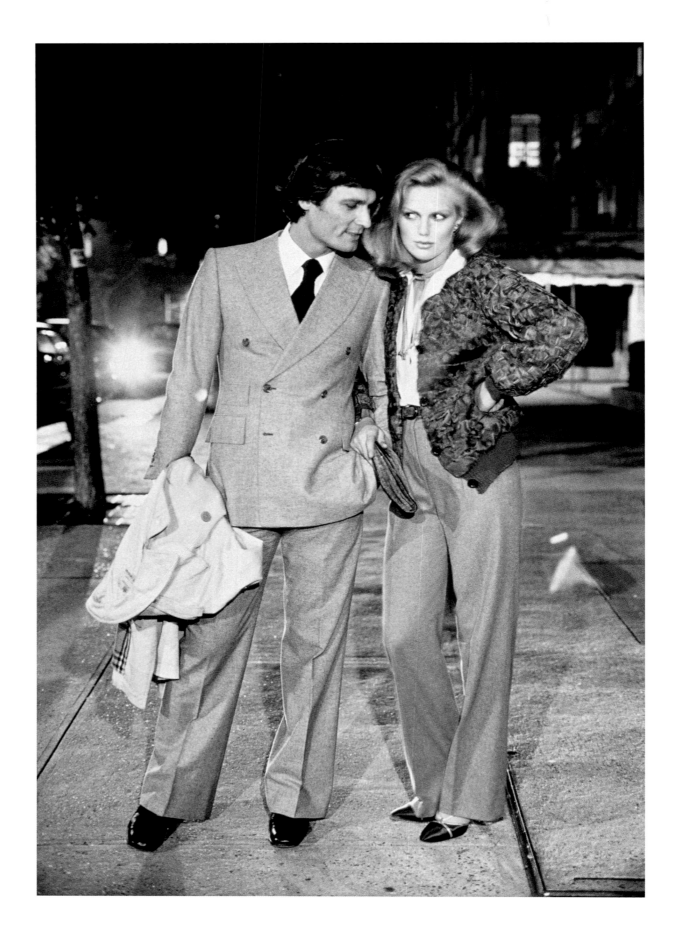

Hansen with Uva Harden.
Bob Richardson, *Vogue,* November 1976.

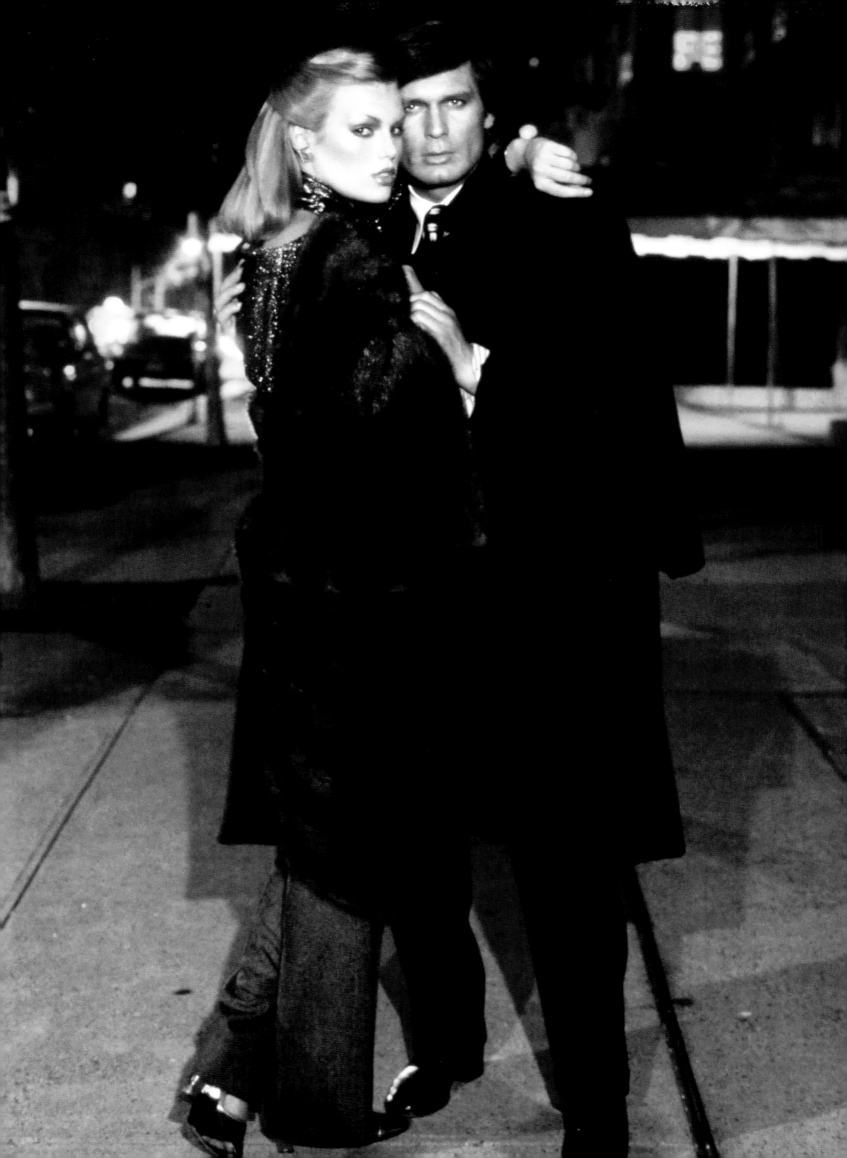

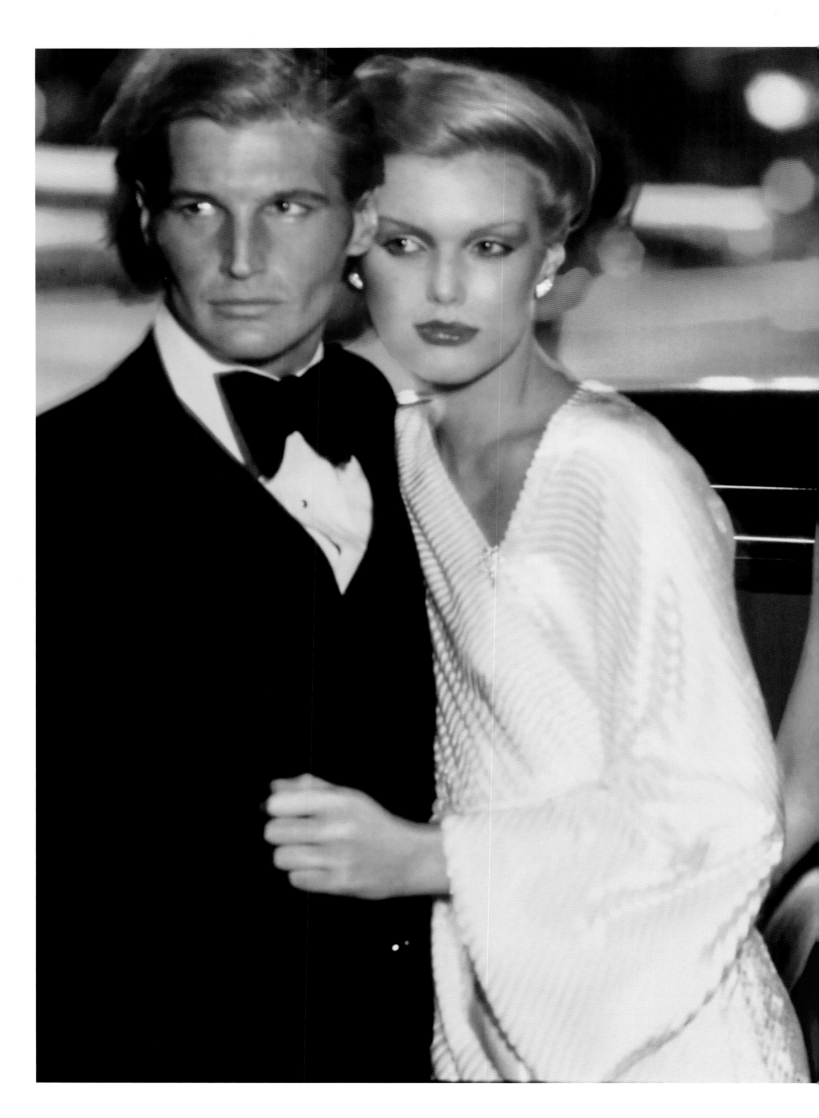

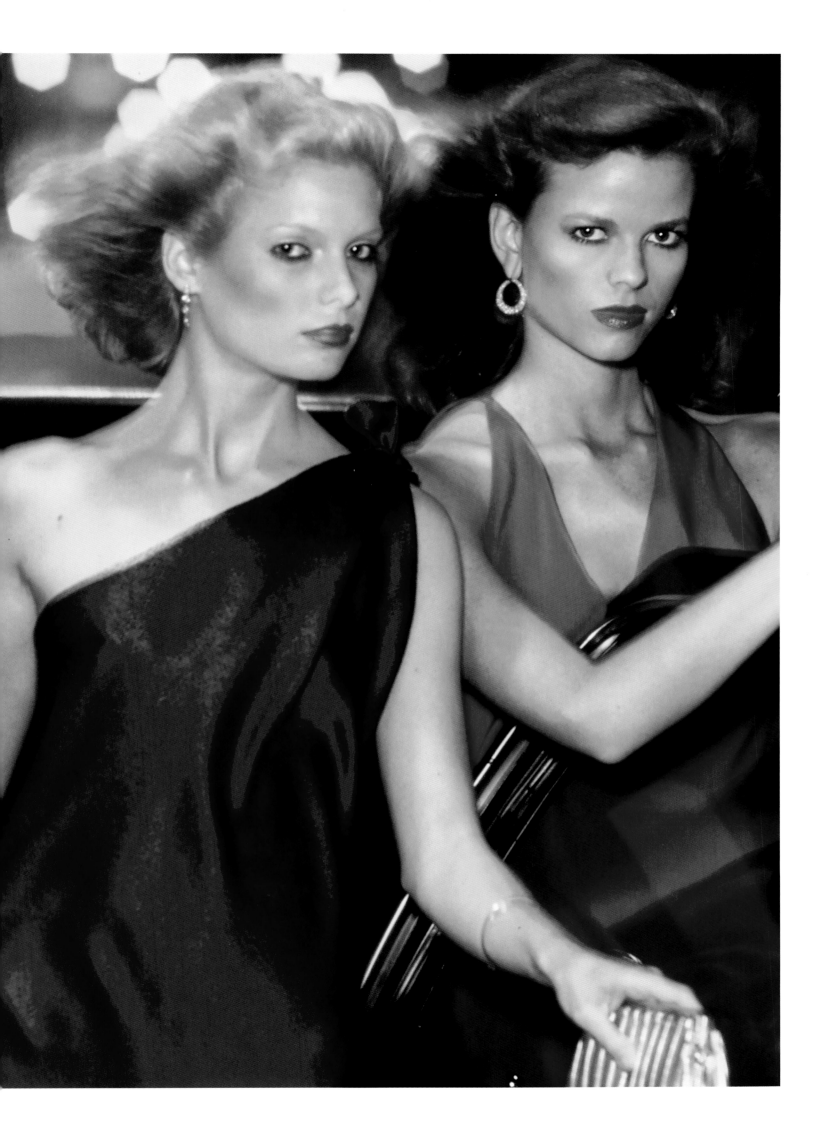

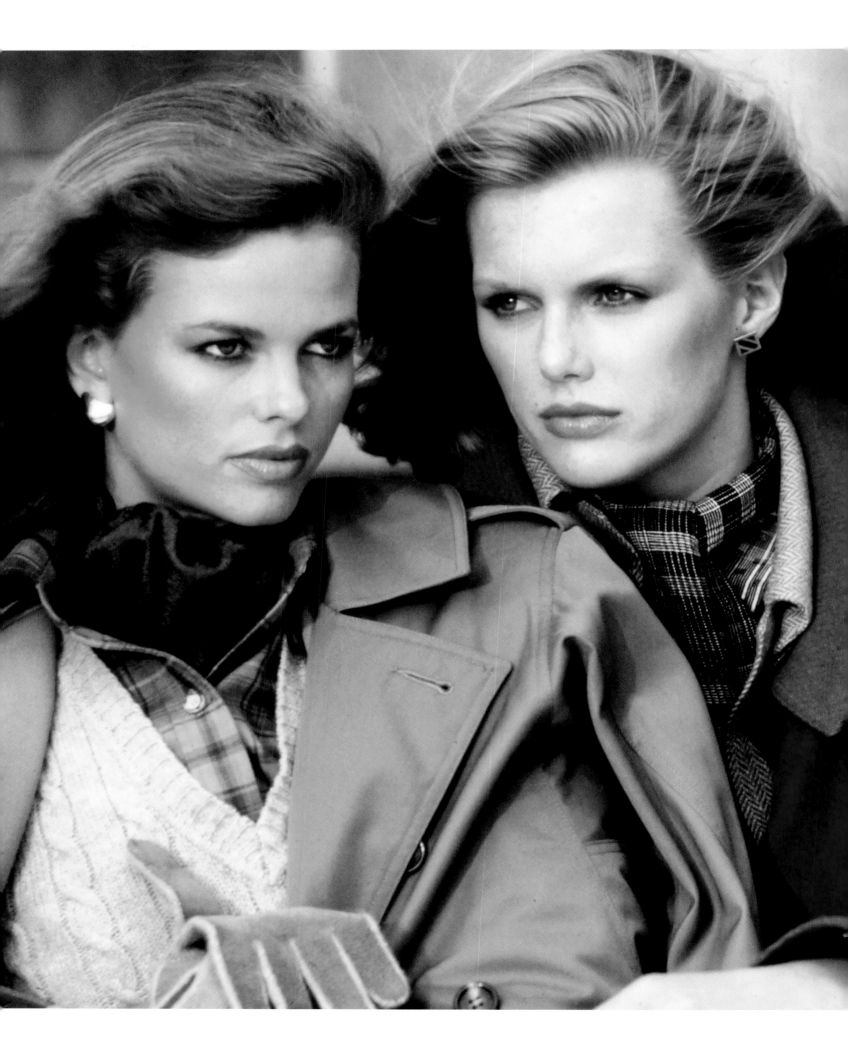

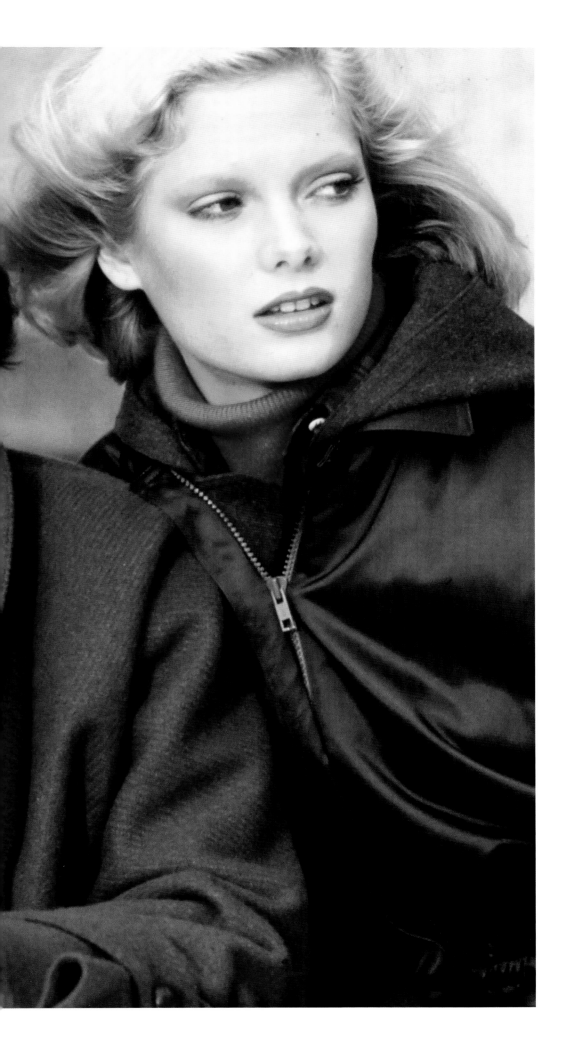

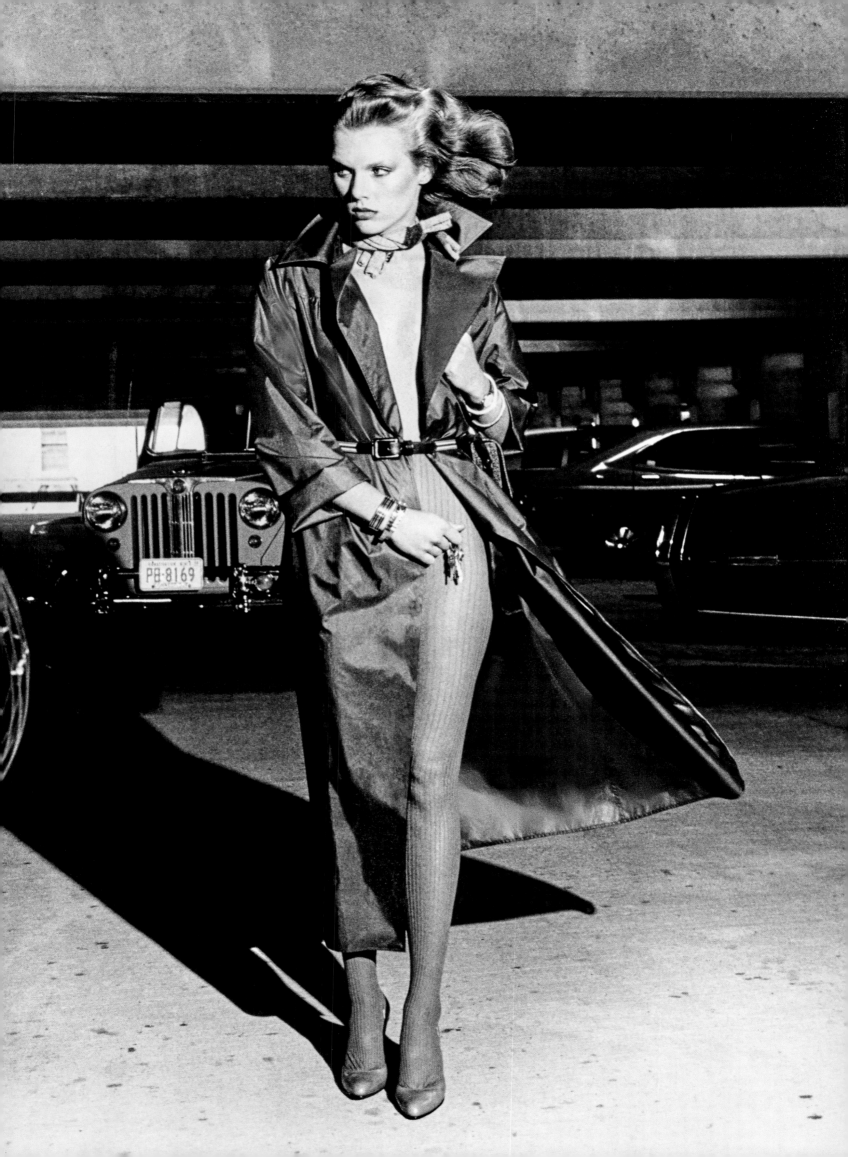

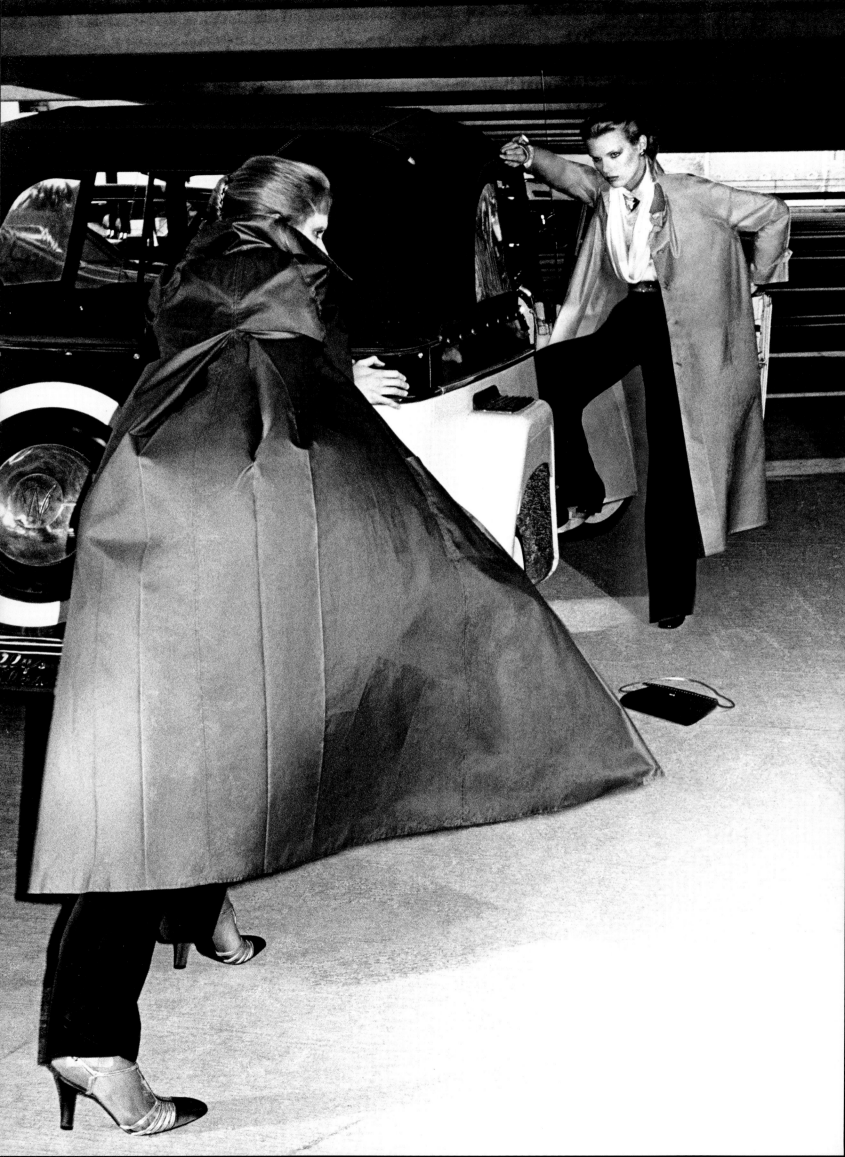

Chris von Wangenheim, *Vogue*, July 1976.

Hansen with Peter Keating.
Arthur Elgort, *Vogue*, September 1976.

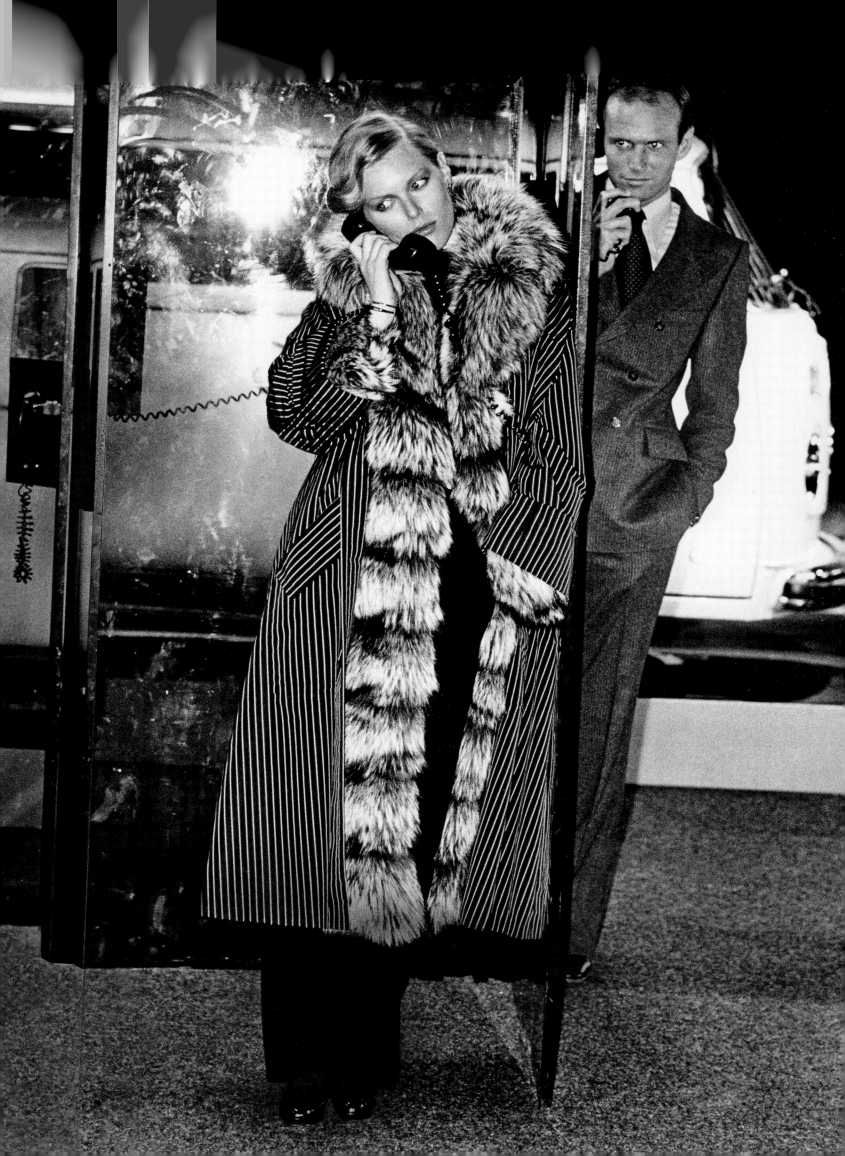

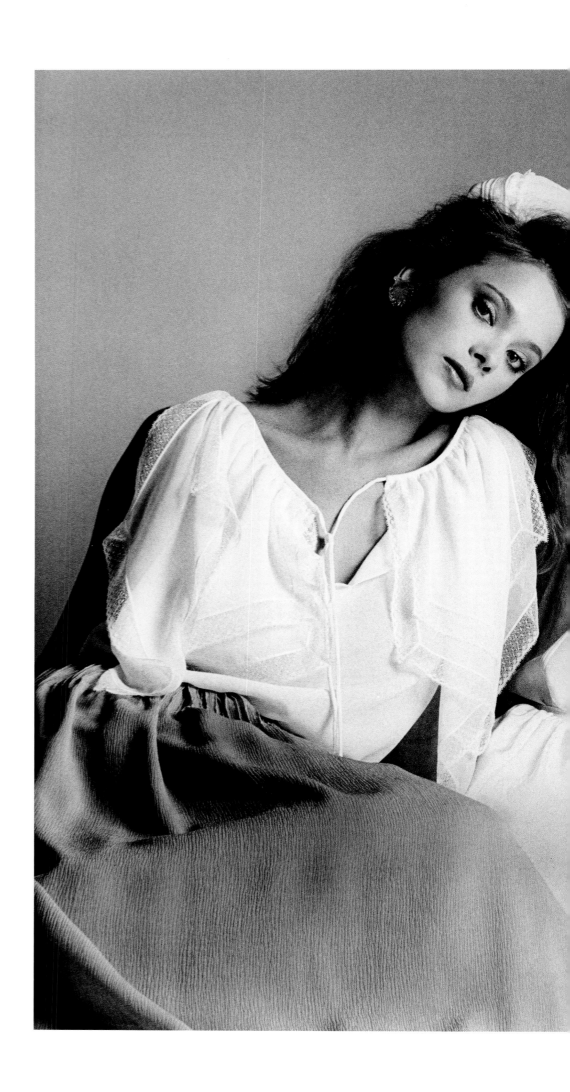

Hansen with Lena Kansbod
and Juli Foster.
Francesco Scavullo,
Vogue, December 1977

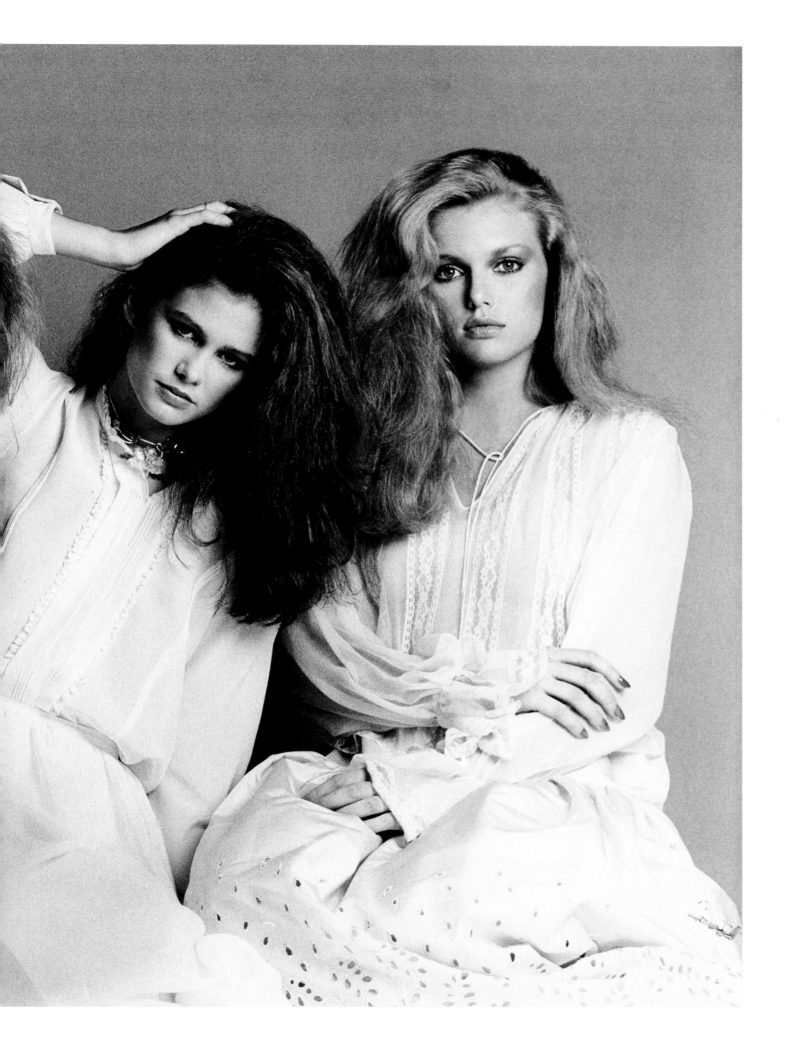

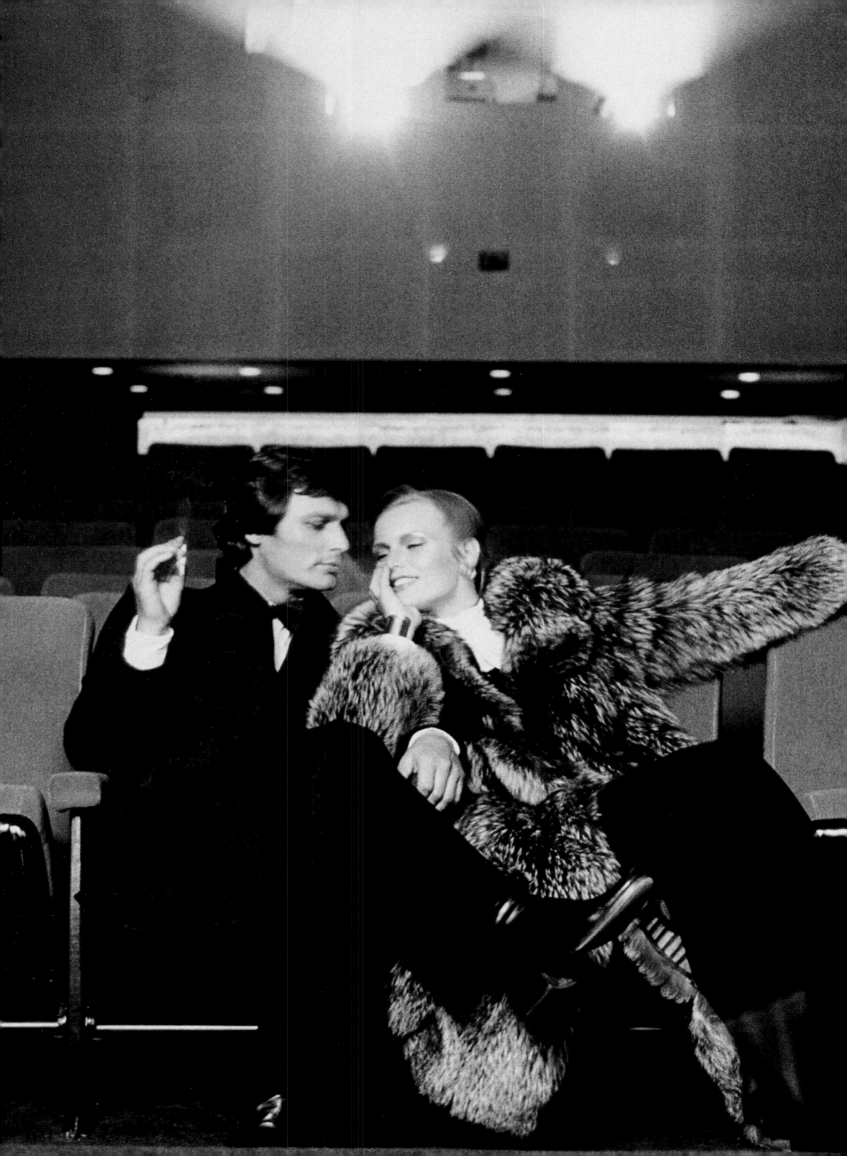

LEFT
Hansen with Uva Harden.
Bob Richardson, *Vogue,* November 1976.

FOLLOWING PAGES
Deborah Turbeville, *Vogue,* July 1977.

143

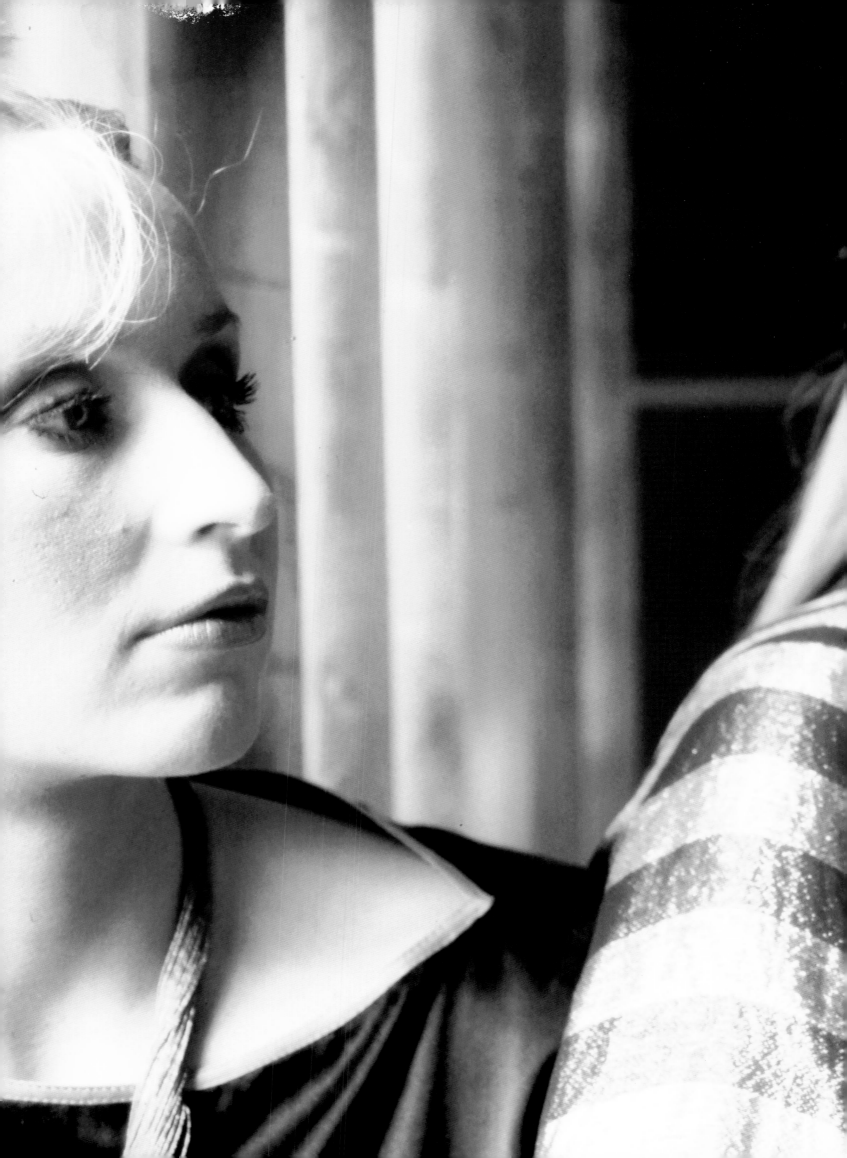

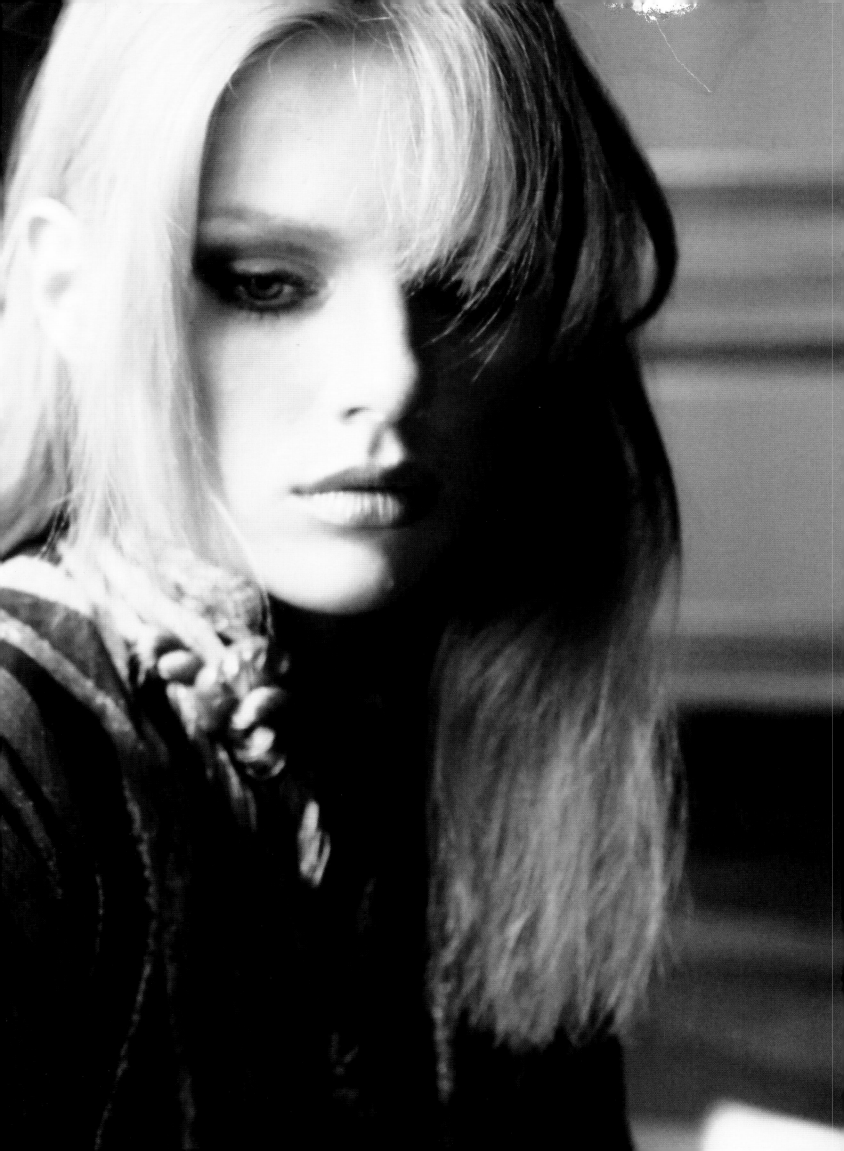

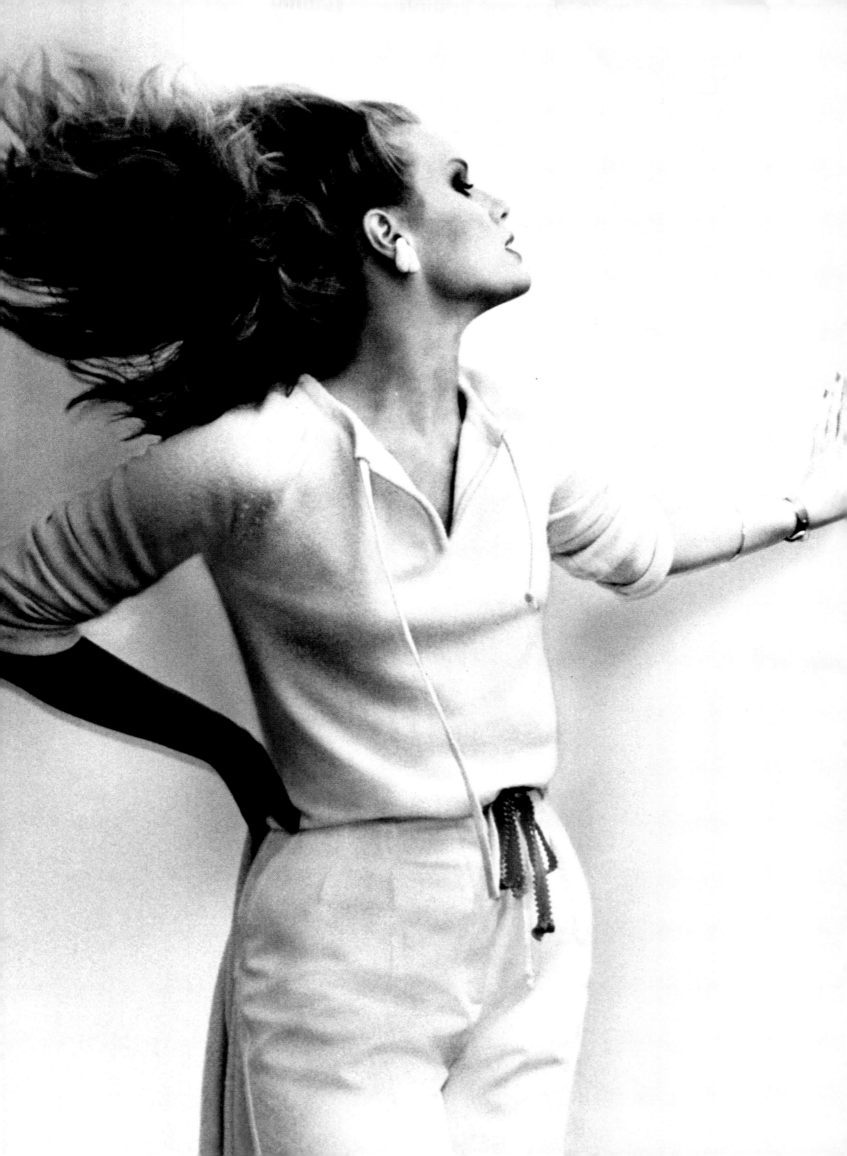

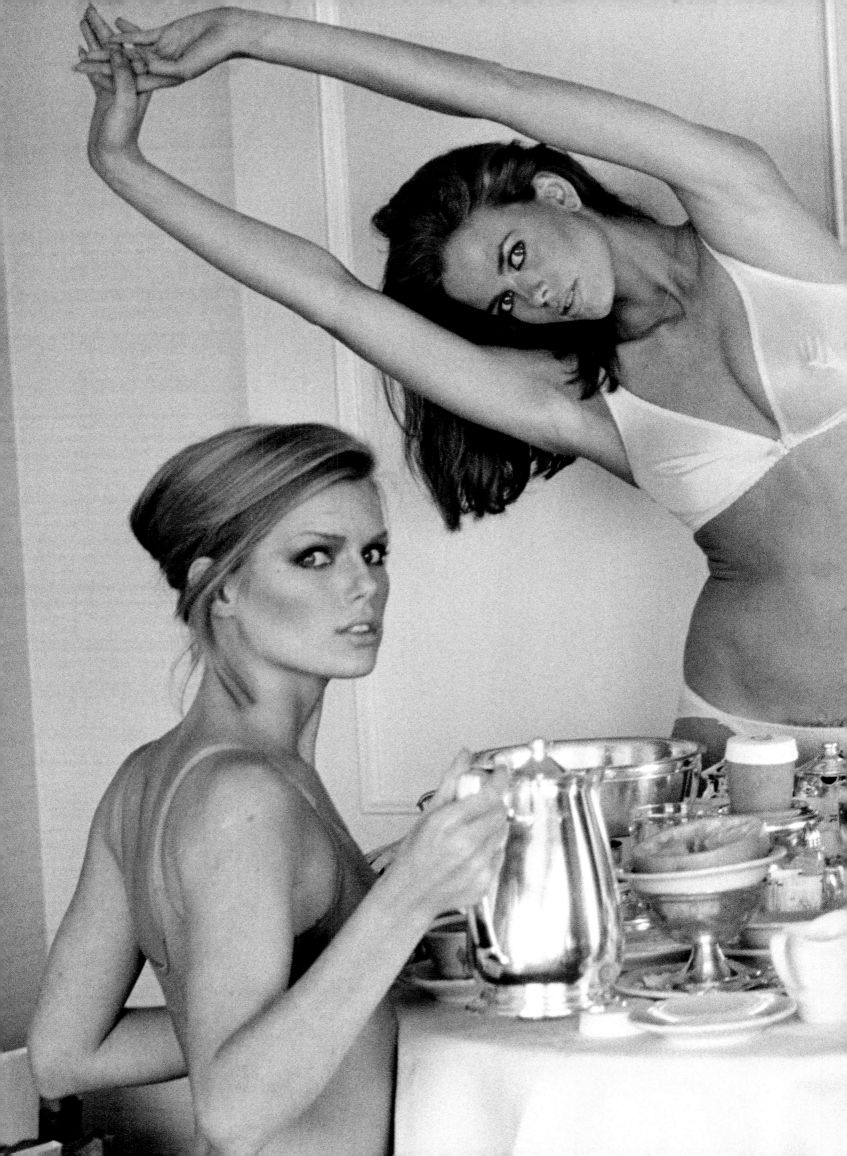

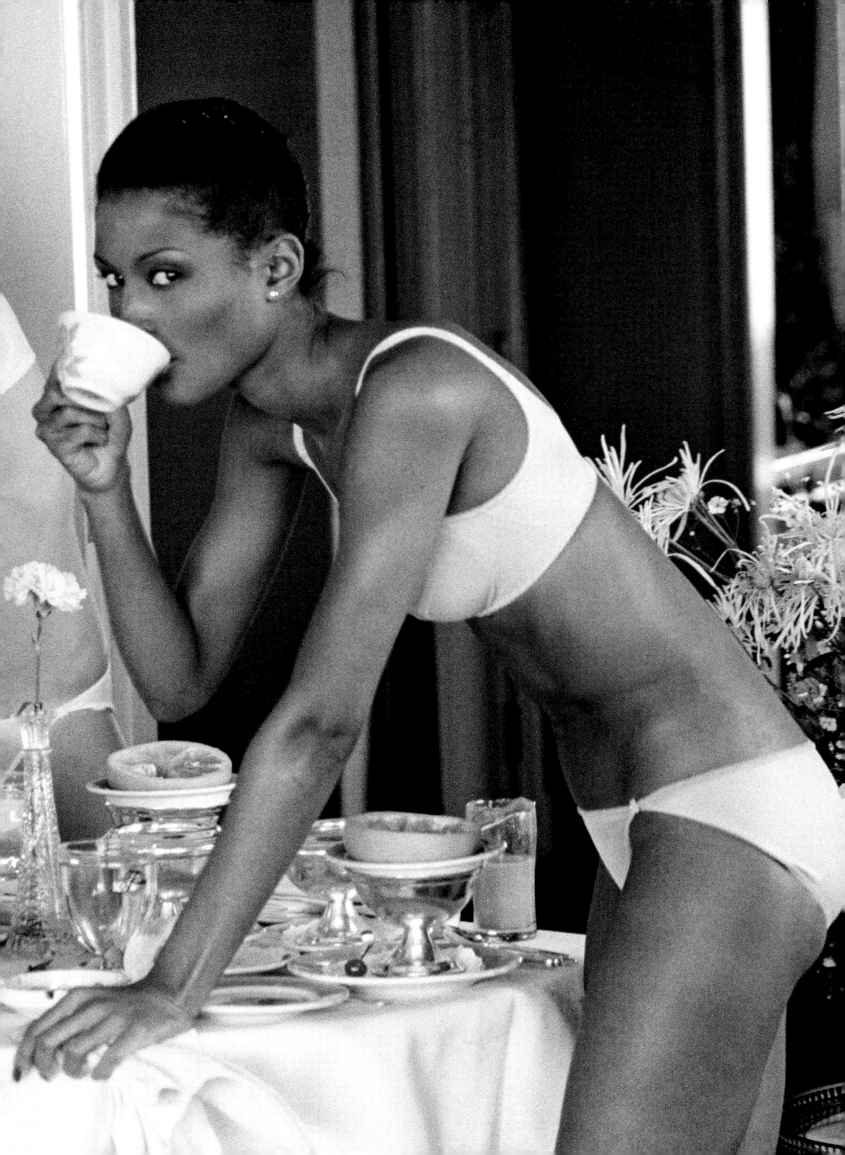

Hansen with Lisa Taylor.
Arthur Elgort, *Vogue,* August 1976.

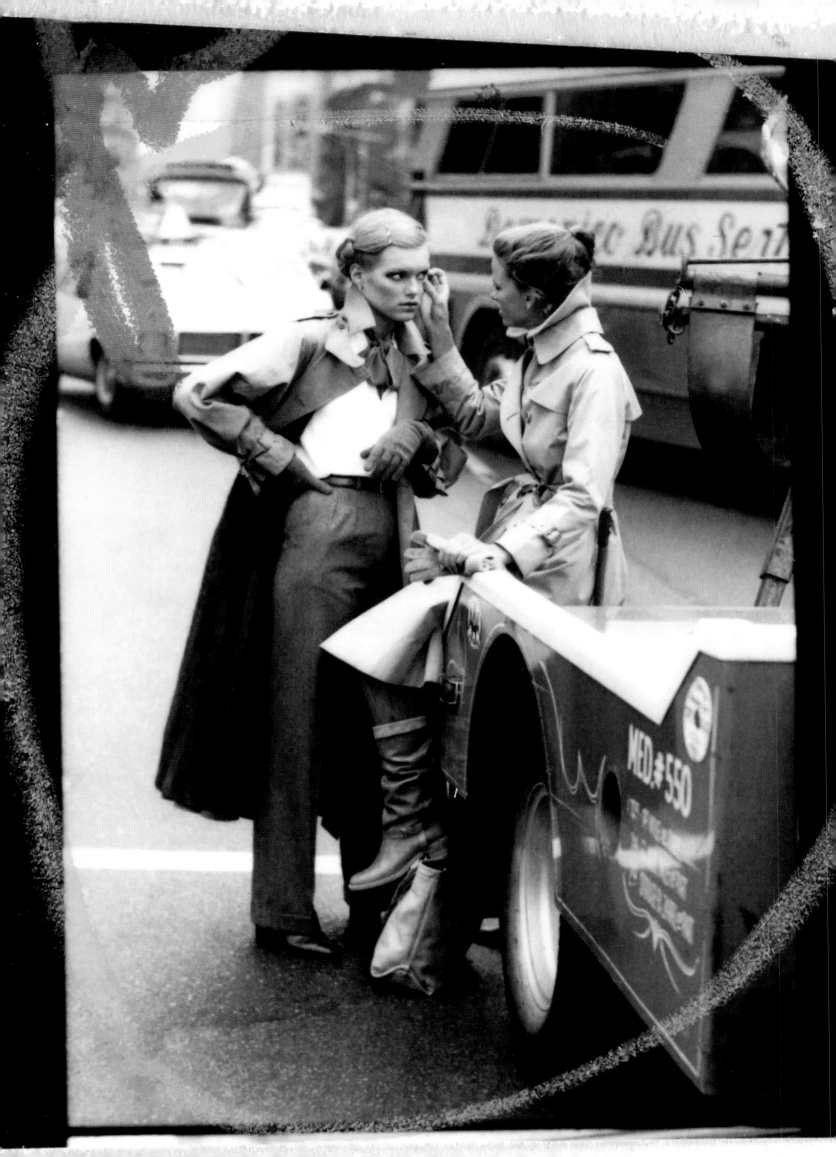

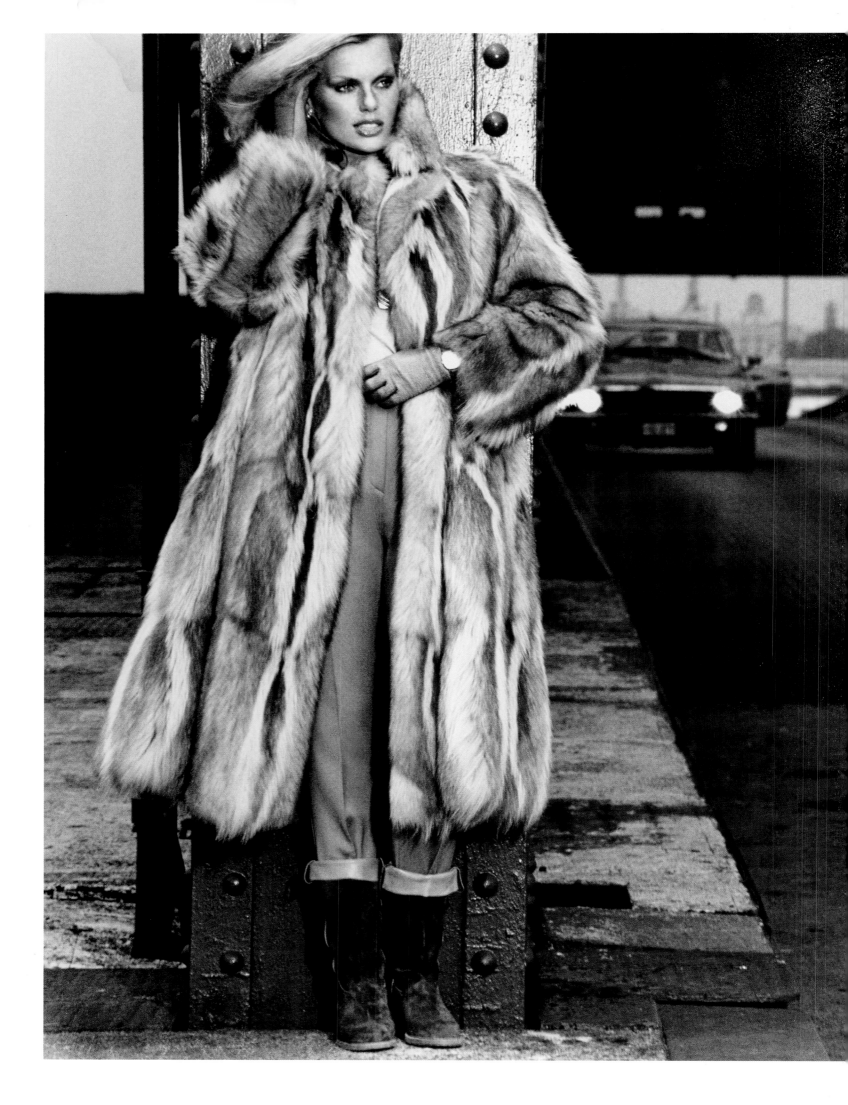

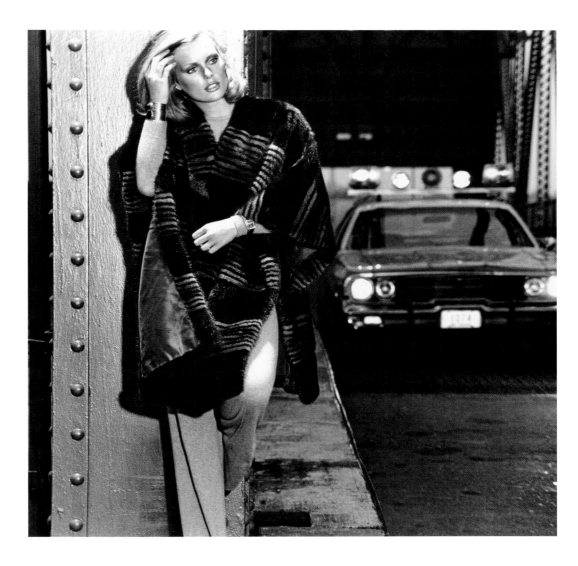

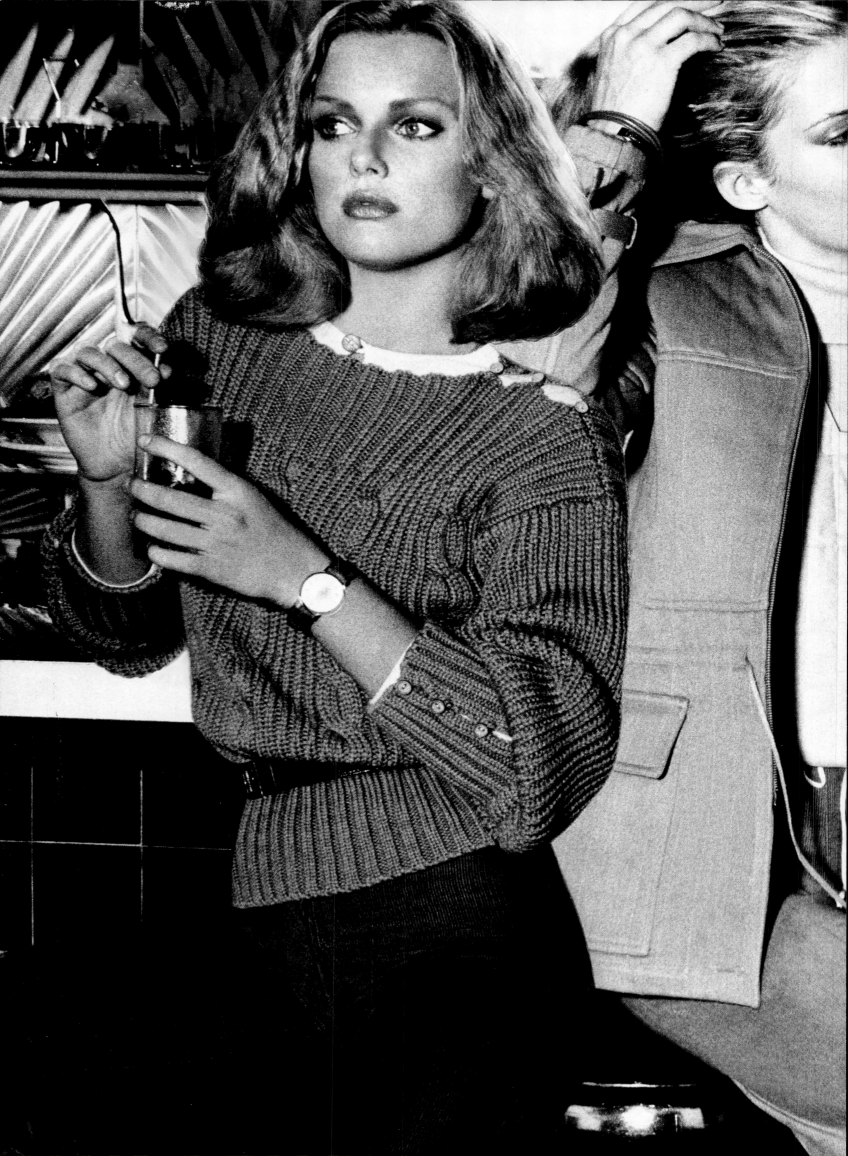

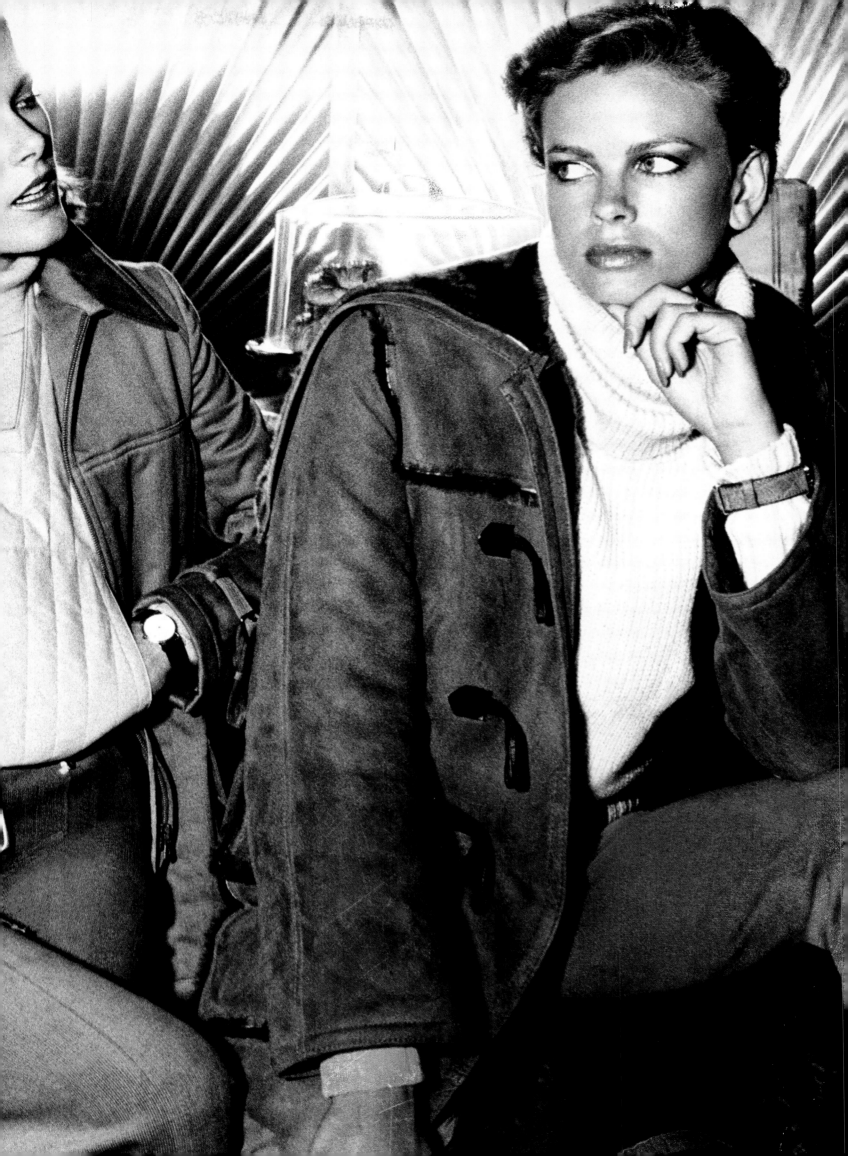

PREVIOUS PAGES
Hansen with Chris O'Connor and Lisa Taylor.
Guy Le Baube, *Vogue,* October 1976.

OPPOSITE
Guy Le Baube, *Vogue,* September 1977.

156

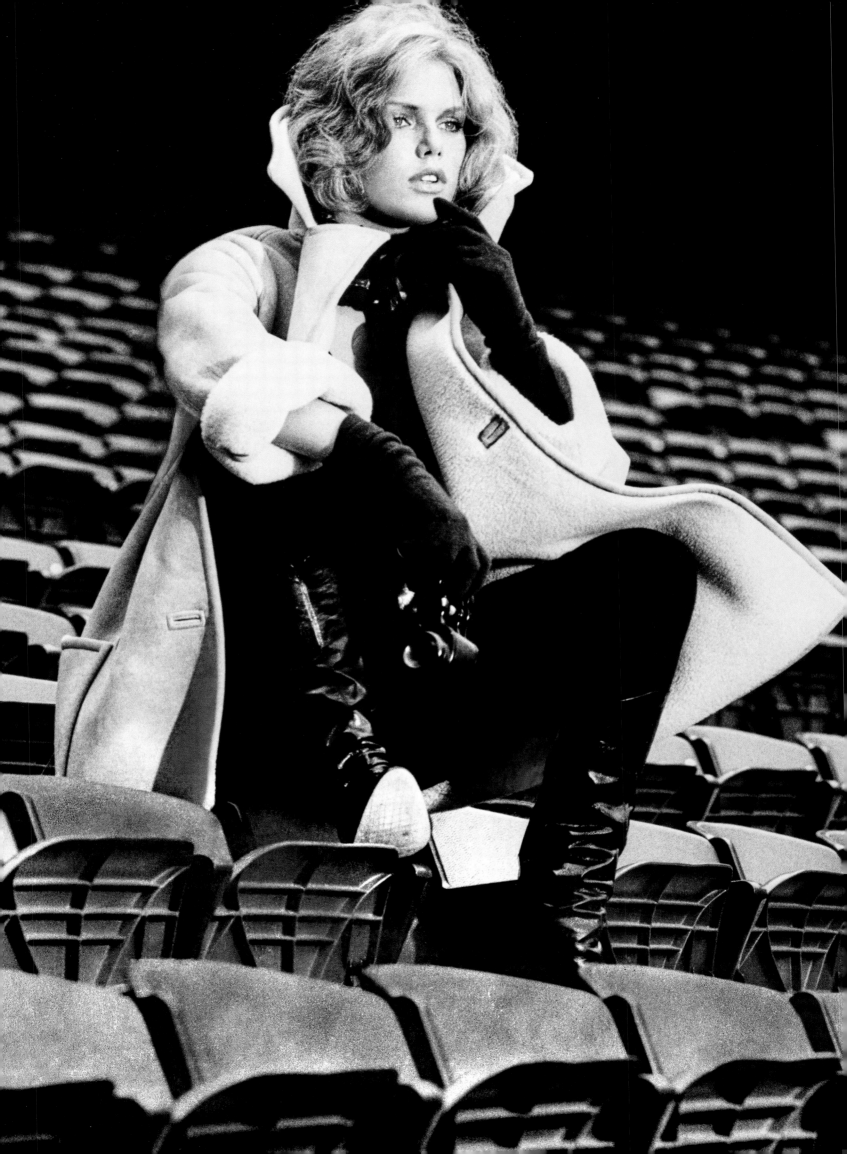

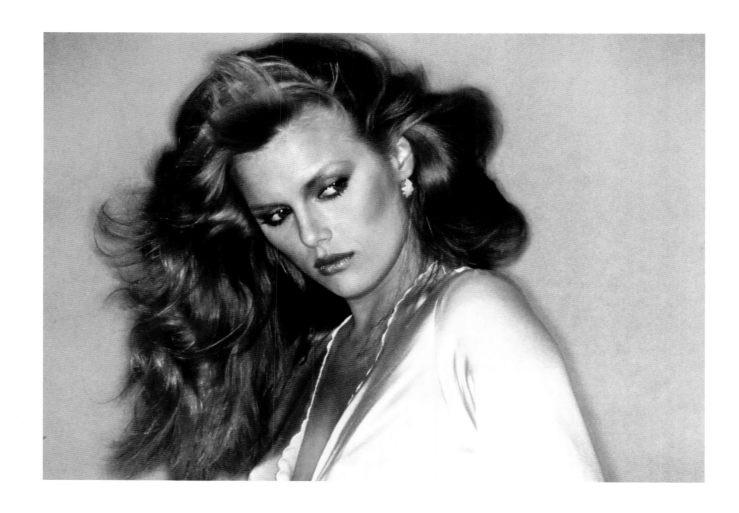

THESE PAGES AND FOLLOWING PAGES
Patrick Demarchelier, *Vogue,* September 1977.

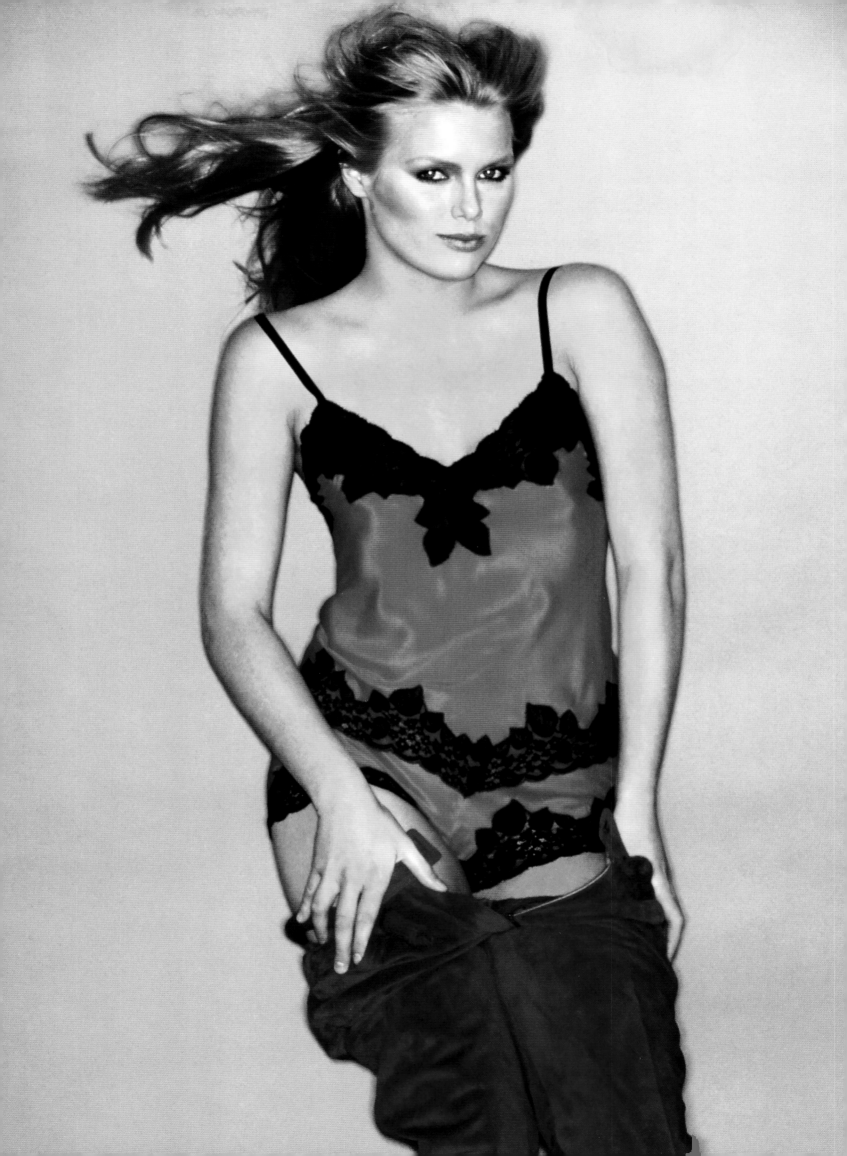

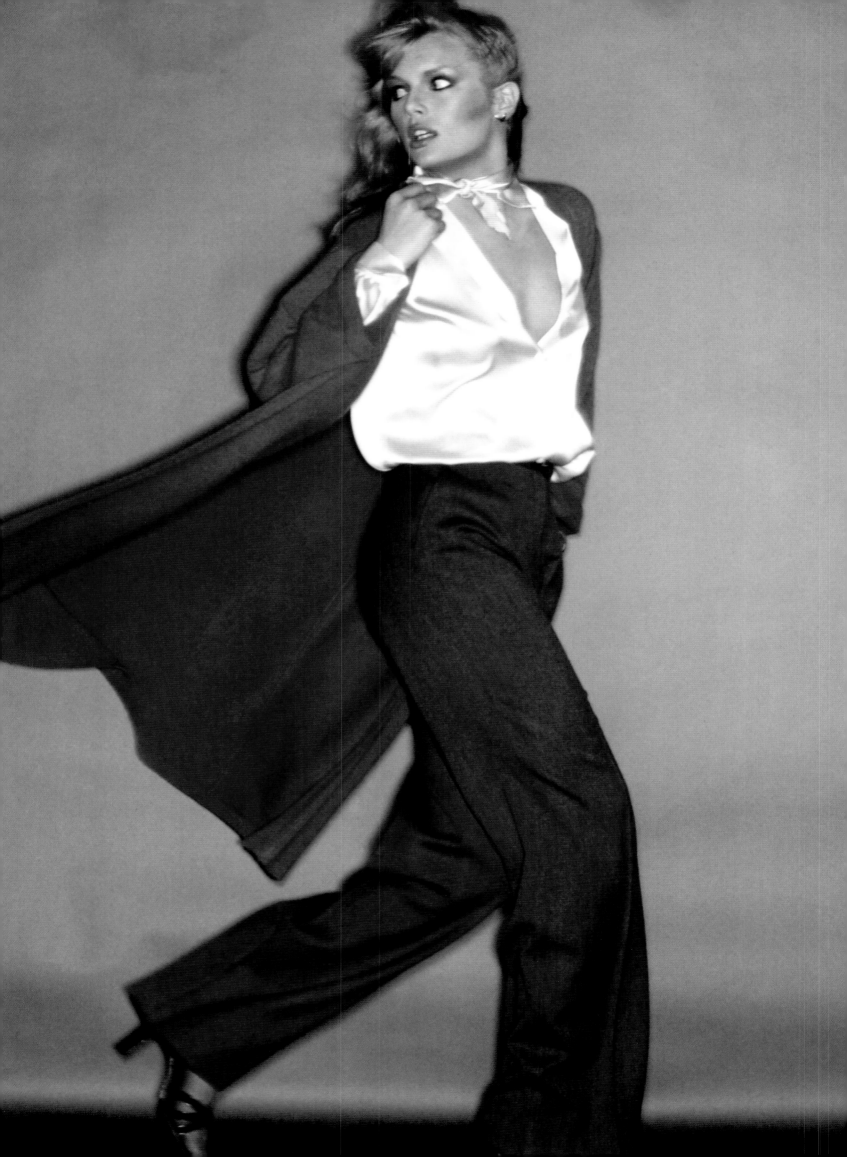

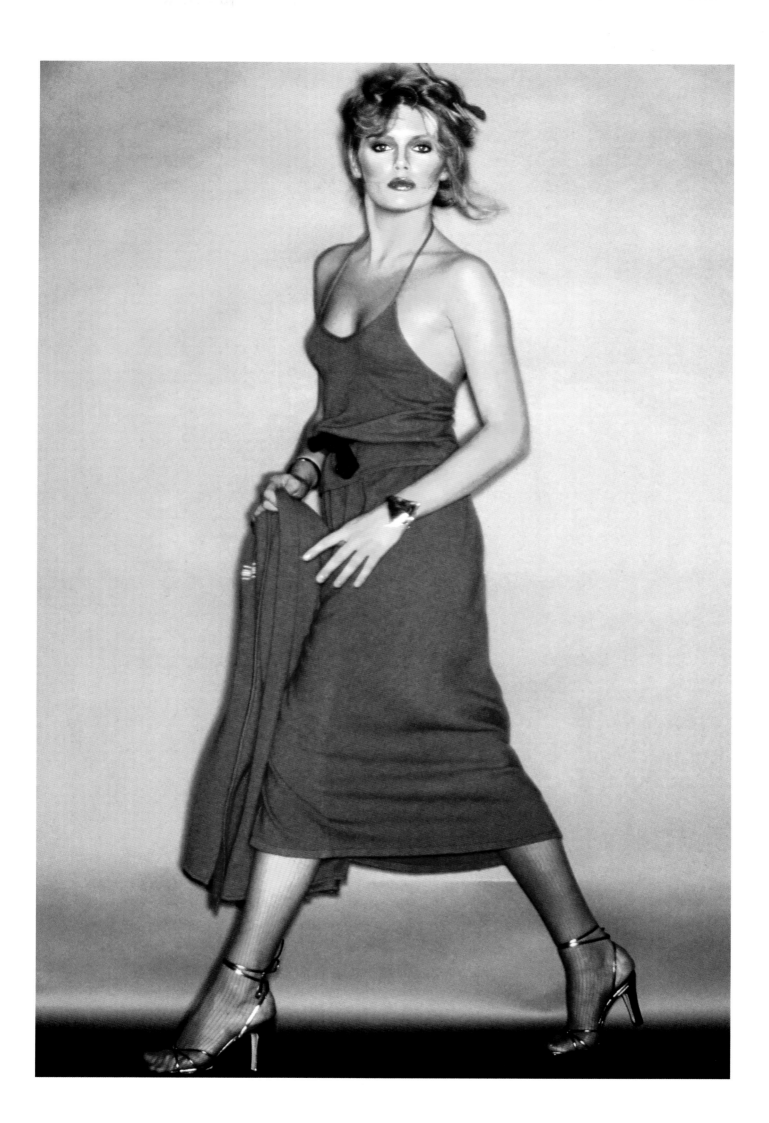

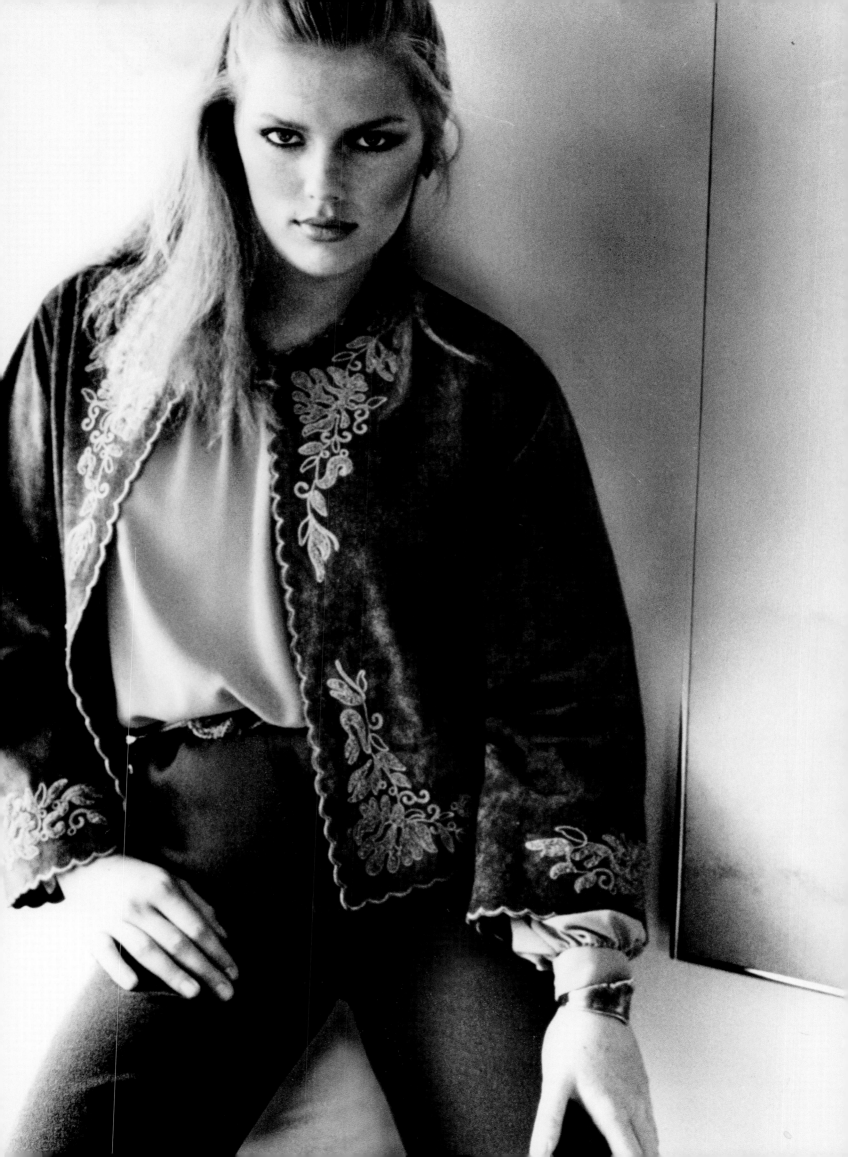

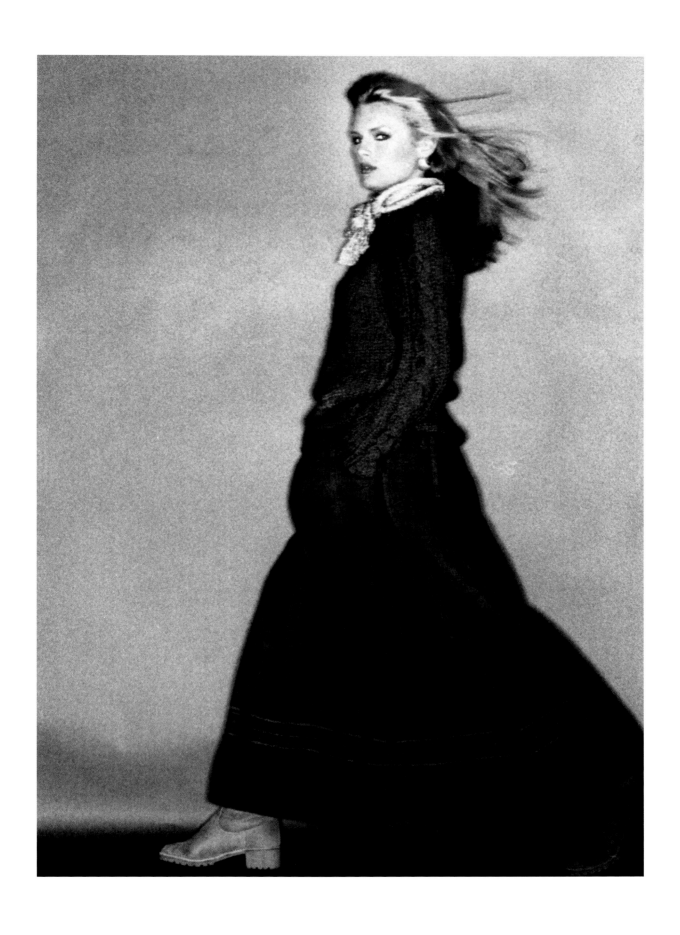

ABOVE
Patrick Demarchelier, *Vogue*, September 1977.

OPPOSITE
Bob Richardson, *Vogue*, September 1977.

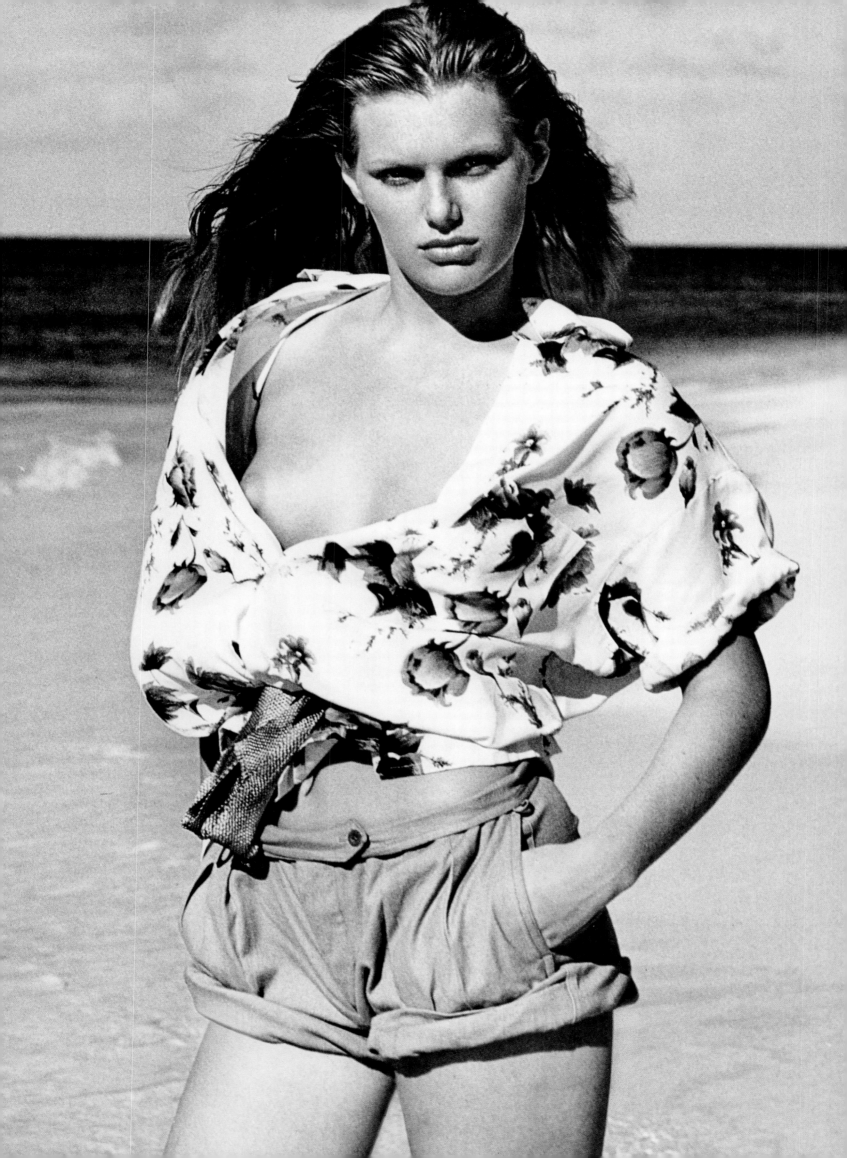

Aldo Ballo, *Vogue,* April 1978.

Francesco Scavullo, *Vogue*, April 1978.

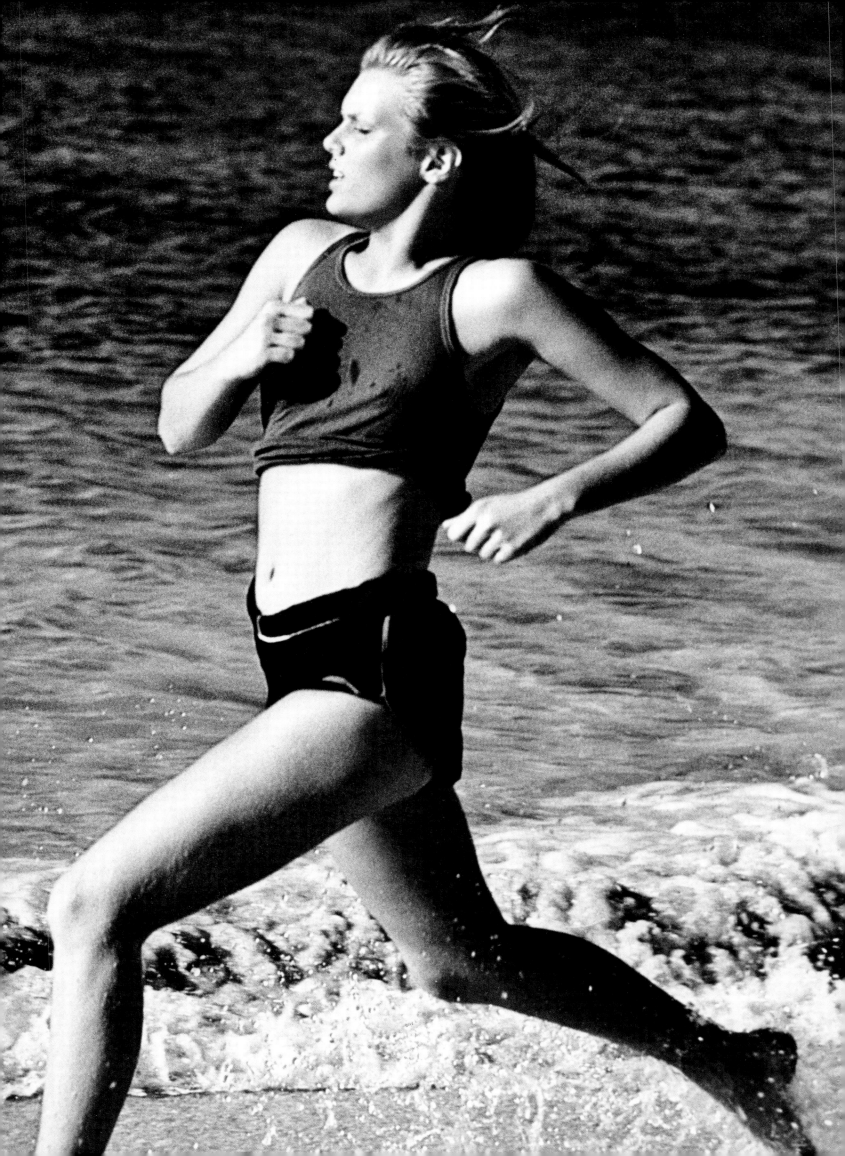

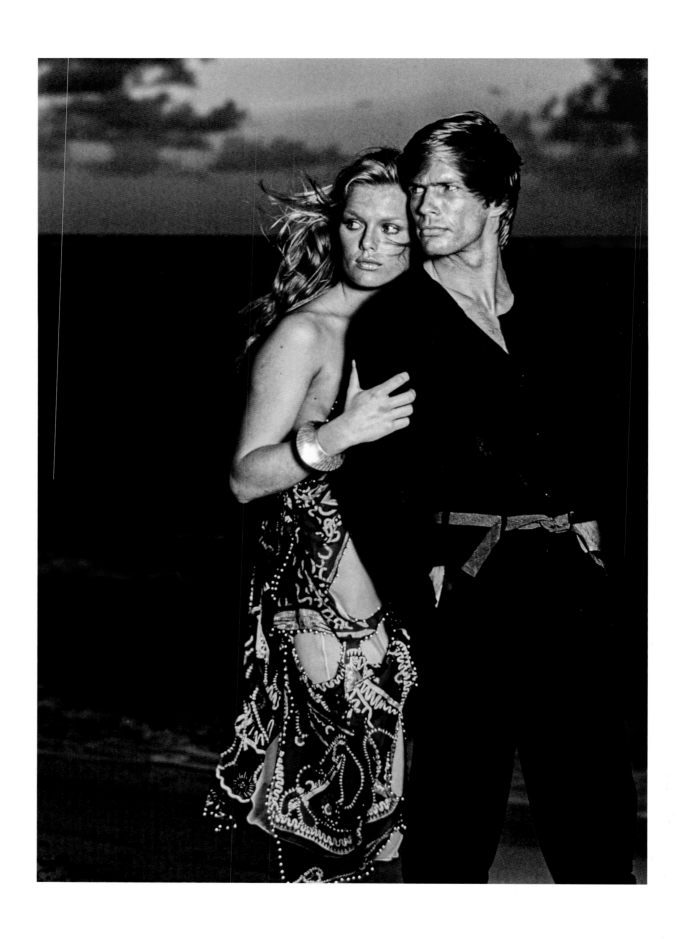

ABOVE AND OPPOSITE
Hansen with Pat Andersen.
Francesco Scavullo, *Vogue,* April 1978.

168

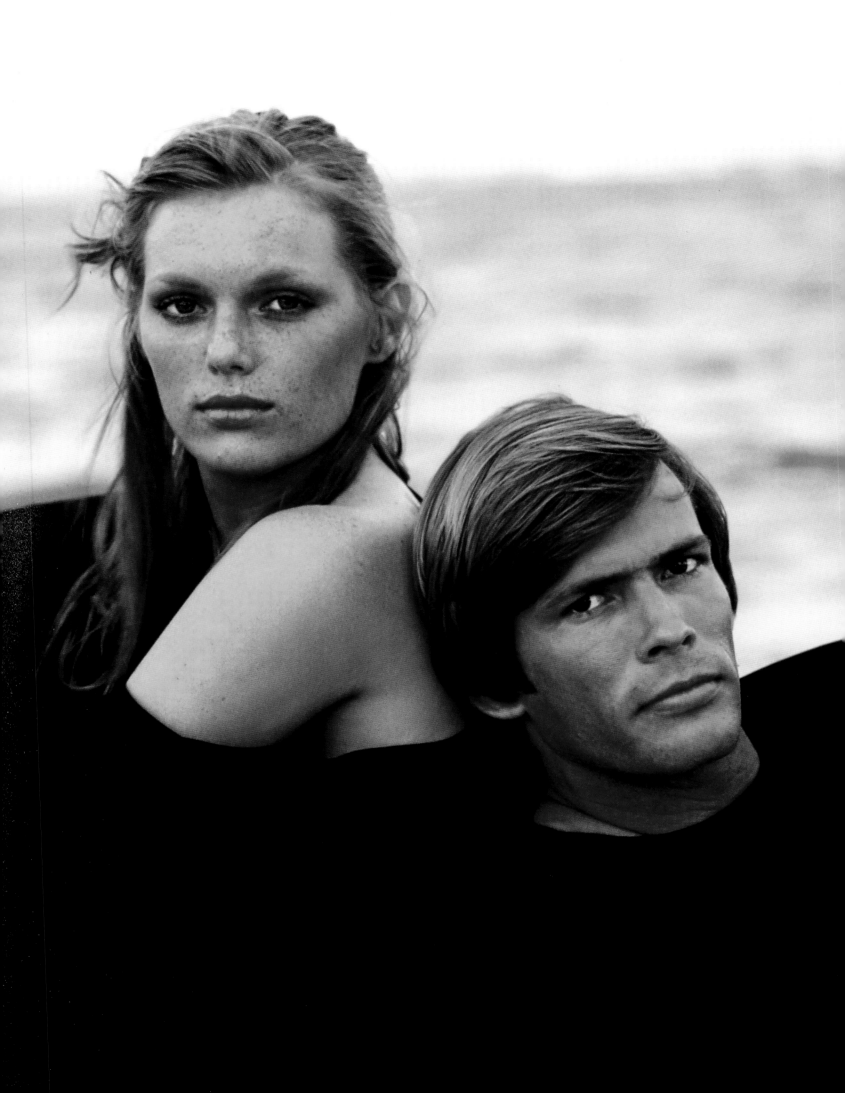

Mike Reinhardt, *Vogue,* May 1979.

Mike Reinhardt, *Vogue,* May 1979.

Hansen with Gia Carangi.
Mike Reinhardt, *Vogue,* May 1979.

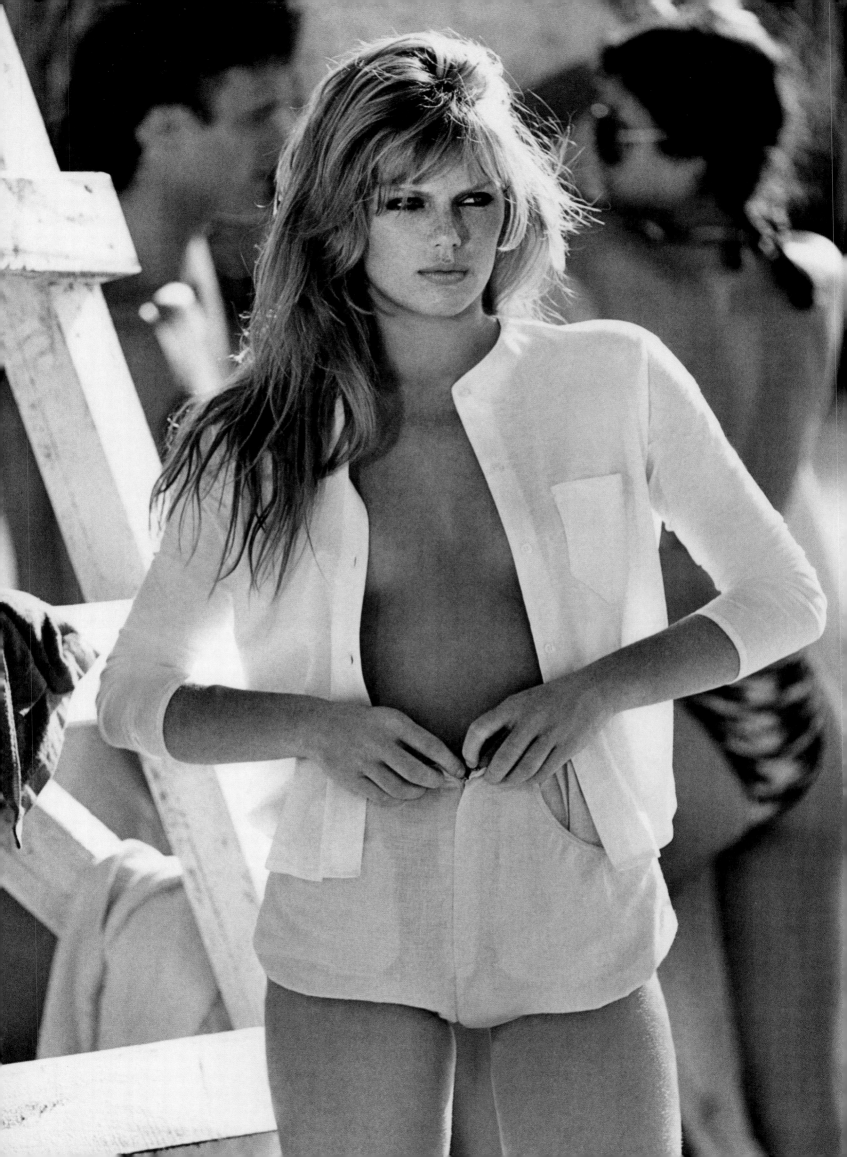

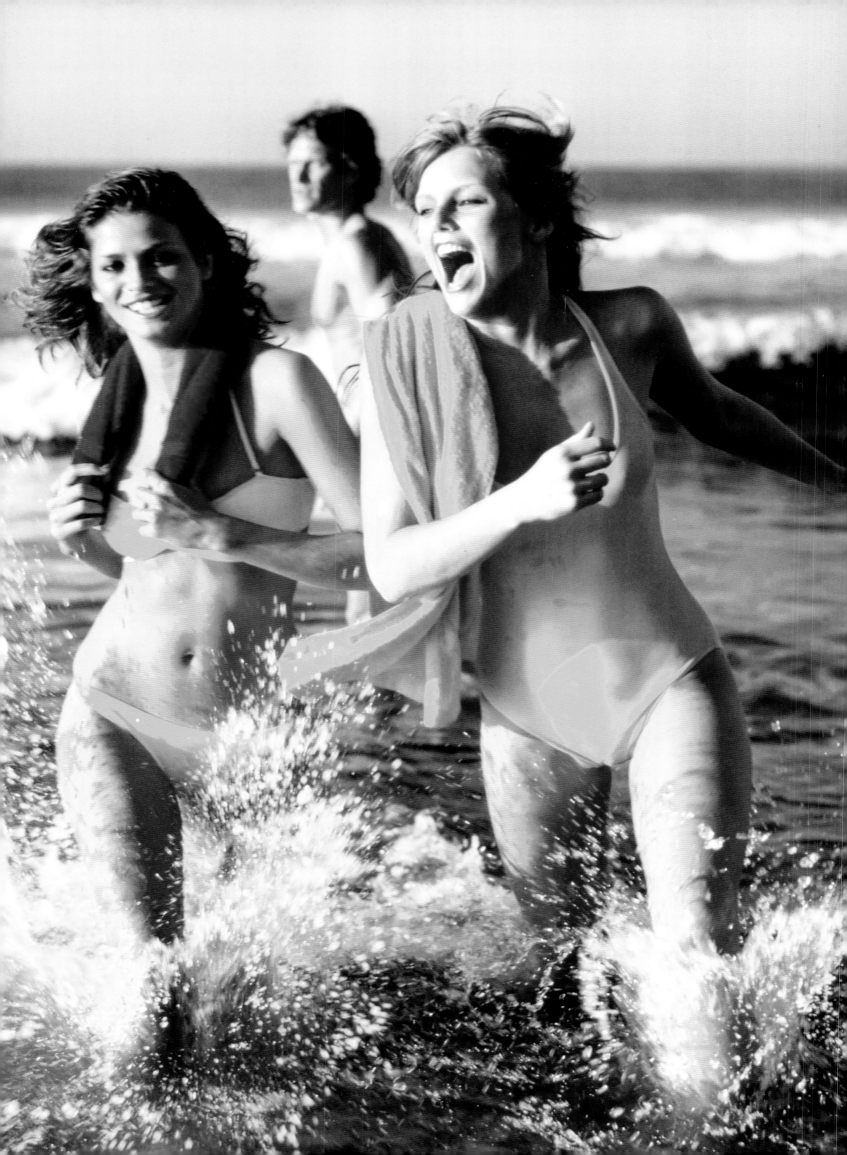

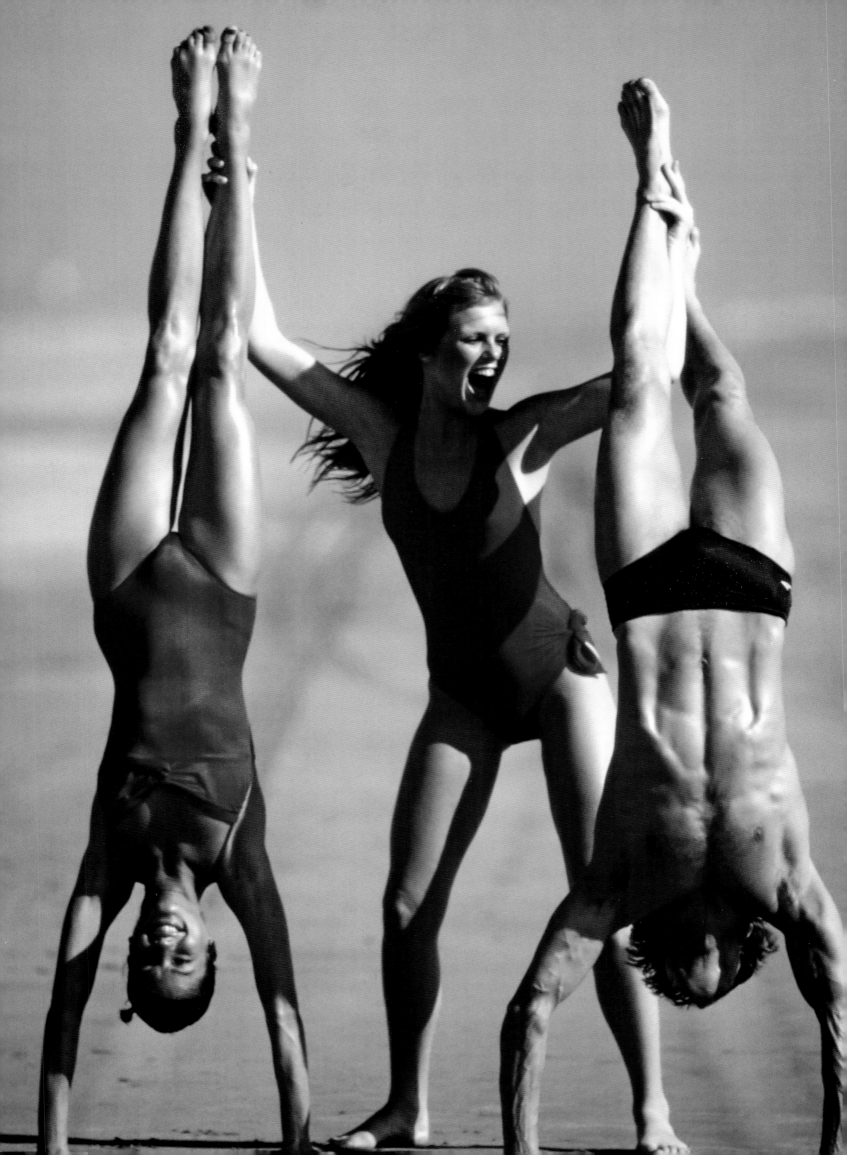

Albert Watson,
Vogue, May 1978.

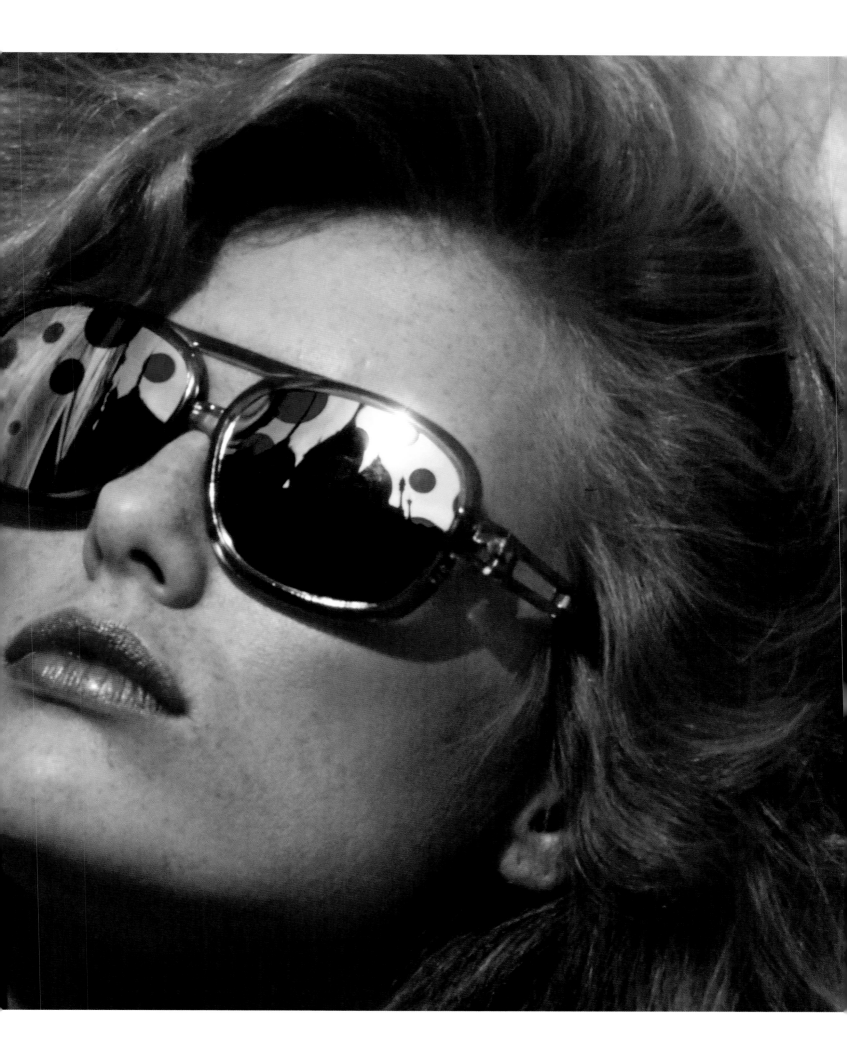

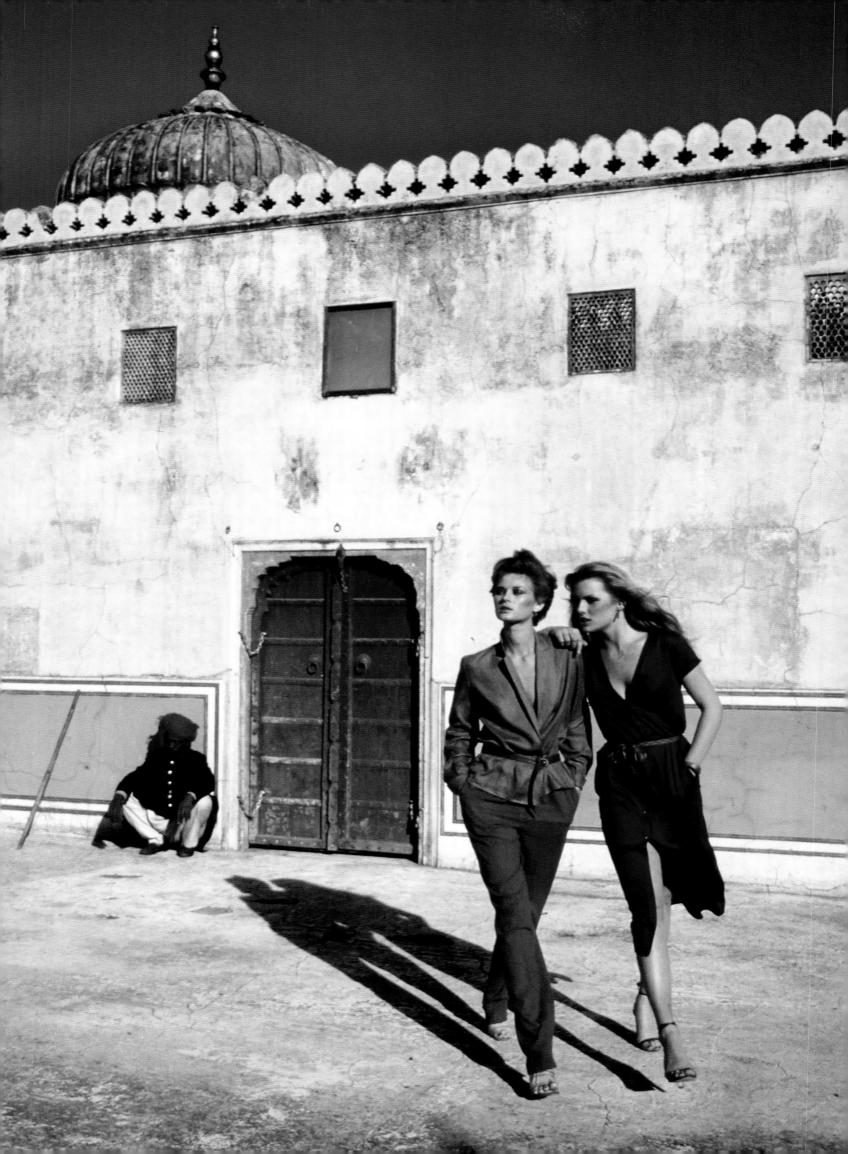

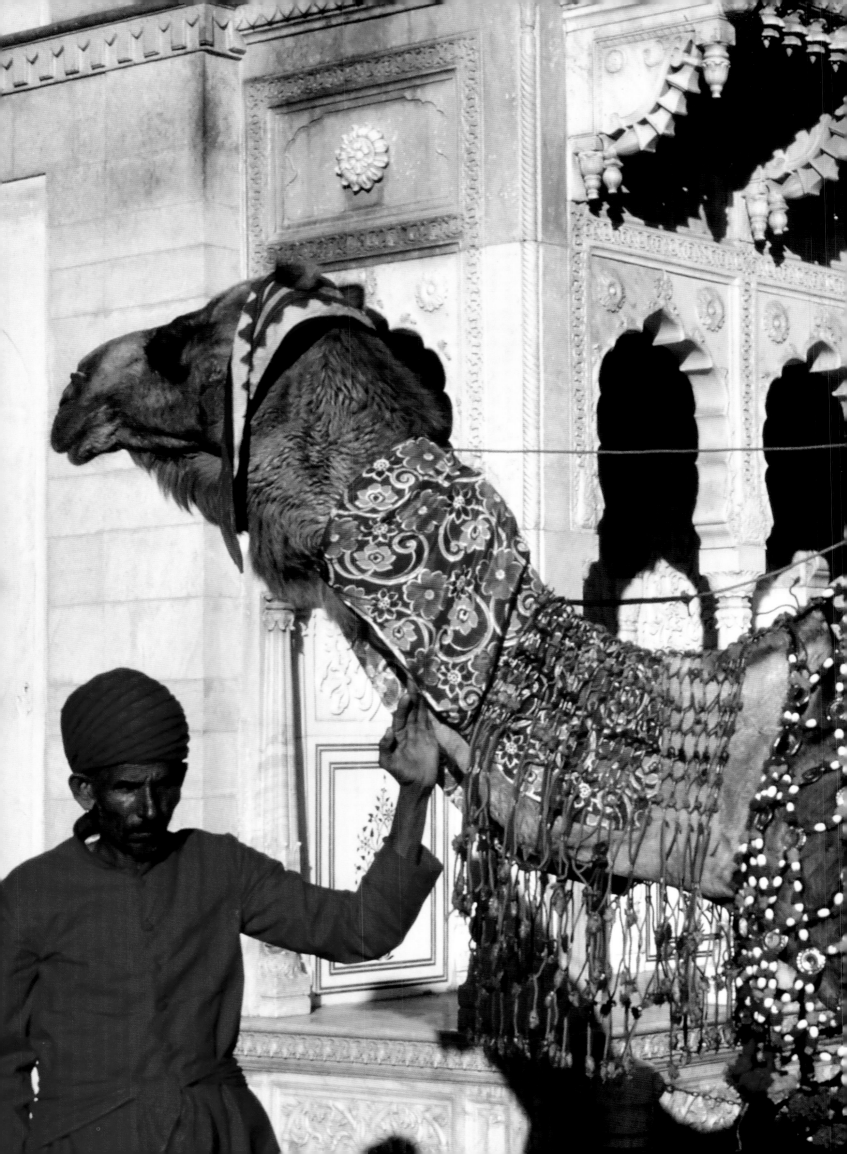

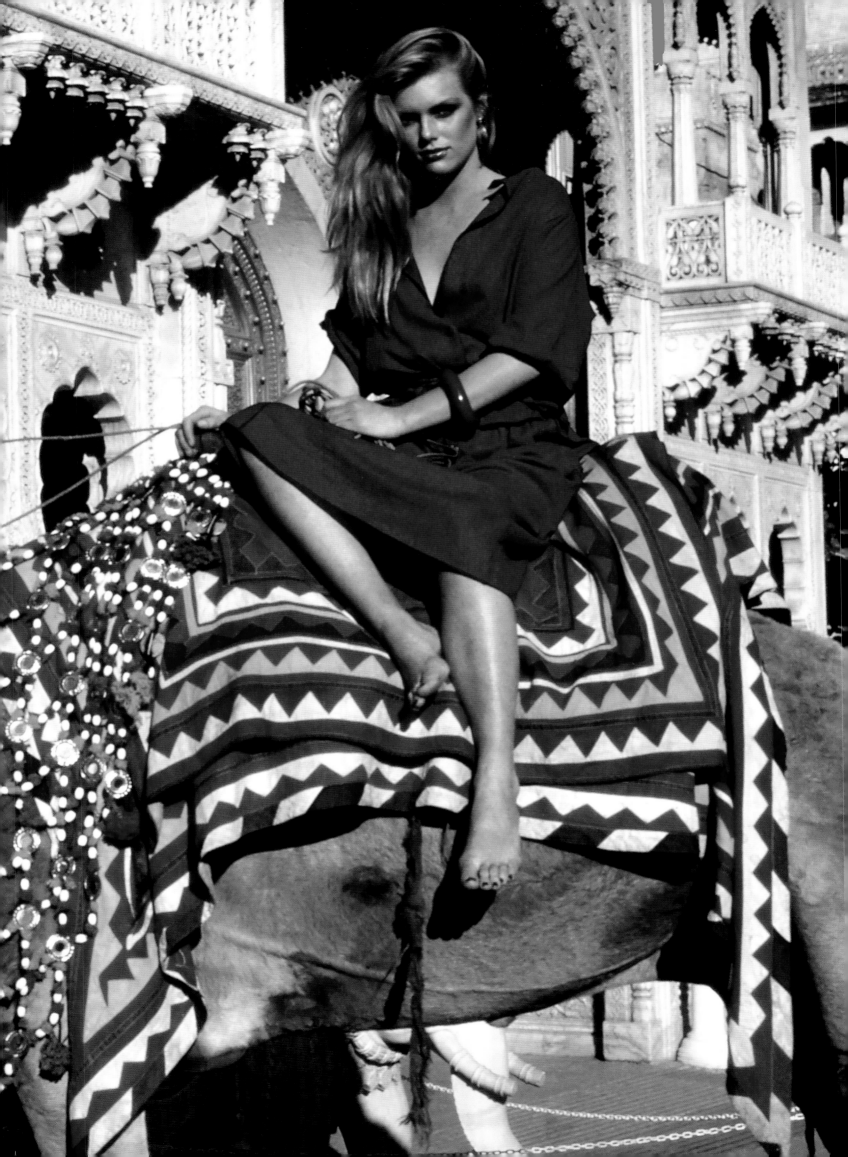

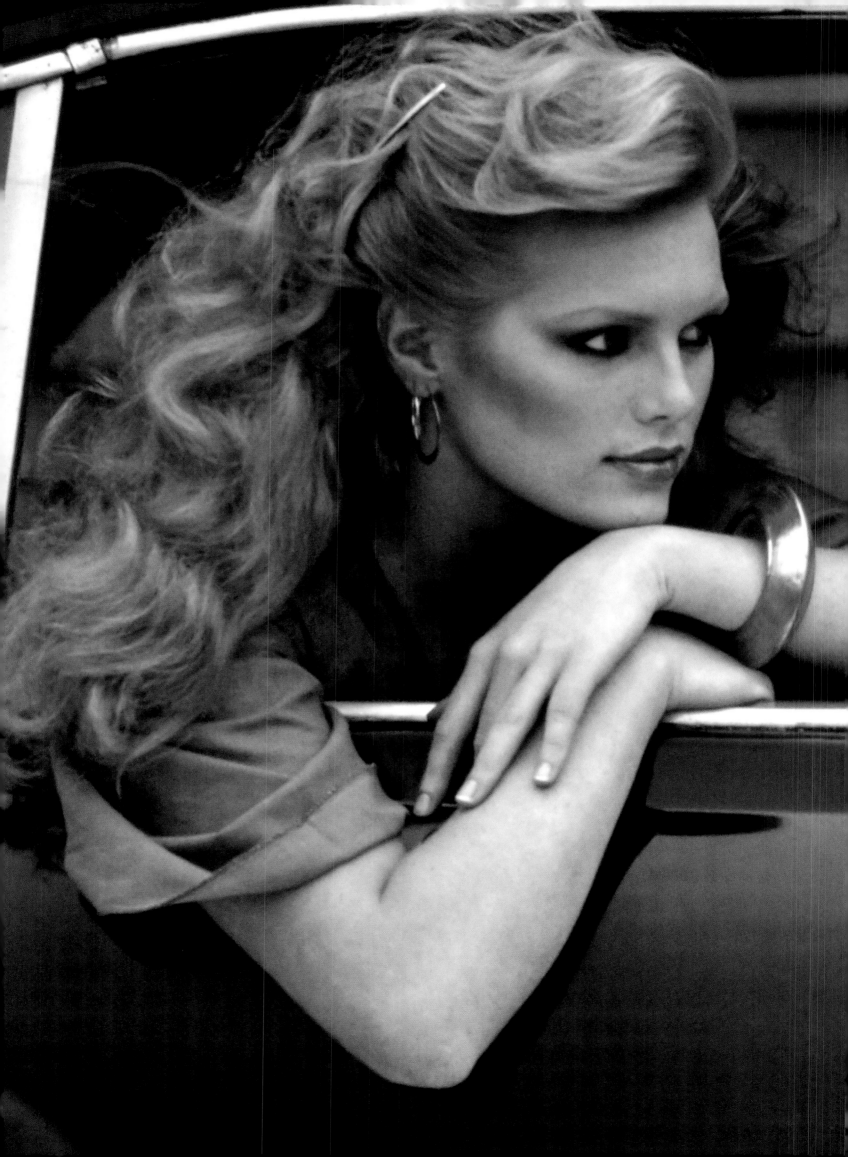

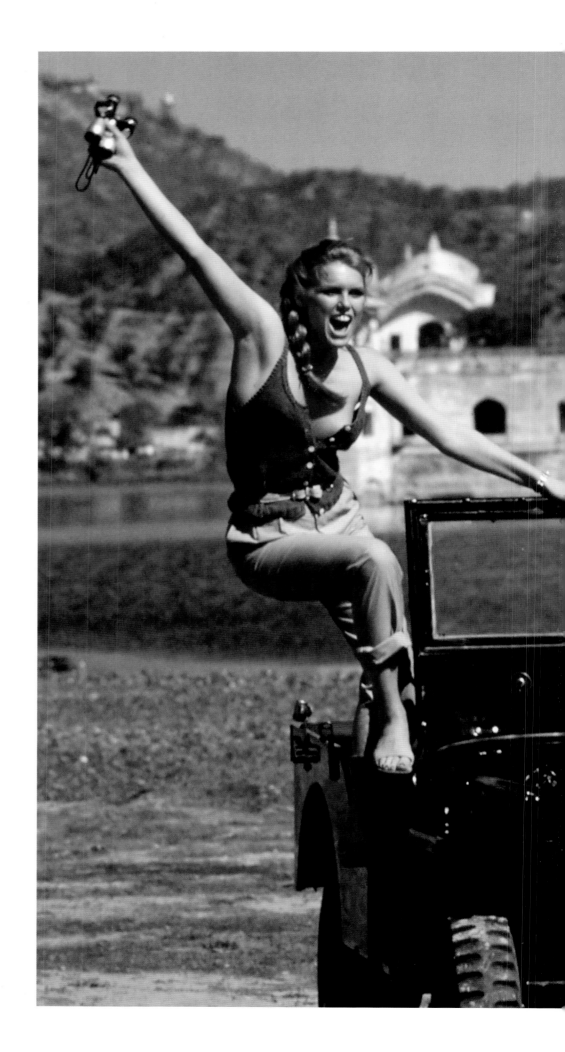

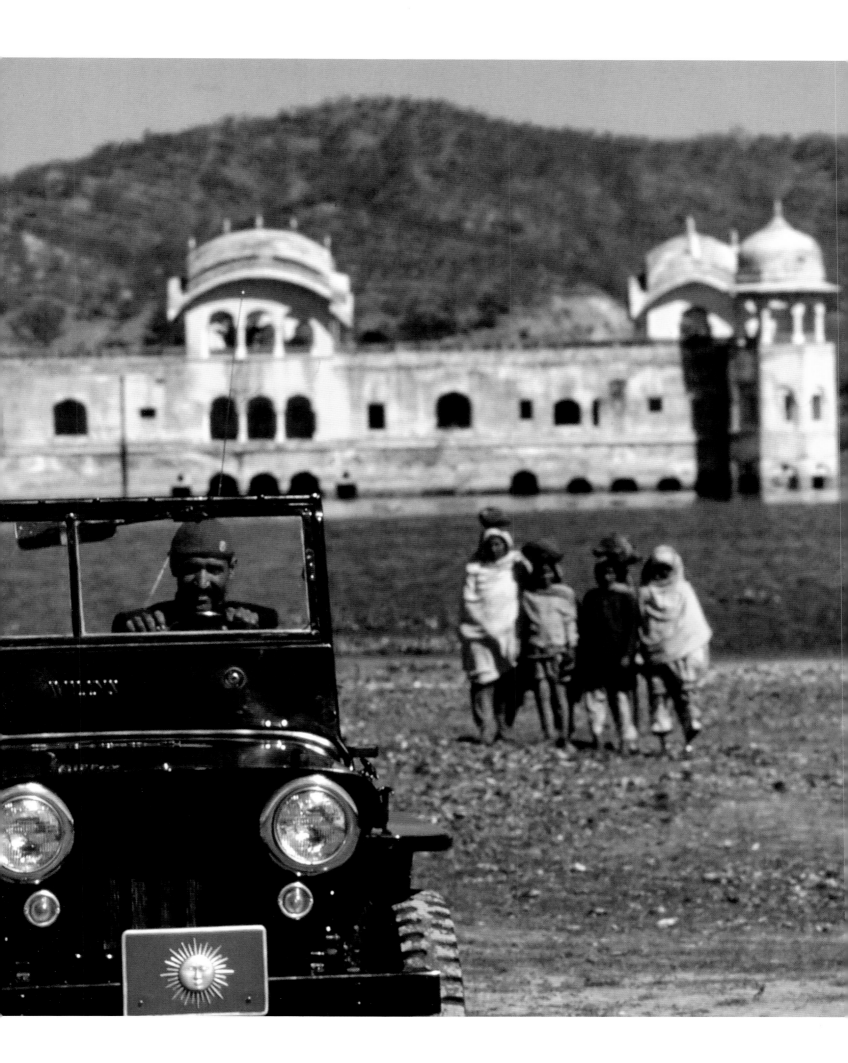

OPPOSITE
Arthur Elgort, *Vogue,* December 1979.

FOLLOWING PAGES
Hansen with Calvin Klein in Tokyo.
Mikoto Arai, September 1979.

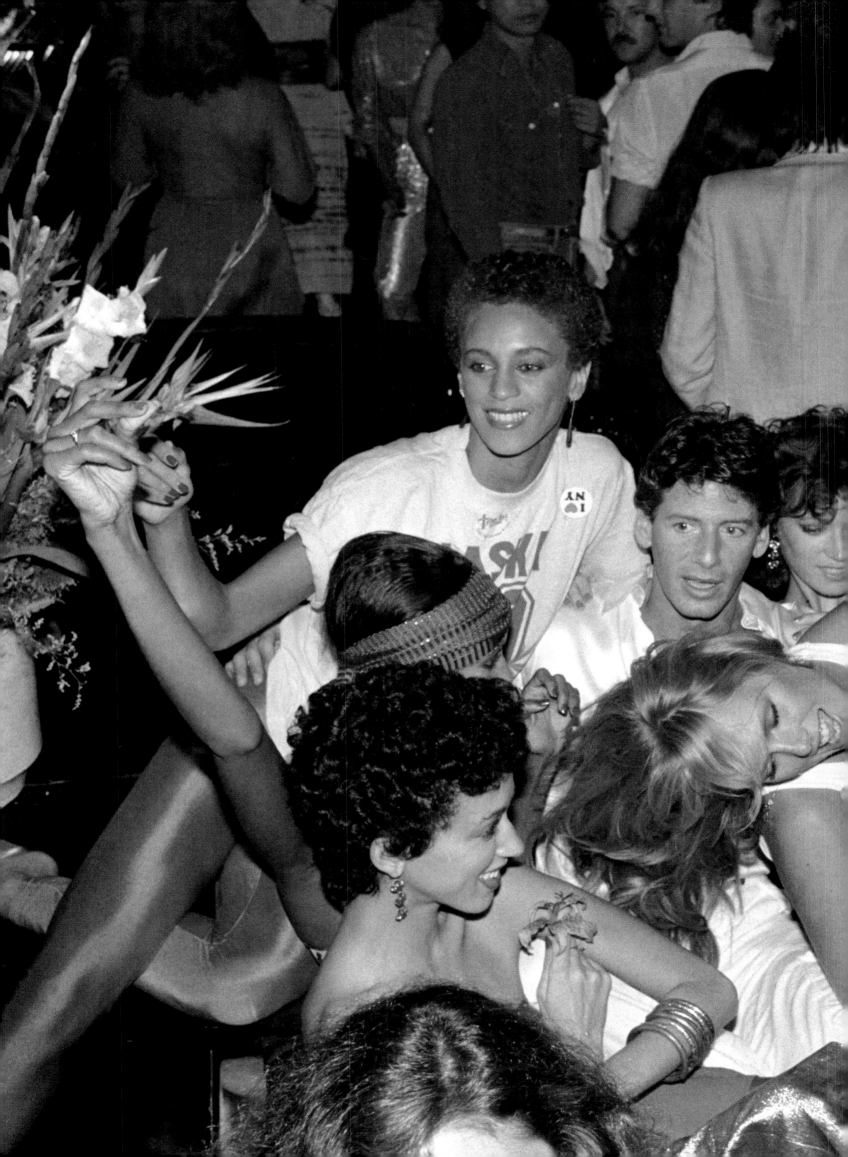

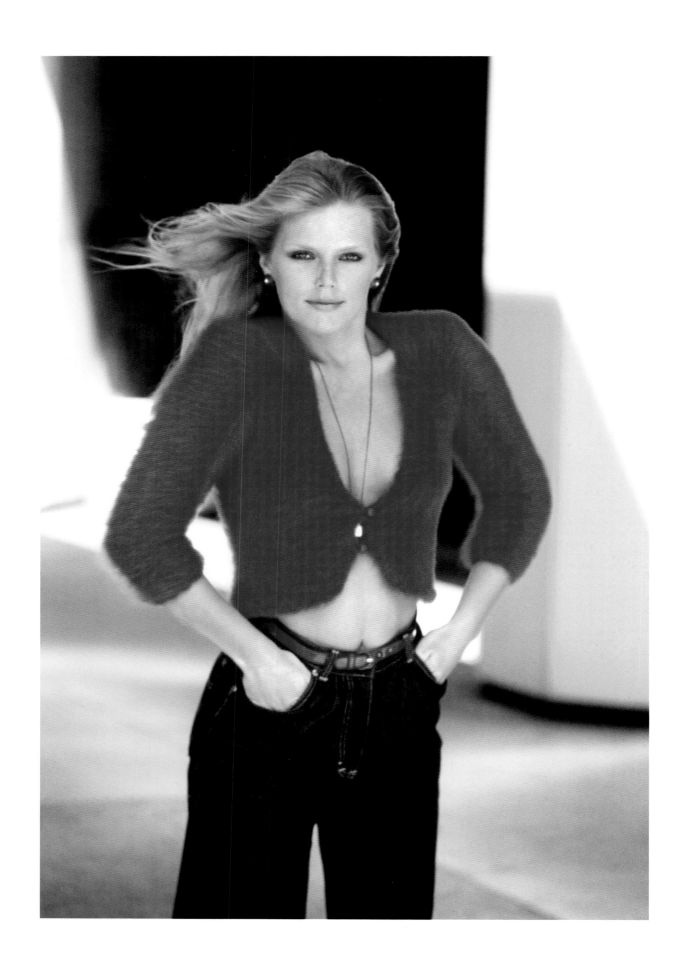

ABOVE AND OPPOSITE
Arthur Elgort, *Vogue,* December 1979

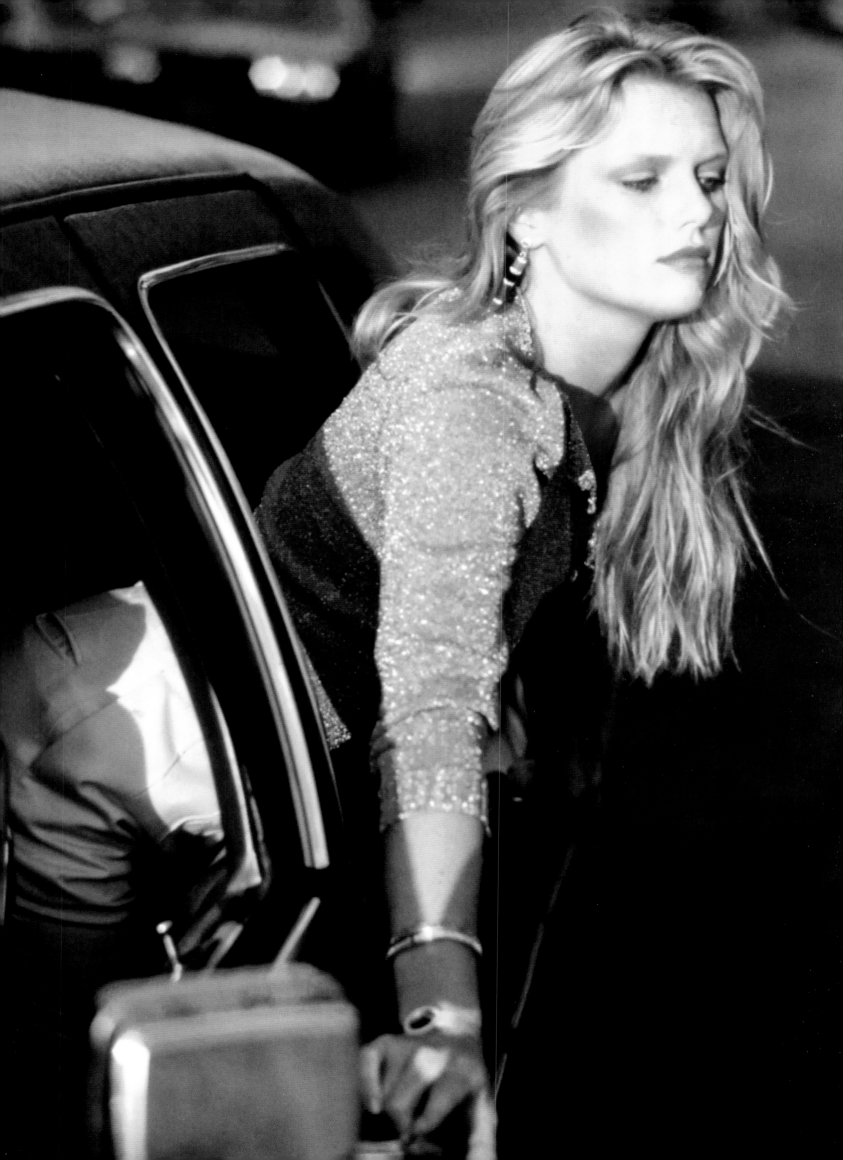

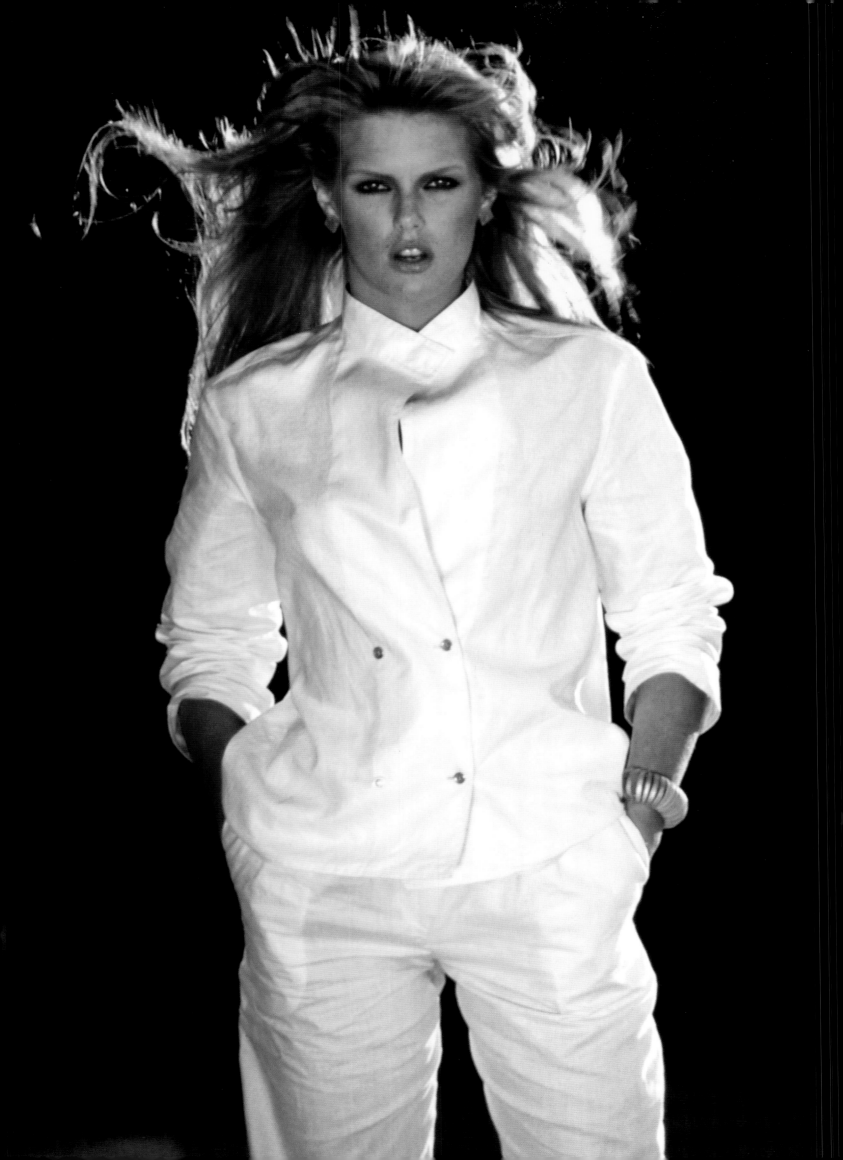

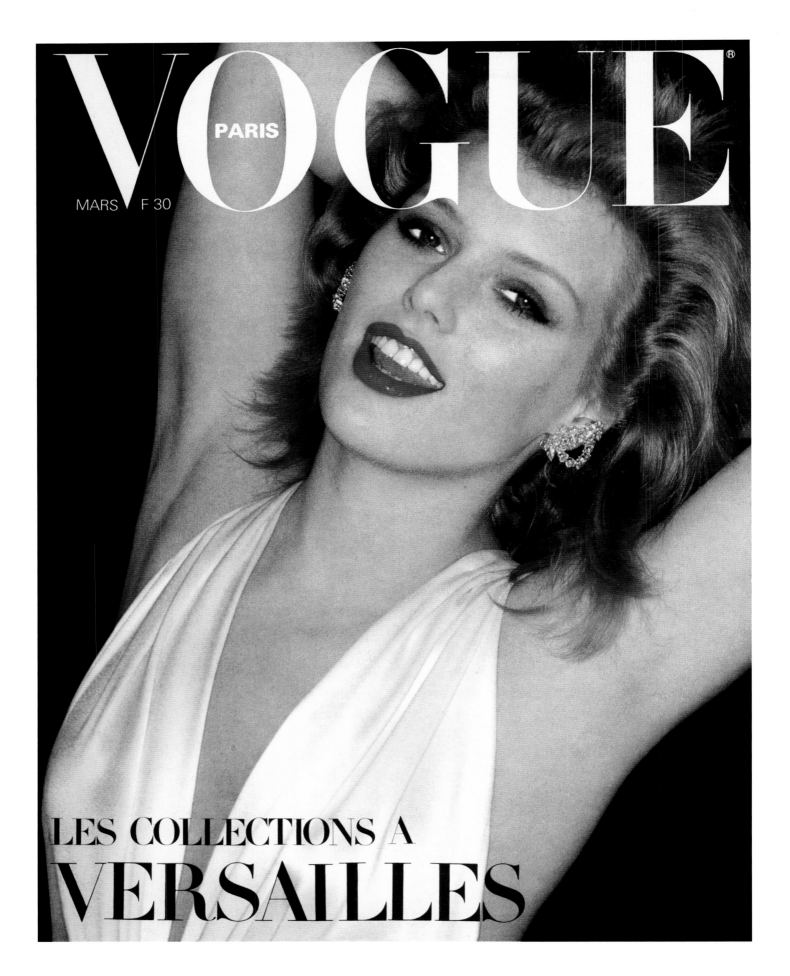

VOGUE
PARIS

MARS F 30

LES COLLECTIONS A
VERSAILLES

ABOVE
Helmut Newton, French *Vogue,* March 1980.
OPPOSITE
Helmut Newton, French *Vogue,* October 1977.

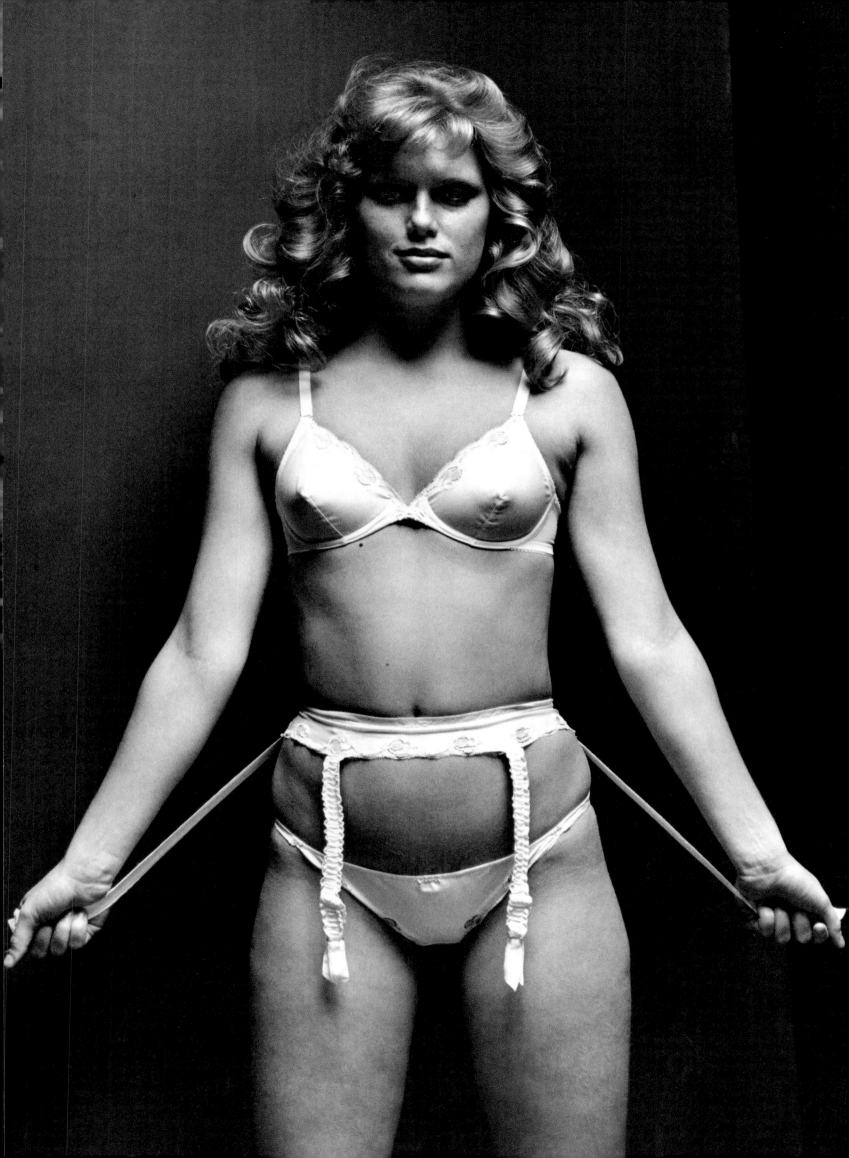

Chris von Wangenheim, *Vogue,* April 1979.

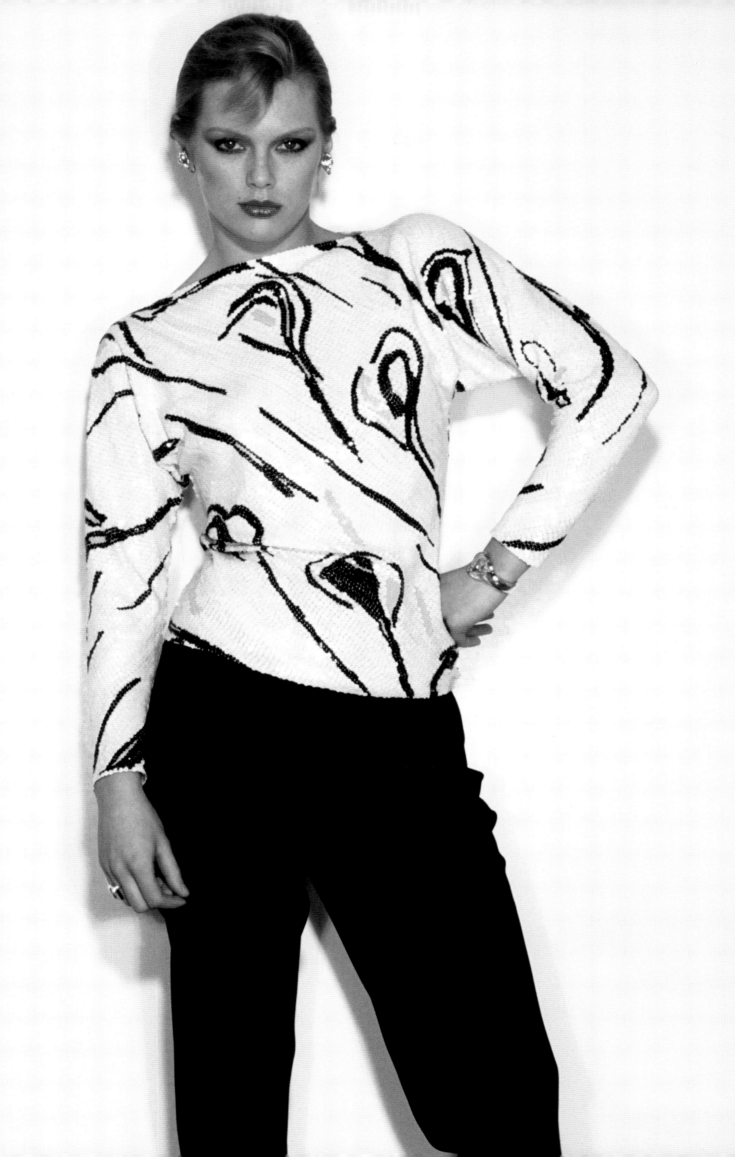

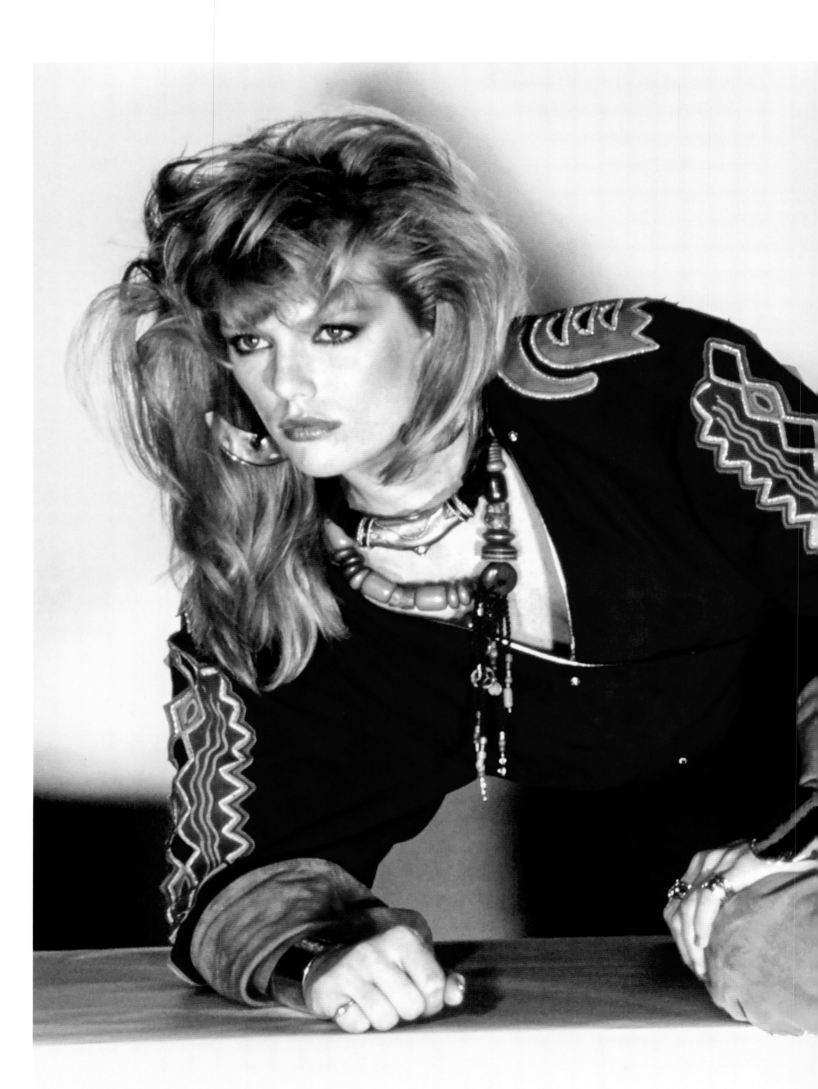

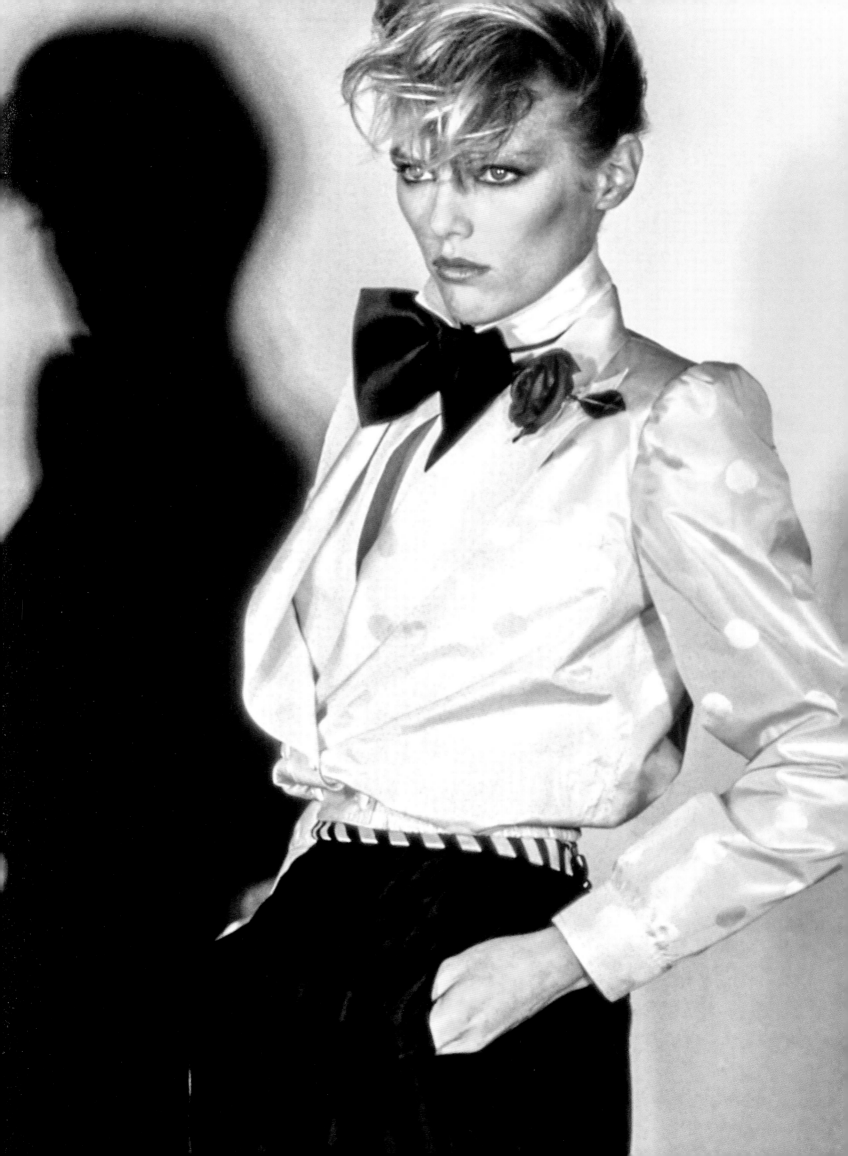

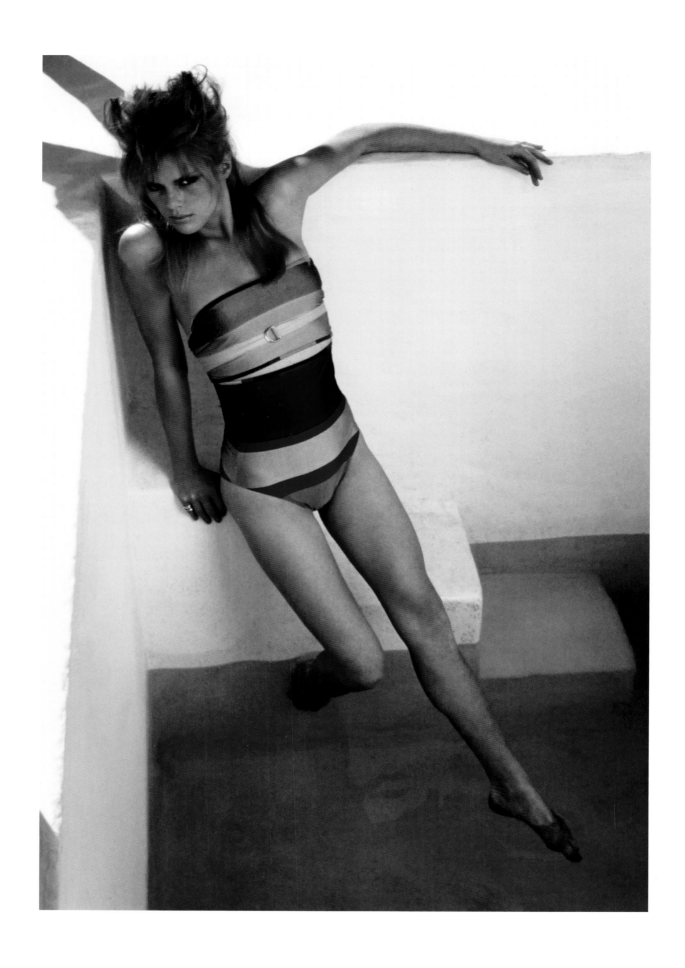

THESE PAGES AND FOLLOWING PAGES
Chris von Wangenheim, *Vogue*, April 1981.

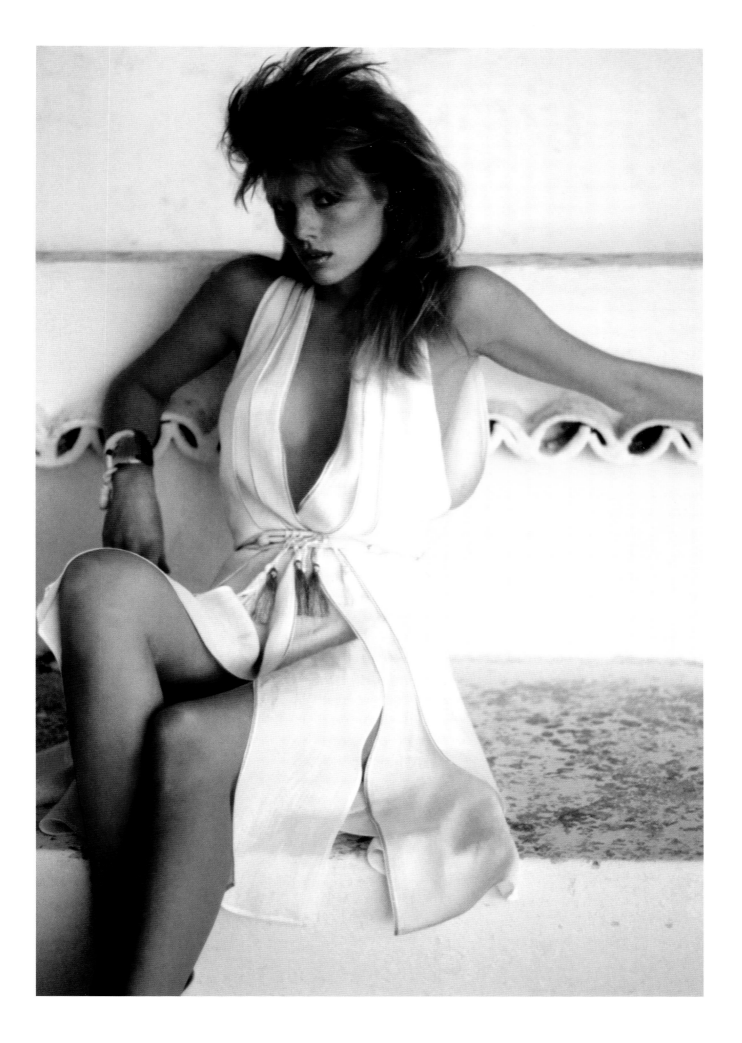

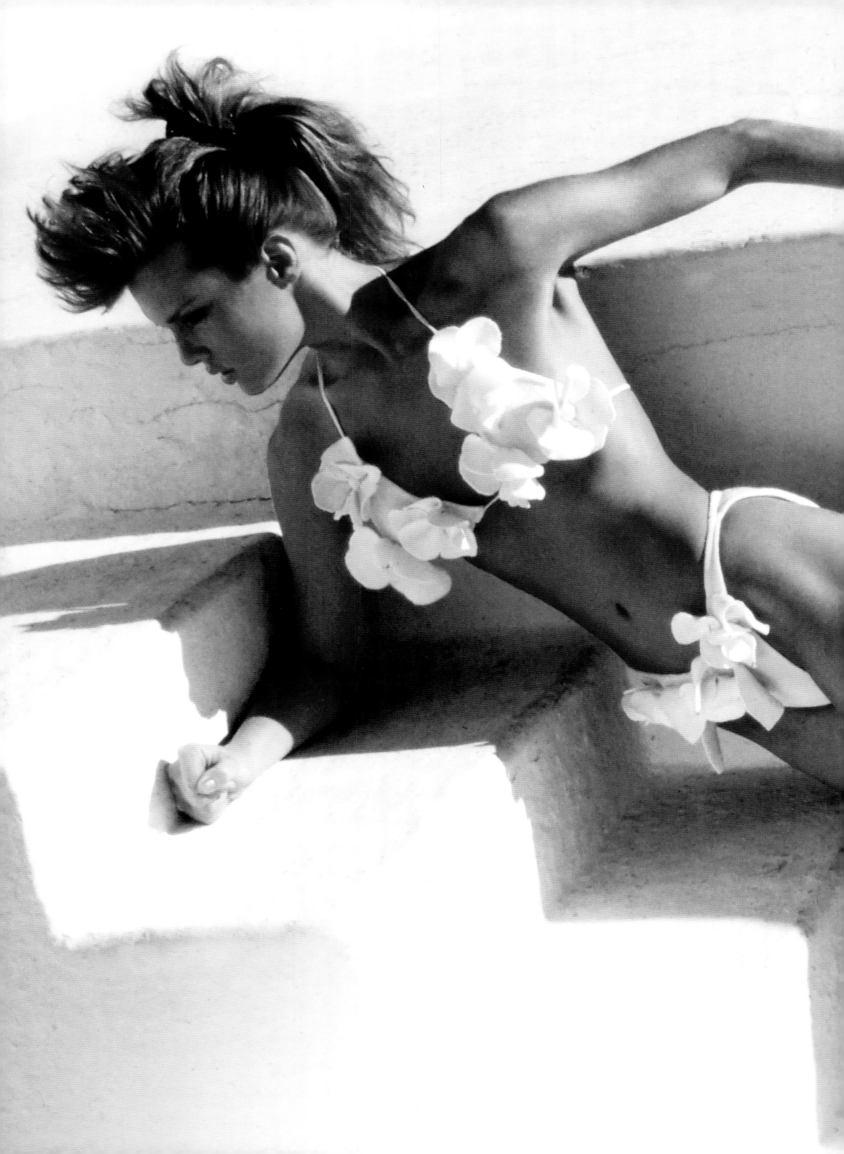

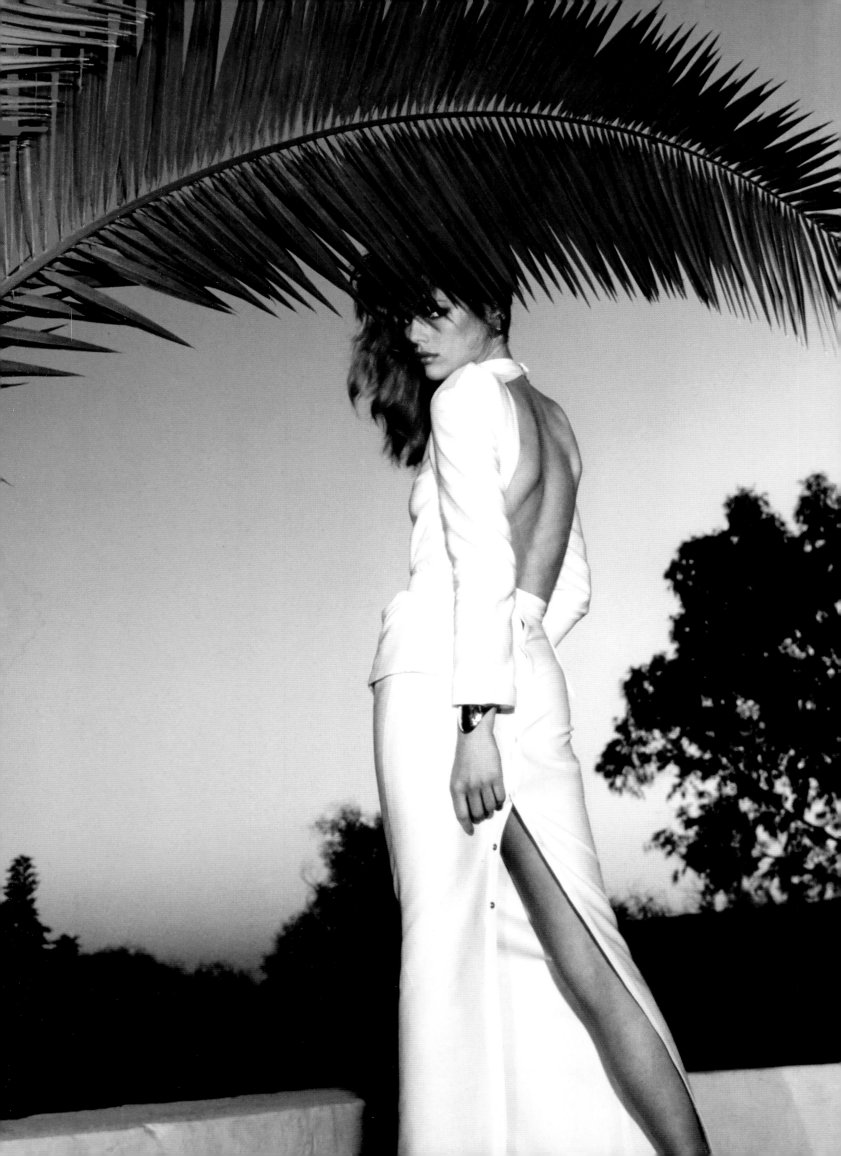

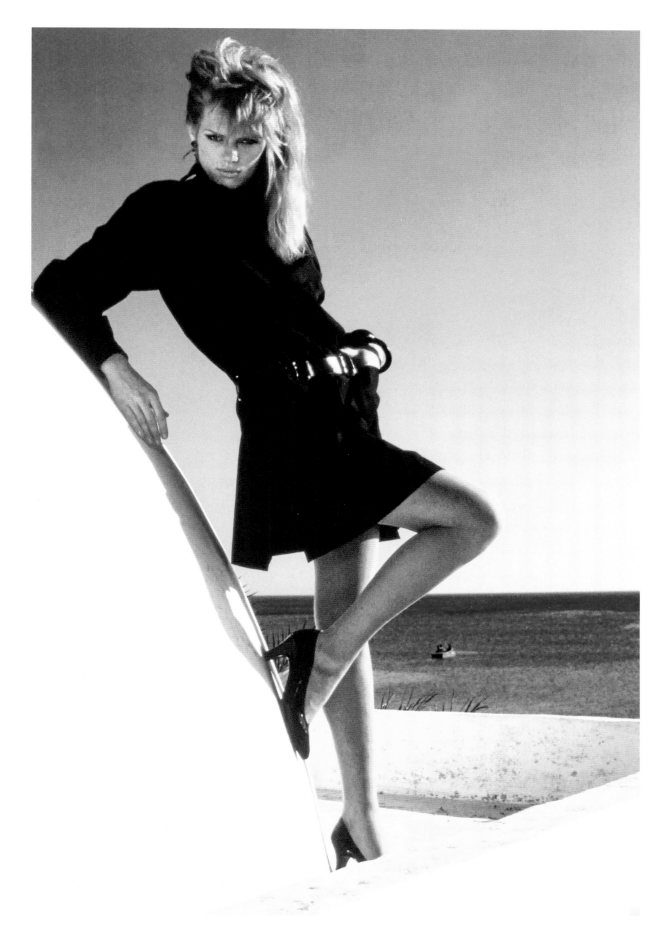

Chris von Wangenheim, *Vogue*, April 1981.

Keith Richards and Hansen on their
wedding day, Cabo San Lucas, Mexico,
Ken Regan, December 1983.

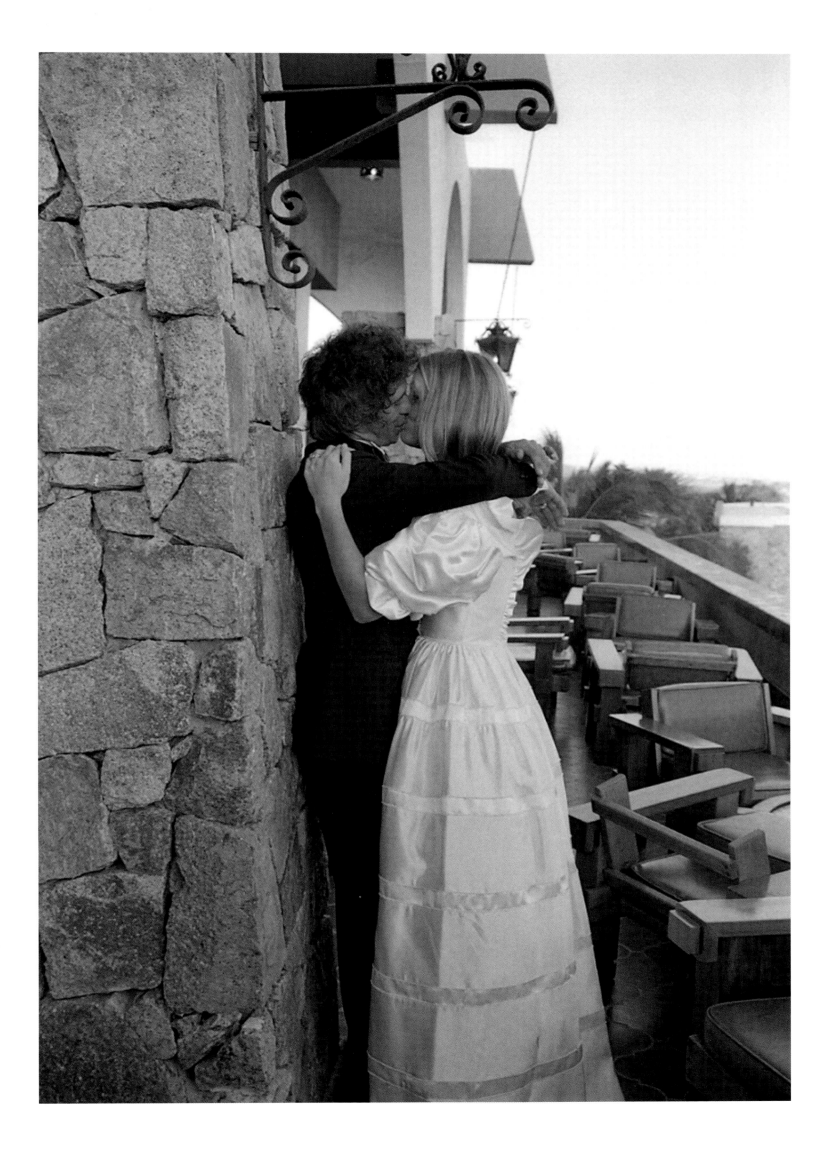

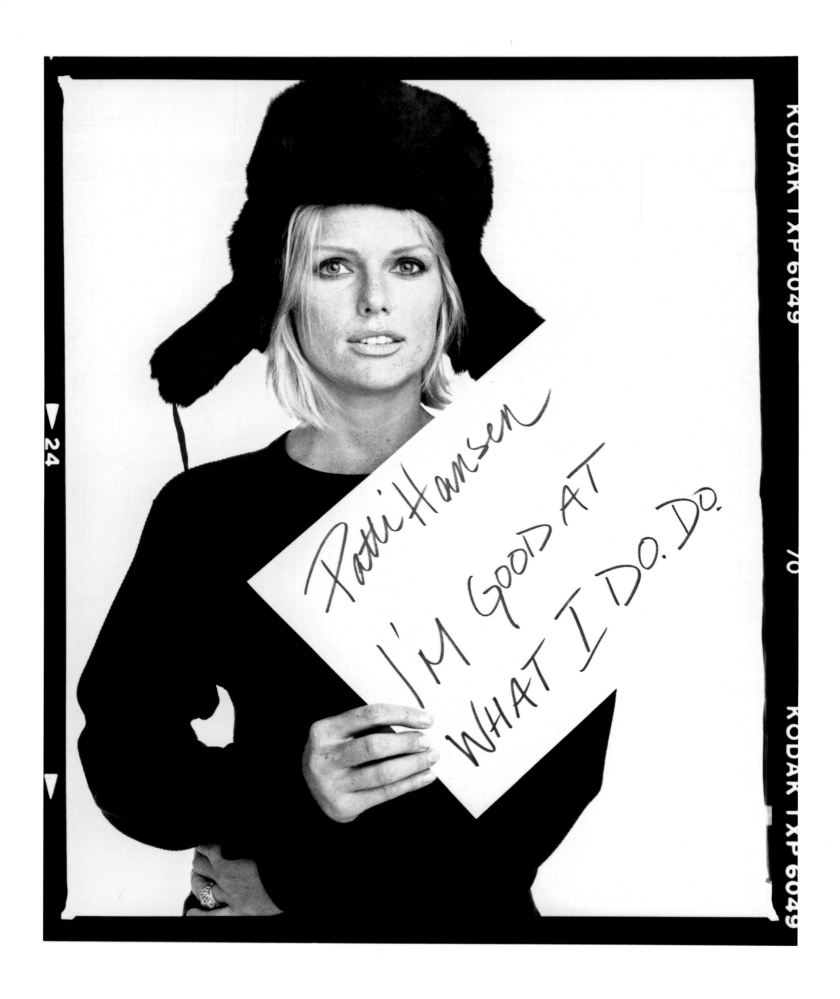

Steven Meisel, Italian *Vogue*, October 1992.

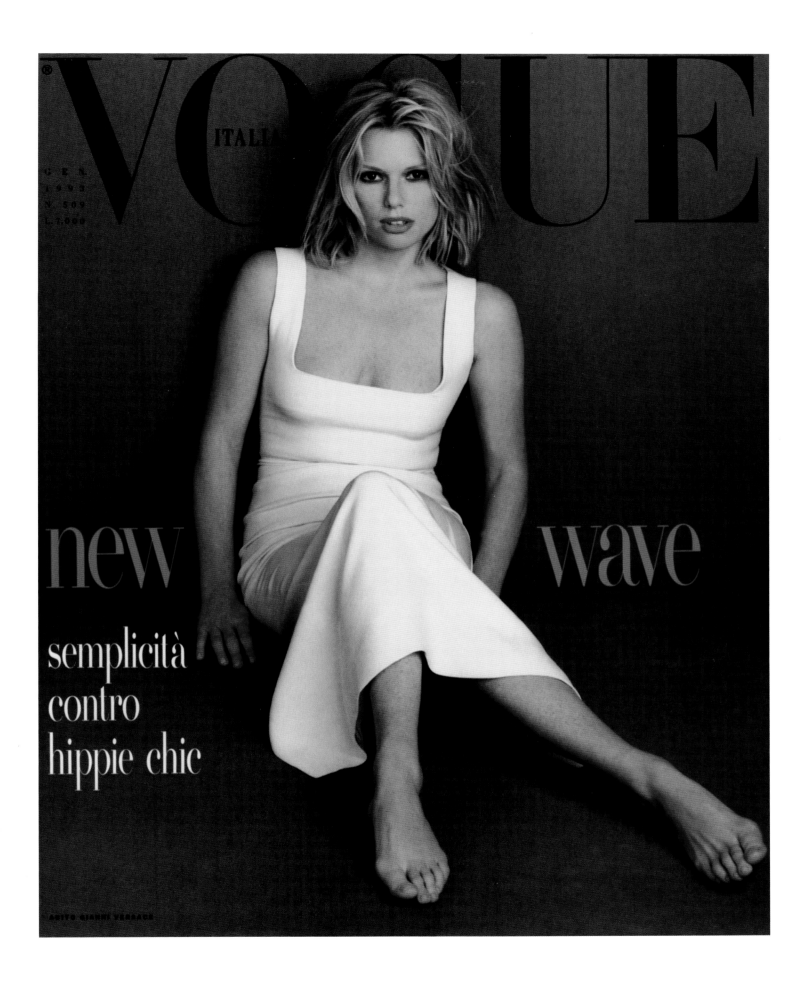

VOGUE ITALIA

new wave

semplicità
contro
hippie chic

Steven Meisel, Italian *Vogue*, January 1993.

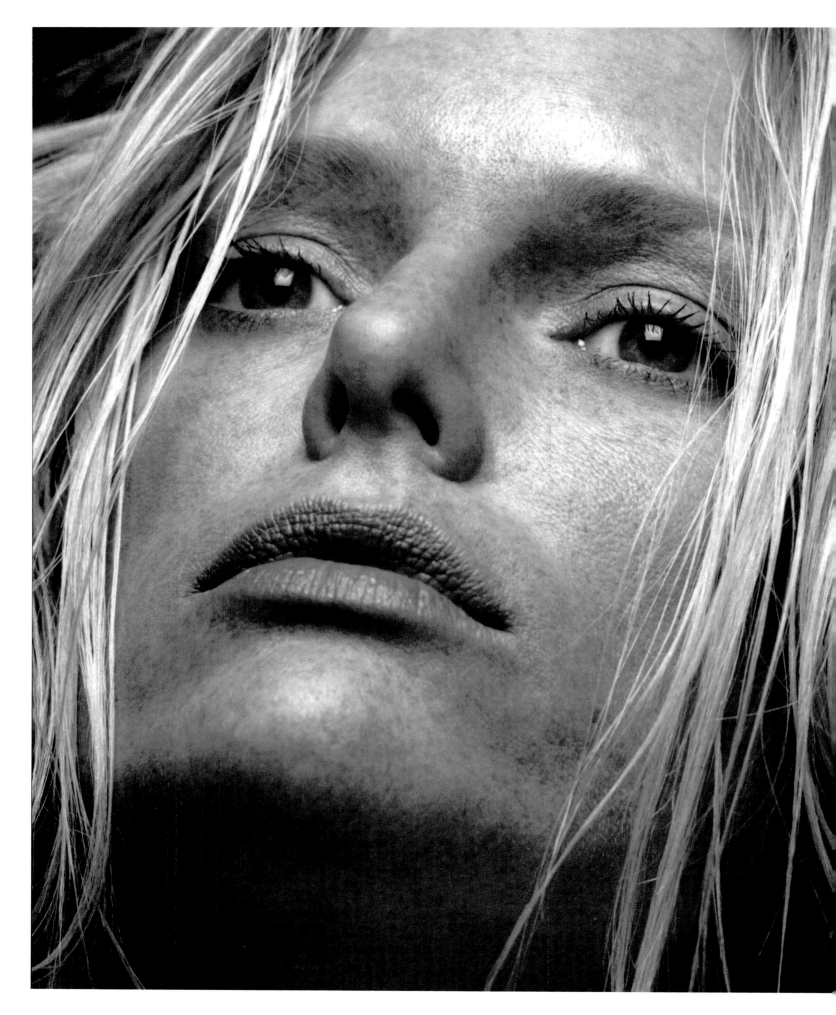

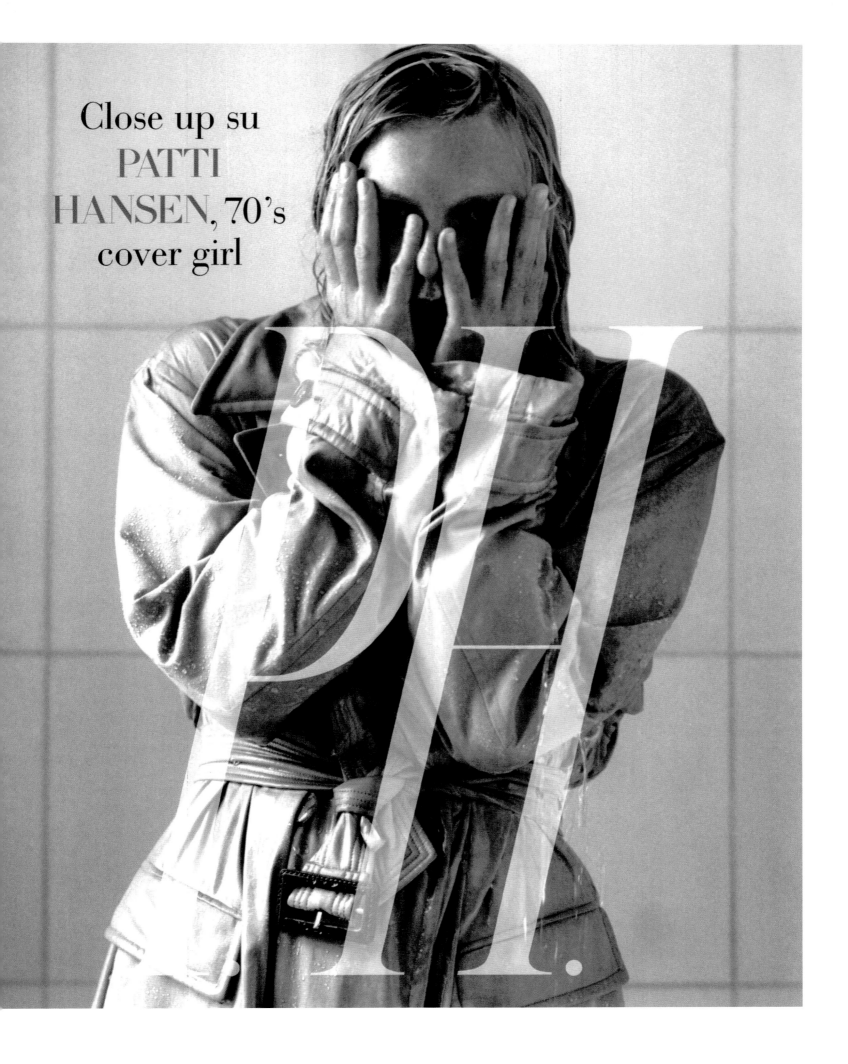

Close up su
PATTI
HANSEN, 70's
cover girl

Hansen with Richards.
Annie Leibovitz, *Vanity Fair,*
December 1992.

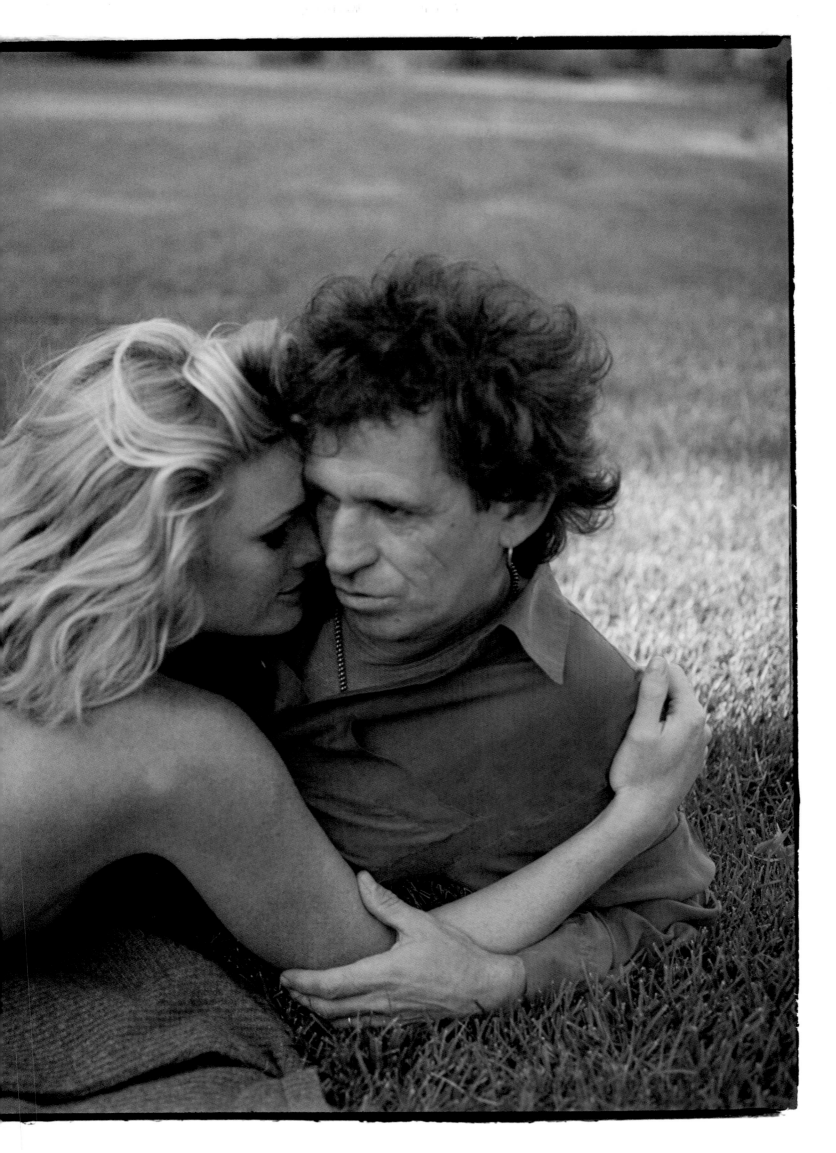

Nick Knight, British *Vogue,* December 1999.

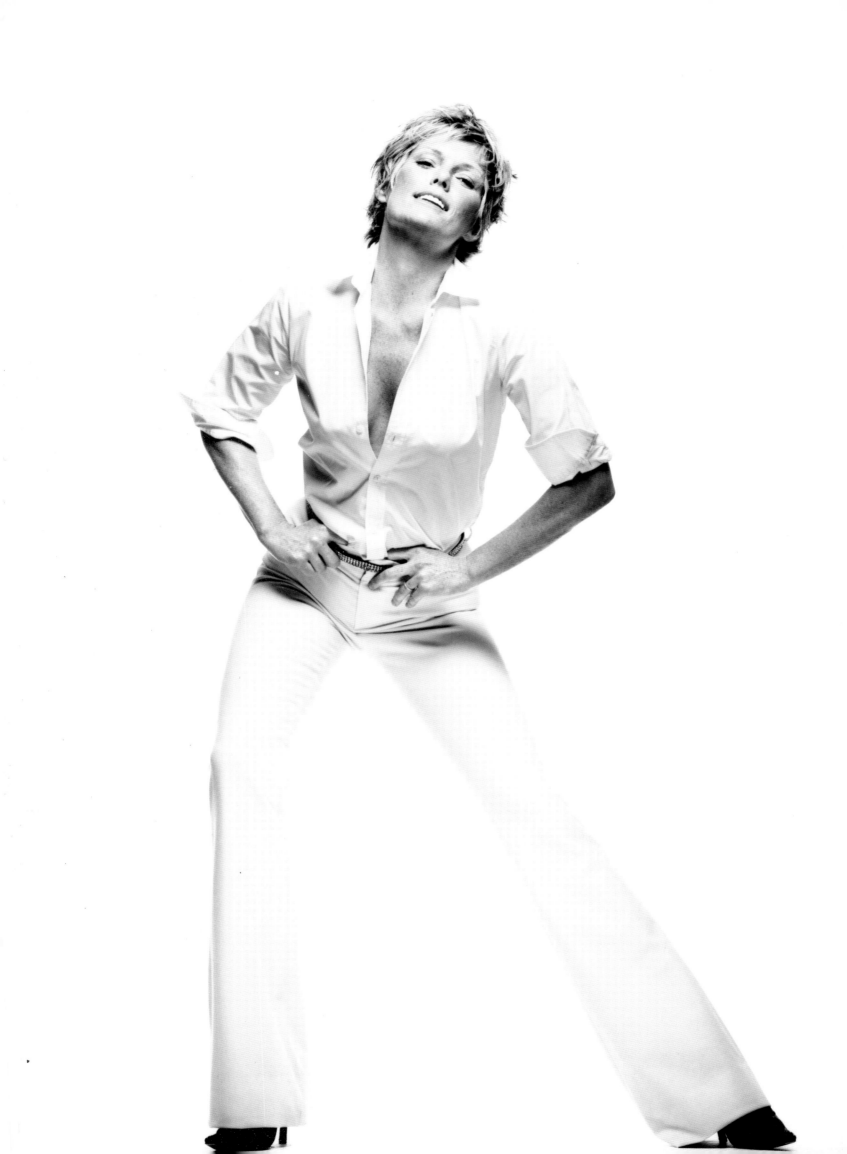

Hansen with daughters Theodora and Alexandra.
Pamela Hanson, *Glamour,* December 2002.

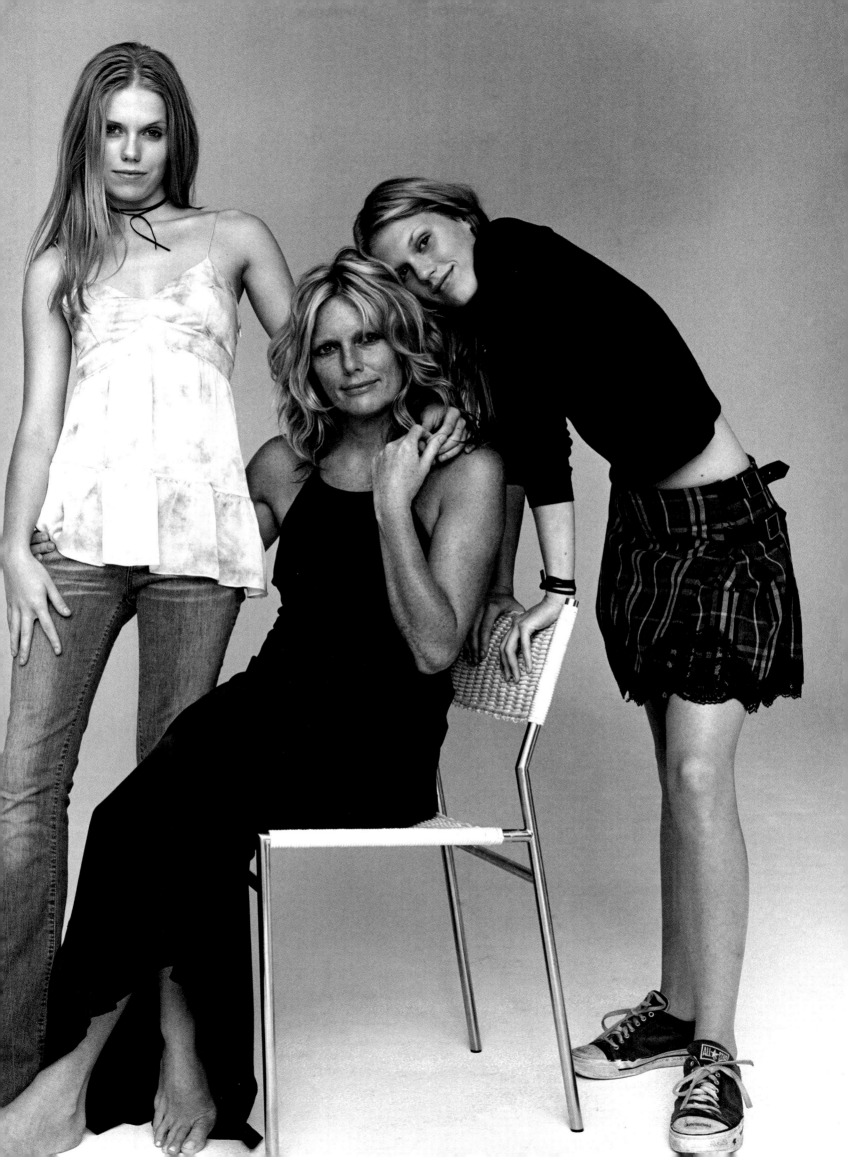

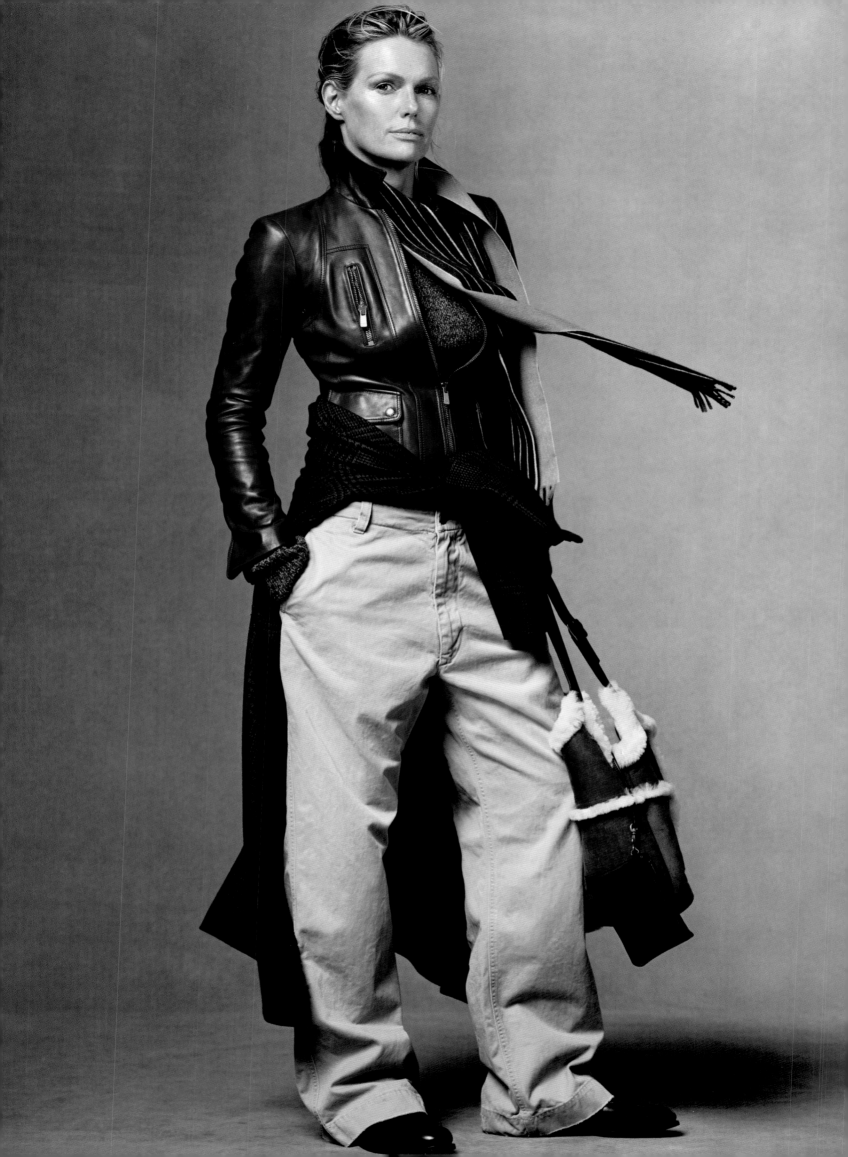

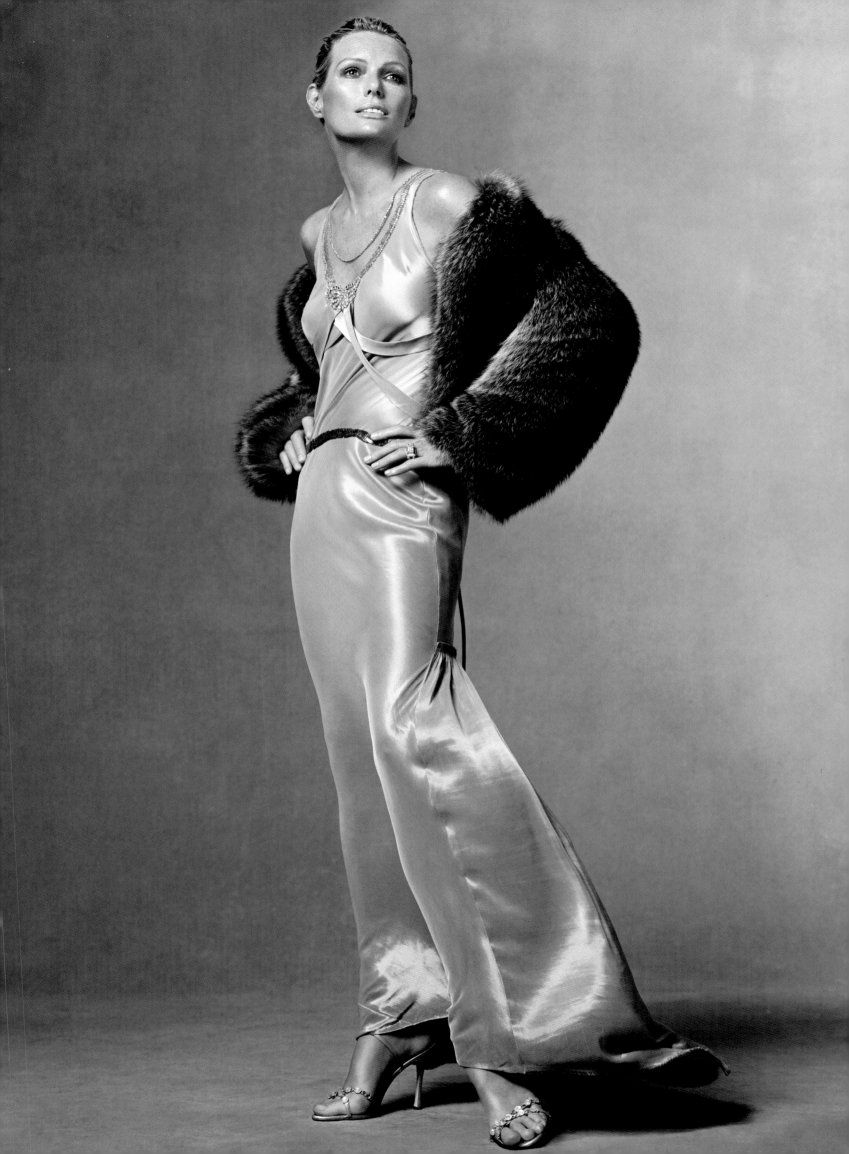

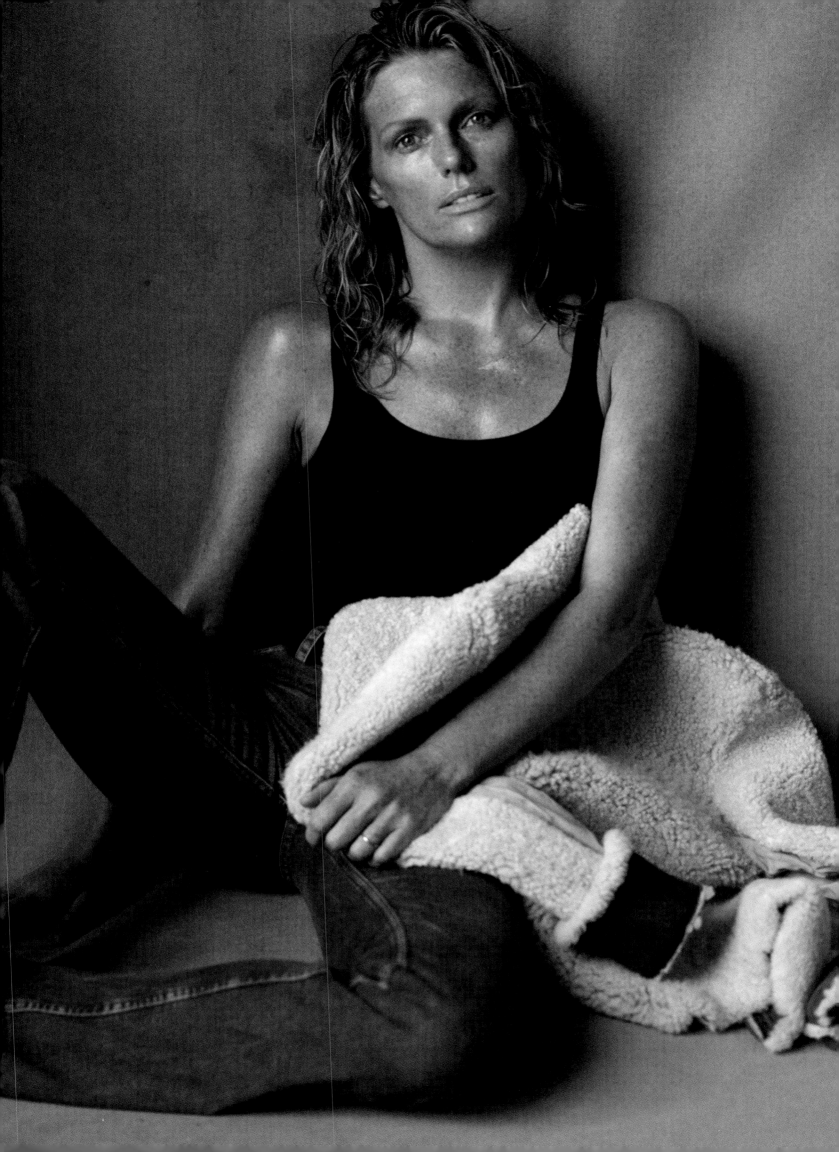

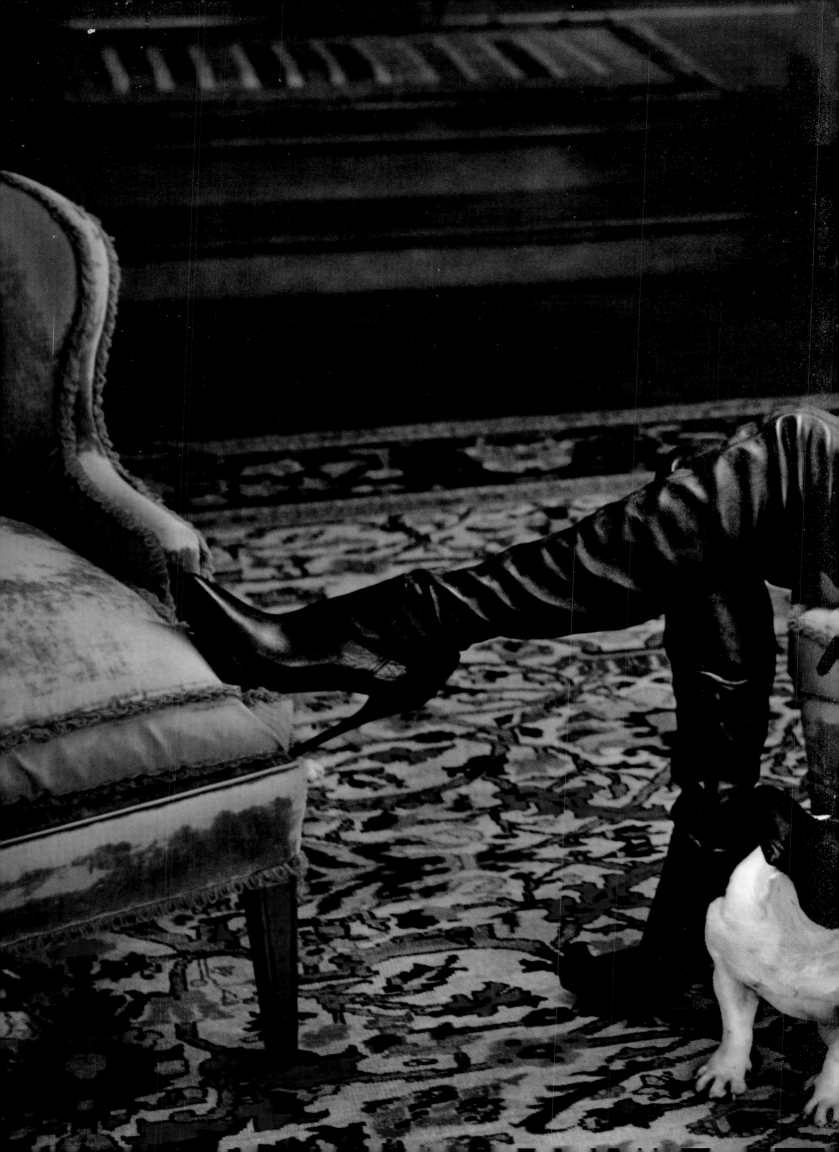

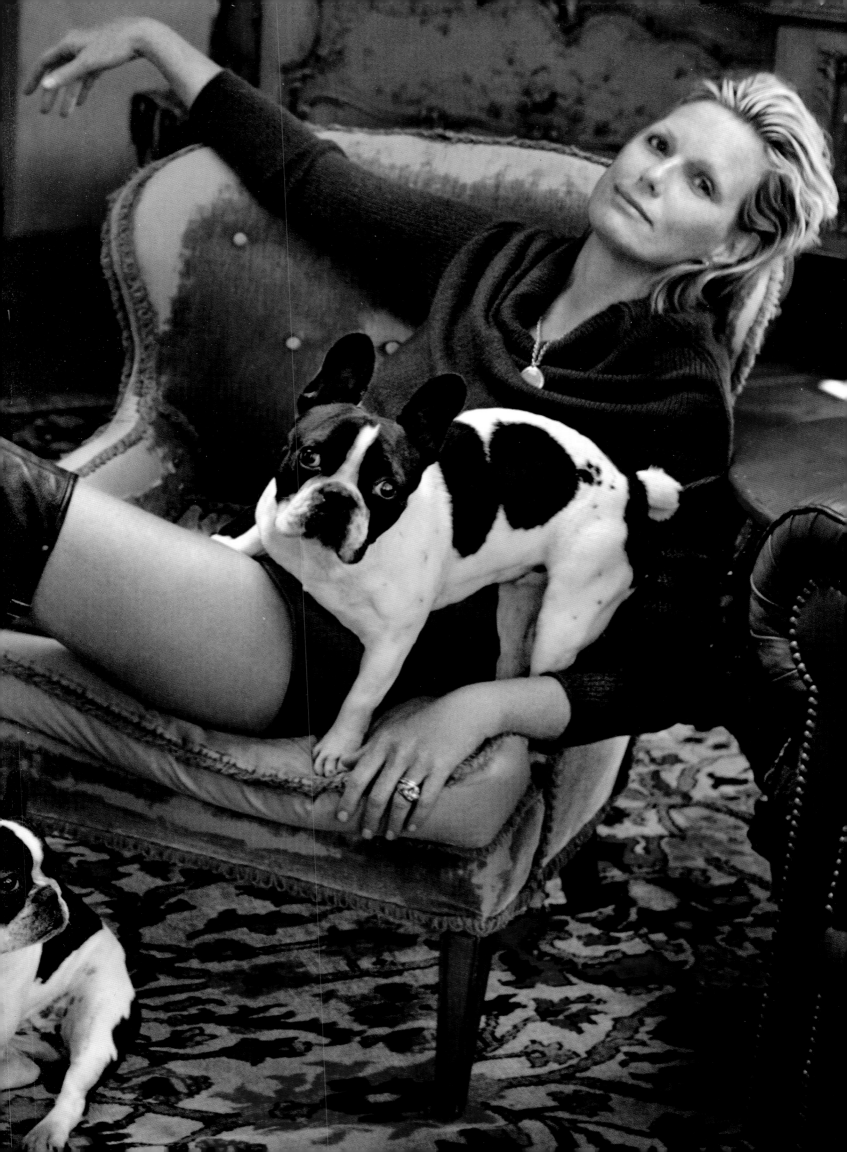

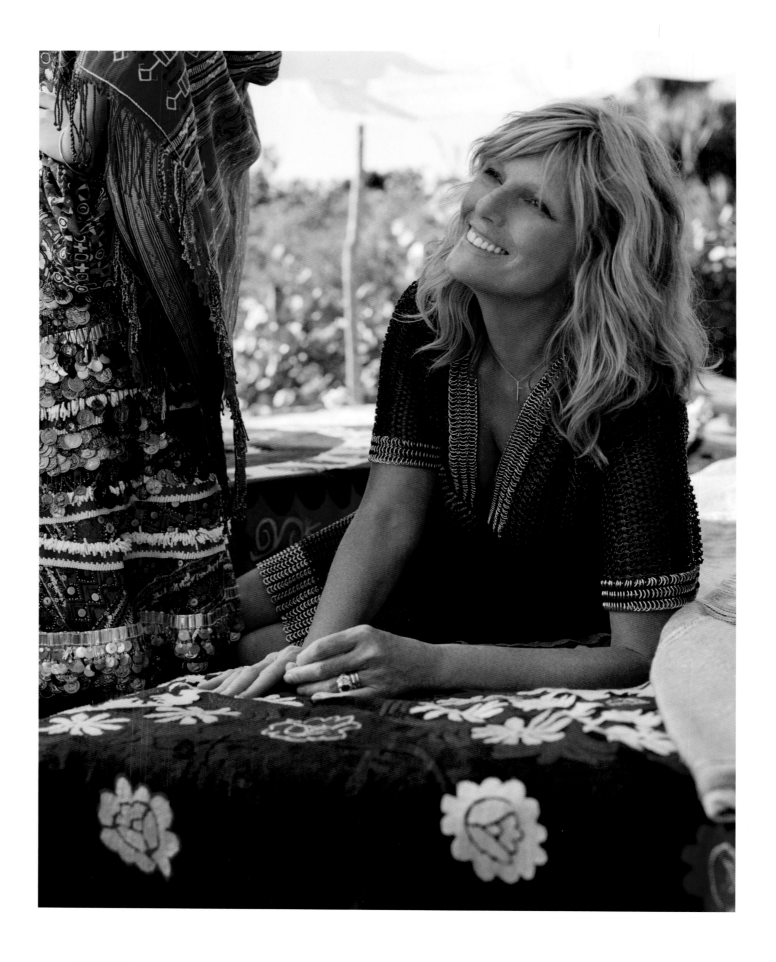

THESE PAGES AND FOLLOWING PAGES
Bruce Weber, *Vogue,* August 2012.

226

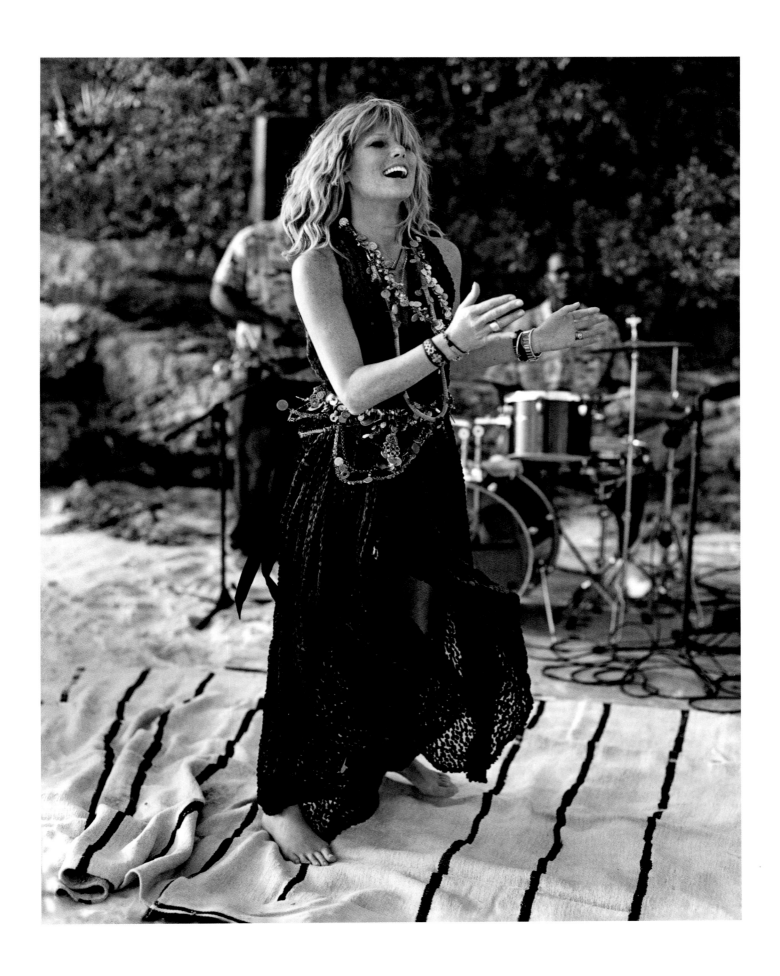

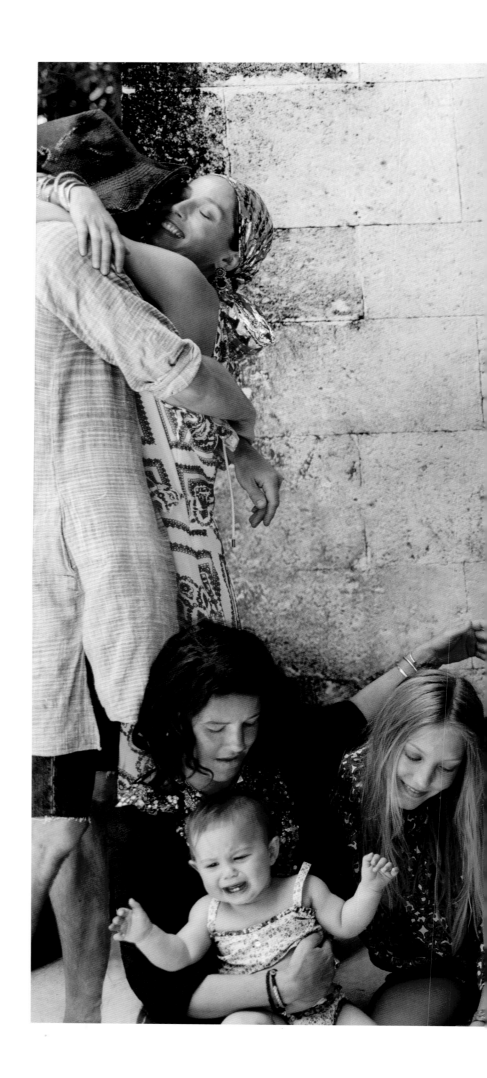

The Richards family, COUNTERCLOCKWISE FROM FAR LEFT:
Marlon and wife Lucie; Angela, Ava, and Ella;
Theodora; Ida, Orson, and Alexandra; Graham
and son Adam; Patti and Keith.

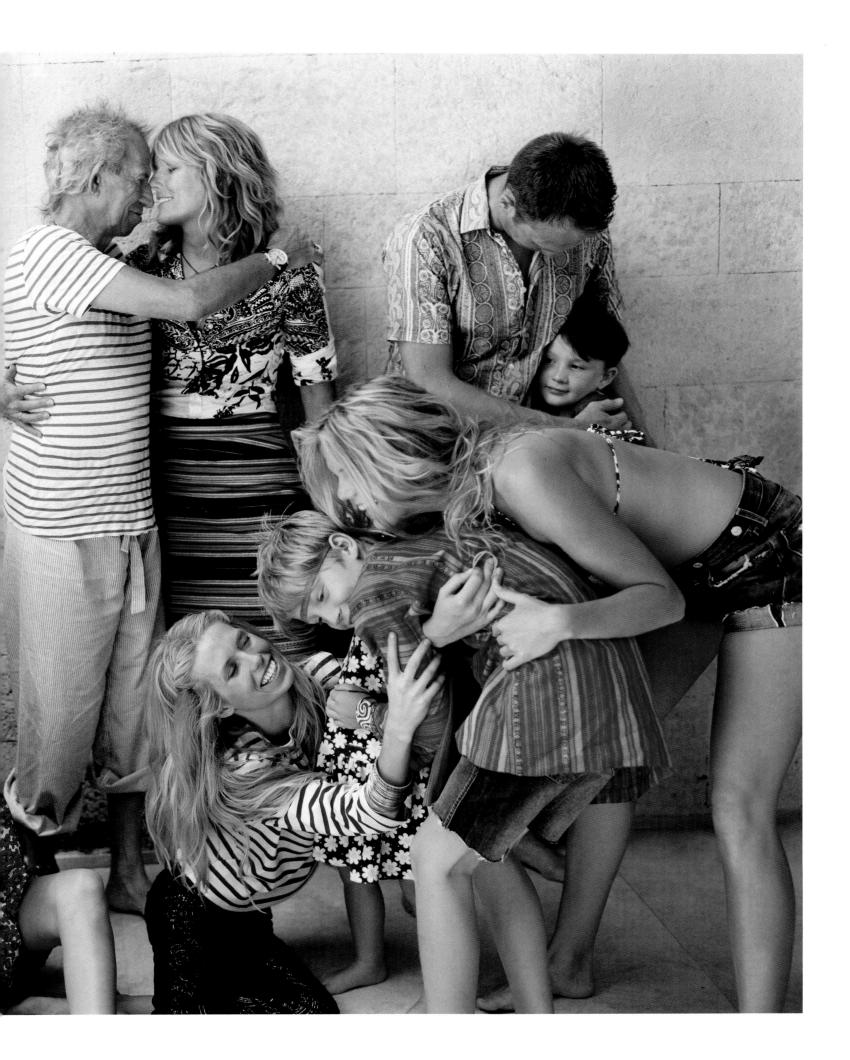

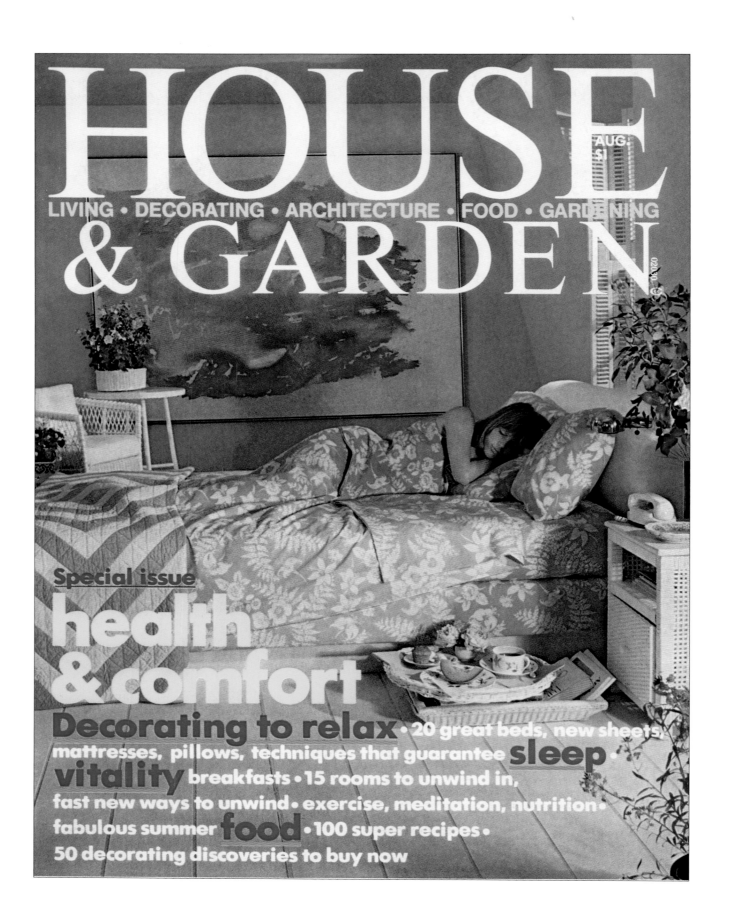

Horst P. Horst, *House & Garden,* August 1975.

ACKNOWLEDGMENTS

THANK YOU TO ANNA WINTOUR for her belief in, and support of, this project. This book would not have been possible without the guidance of Christiane Mack and the vision of Raúl Martinez.

Essential to this project were: Fred Woodward and Kristie Bailey for their design vision. Marianne Brown for always knowing where to find just the right image. David Byars, without whose steady hand this project would not have been possible. Jonathan Van Meter for his wisdom and knowledge. Laird Borrelli-Persson for her brilliant insights and edits. Corey Seymour for applying his expert editing skills. Alexa Elam for her thoughtful and careful planning. The Arthur Elgort Studio for their generosity. Patty Sicular for her unsurpassed knowledge of model history. Karlie Kloss, thank you for your fond memories of your early days at *Vogue* and for your kind words. And my wife, Lisa von Weise, for always listening to my ideas.

At Abrams: Jennifer Brunn, Paul Colarusso, Eric Himmel, and Rebecca Kaplan for their enthusiasm and support.

This book was a collaborative effort, and thanks are also due to David Agrell, Robin Aigner, the Richard Avedon Foundation, John Banta, Matthew E. Barad, Arielle Baran, Adriana Bürgi, Laura Cali, Elizabeth Covintree, Andy Cowan, Brett Croft, Patrick Demarchelier, Christopher Donnellan, Arthur Elgort, Nancy Frederick, Andrew Gillings, Alessia Glaviano, Cathy Hoffman Glosser, Lee Gross, Kate Hambrecht, Erin Harris, Timothy Herzog, Jade Hobson, Maury Hopson, Marianne Houtenbos, Mira Ilie, Allison Ingram, Oneta Jackson, Nathaniel Kilcer, Charlotte Knight, Nick Knight, Matthew Krejcarek, Chelsea Lee, Annie Leibovitz, Rocco LiCalsi, Sandy Linter, Maconochie Film & Photography Ltd., Molly Madden, Steven Meisel, Polly Mellen, Jimmy Moffat, Karen Mulligan, Becky Murray, Monique Parish, the Irving Penn Foundation, Tom Penn, Andreas Pieper, Mike Reinhardt, Jason Roe, Joyce Rubin, the Francesco Scavullo Foundation, Julie Schilder, Micki Schneider, Jay and Miriam Shaw, Etheleen Staley and Taki Wise, Josh Stinchcomb, Helena Suric, Tanisha A. Sykes, Caitlin Tormey, Kyle Torrence, Lewis Van Arnam, Michael Van Horne, Zach Vietze, Samantha Vuignier, Aaron Watson, Albert Watson, Bruce Weber, Harriet Wilson, and Vasilios Zatse.

And a special thank-you to Patricia Hansen Richards for allowing me the honor of telling her story in pictures.—IVAN SHAW

CREDITS

All images copyright © by the Condé Nast Archive unless otherwise noted. Large center image, courtesy of **Sandy Linter archives:** 15; © **Aldo Ballo:** 164; **The Irving Penn Foundation:** 112–115; © **The Helmut Newton Estate/Maconochie Photography Ltd.:** 194–195; © **The Richard Avedon Foundation,** Patti Hansen, crepe de Chine blouse by Versace, New York, April 18, 1977: 120; Patti Hansen, fur jacket by Fendi, New York, April 18, 1977: 121; Patti Hansen, shearling jacket by Geoffrey Beene, New York, April 18, 1977: 122; Patti Hansen, sweater and dress at Krizia, New York, April, 18, 1977: 123; © **Shutterstock:** 17; © **VAGA/The Collection of Chris von Wangenheim:** 136–137, 147, 197–207; © **Mikoto Arai/*WWD:*** 188–189; © **Ken Regan/Getty Images:** 209; © **The Francesco Scavullo Foundation:** 167–169; © **Mike Reinhardt:** 43, 170–175, 192; © **Albert Watson:** 176–185; © **Steven Meisel/Art+Commerce:** 210–211, 220–223; © **Michel Comte/ActionPress:** 212–213; © **Nick Knight:** 217; © **Annie Leibovitz:** 214–215, 224–225; © **Pamela Hanson:** 219; © **Bruce Weber:** 226–229.

FROM ABRAMS:
Editor: Rebecca Kaplan
Design Manager: Danielle Youngsmith
Production Manager: Rebecca Westall

Library of Congress Control Number: 2017956861

ISBN: 978-1-4197-3251-5
eISBN: 978-1-68335-418-5

Copyright © 2018 Condé Nast

Jacket © 2018 Abrams

Printed and bound in China
10 9 8 7 6 5 4 3 2 1

Abrams books are available at special discounts when purchased in quantity for premiums and promotions as well as fundraising or educational use. Special editions can also be created to specification. For details, contact specialsales@abramsbooks.com or the address below.

Abrams® is a registered trademark of Harry N. Abrams, Inc.

ABRAMS The Art of Books
195 Broadway, New York, NY 10007
abramsbooks.com